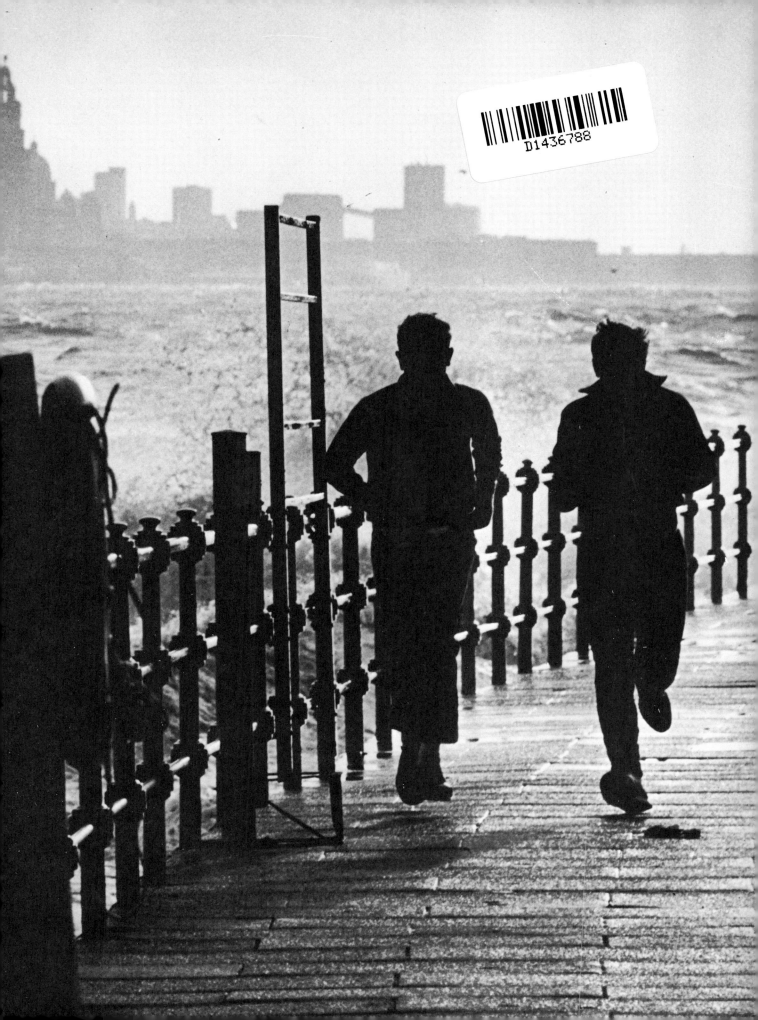

PHOTOGRAPHY YEAR BOOK 1985

CLOSEST TO PERFECTION.

Acknowledged worldwide for precision, optical perfection and total reliability, the Leitz reputation extends beyond the acclaimed Leica cameras, lenses and quality photographic accessories to Focomat enlargers, Pradovit projectors and Trinovid binoculars. Visit an appointed Leica specialist near you and see the world's finest.

Leitz means precision worldwide.

E Leitz (Instruments) Ltd., 48 Park Street, Luton, Beds. LU1 3HP. Telephone No. 0582 413811.

PHOTOGRAPHY YEAR BOOK 1985

Edited by Peter Wilkinson Hon. FRPS

FOUNTAIN PRESS LTD.

Fountain Press Ltd,
45 The Broadway,
Tolworth,
Surrey KT6 7DW,
England

ISBN 0 863 430 279

© Fountain Press Ltd., 1985

N.P. Advertising Office:
 Colette Boland
 Boland Advertising,
 Tempo House,
 15-27 Falcon Road,
 London SW11 2Pl

Typeset by Tenreck Ltd.

Origination by Culver Graphics Ltd

Printed and Bound by Graficromo S.A., Cordoba, Spain.

CONTENTS

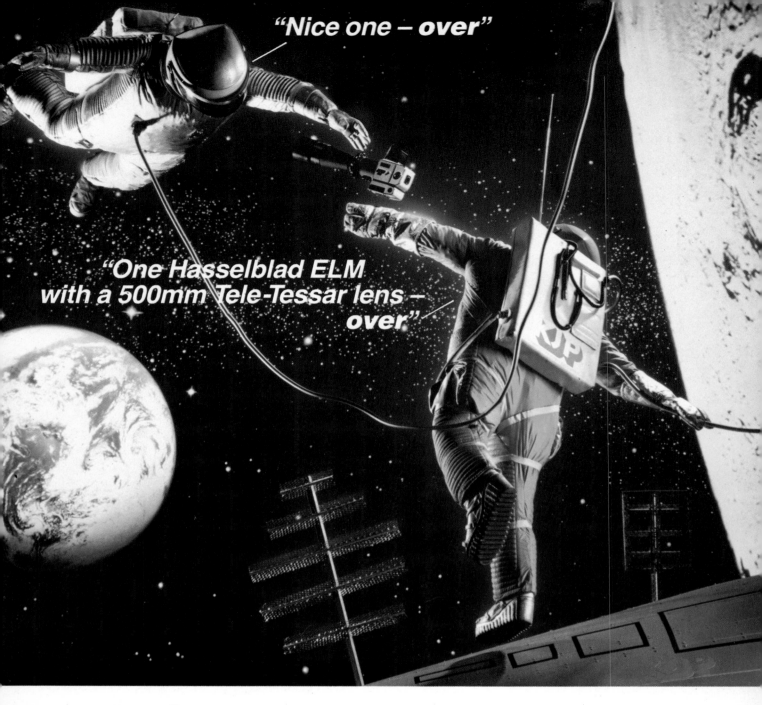

"Nice one – over"

"One Hasselblad ELM with a 500mm Tele-Tessar lens – over"

We'd certainly do our best

Space has never proved an obstacle to our intrepid deliverymen. Trained on all forms of transport they some how always manage to get the order through on time.

Fulfilling the needs of professional photographers is an art we have pretty well perfected at KJP. No one else provides such a complete range and flexibility of services the busy pro' requires.

Besides our same day delivery service operated in London by our fleet of vans and messengers, there's our unbeatable Trade Counter – the largest in London. The Hire,

Repair and Export Departments provide valuable back-up services too.

At KJP House you will also find under one roof the most comprehensive range of professional photographic equipment and materials. And ask about our 9 months interest free credit scheme.

KEITH JOHNSON PHOTOGRAPHIC LTD
KJP House
11 Great Marlborough Street
London W1V 2JP
Tel: 01-439 8811 Telex: 24447

Distributors of Professional Photographic Equipment

The Nikon F3 is built tough. It's as reliable in the tropics as in the arctic, as precise at 8 seconds as at 1/2000 sec. Known for its rugged dependability, the F3 is a true thoroughbred.

The F3 High Eyepoint has a larger viewfinder eyepiece, enabling you to see the entire frame at a glance. And so it's ideal for photographers who wear spectacles, or for those who shoot fast action.

The Nikon F3AF is built to take great shots automatically exposed and automatically focused. It will enable action photographers and photo-journalists to keep fast-moving subjects pin-sharp.

The F3T uses titanium in its construction. Capable of withstanding corrosion, impact and extremes of temperature, it is the ultimate 35mm camera and can truly be called the toughest of the tough.

ONE LEVEL OF EXCELLENCE. FOUR WAYS OF ACHIEVING IT.

NIKON UK LIMITED, 20 FULHAM BROADWAY, LONDON SW6 1BA. TEL: 01-381 1551

Introduction by The Editor

Pictures for this edition of Photography Year Book have been selected from what must have been one of the largest entries in the book's long history. Nearly fifteen thousand pictures were submitted, from which approximately 220 were selected for inclusion which represents an acceptance rate of less than one in seventy.

We thank all the contributors who submitted, offer our condolences to the unsuccessful and congratulations to the successful.

Once again the quality of the colour work entered was generally of a high standard and, in the light of this, it has been decided to increase the number of colour pages in this year's edition. The impression gained from this year's monochrome entry was that the standard of the picture content and print quality was extremely varied, in fact many prints not only lacked interesting subject matter but were unsharp and in some cases badly printed, lacking both good whites and blacks and quite unsuitable for reproduction. In theory, the making of a satisfactory photographic image, either colour transparency, colour print or monochrome print, should be infinitely easier with today's comparatively inexpensive high technology cameras and lenses, coupled with the vast range of films with speeds eight times faster than when I first became involved in photography in the late 1940s, and the making of colour prints either for colour negative or transparencies is now almost as easy as printing in monochrome. We now have access to a whole range of lenses and filters which, used intelligently but with discretion, can be most creative. We have dedicated electronic flash guns which automatically punch out the correct amount of light for a given situation. So why is it that with all this marvellously advanced technical assistance so much of today's photography falls short of what most of us would consider an acceptable standard.

I think there are two main reasons. Firstly, the choice of equipment, accessories and materials is so great as to be confusing. Many of the older school of photographers learned their photography with one camera with a fixed focal length lens, often used a tripod and worked with just one type of film processed in a very orthodox manner, they concentrated on taking and making pictures without the distractions of choice of lens, film etcetera. One great pictorial photographer, Dr. S.G. Jouhar, in the 1950s hammered home the fact that it was the person behind the camera not the camera that produced pictures. He set out to make pictures of exhibition quality with a 1930s Kodak Box Brownie. I well remember some of those pictures which were accepted and hung in the London Salon of Photography exhibition.

Secondly, many pictures seem to be taken without purpose, but I consider that photography often excels when it is used to complement or to illustrate other interests and hobbies, and in this edition of Photography Year Book you will find many obvious examples such as natural history, sport, landscape and, perhaps, pretty girls! For the keen photographer who does not earn a living from the medium but practices it as a hobby, I would suggest that rather than take random pictures when the mood takes them, they use their camera to try and capture the essence of something they know well, to take the opportunity to illustrate their hobby or their job or the town they live in. Looking at pictures from eastern Europe I invariably feel that the photographers have a sympathy or are involved with the subject of their pictures to a greater extent than many of us. From another part of the world, one of this year's contributors, a New Zealander Terry O'Connor, submitted a set of pictures of deprived children at a New Zealand children's health camp. These pictures, together with others in a book for which they were taken, were for me a fine example of the work of an involved photographer. In some of his pictures I felt that he must have been invisible and in others there was a feeling of rapport and complete acceptance on behalf of the subjects.

One of the interests of working on the Year Book is the opportunity of seeing the work of photographers of so many countries, and it is fascinating to see how there are national characteristics in the work from different parts of the world. To generalise, pictures from Scandinavia tend to be contrasty and grainy with little tonal gradation but very effective in illustrating the harshness of these lands. In contrast, pictures from the continent of India are often soft in gradation and expressive of warmth and dust. From the Far East the work usually concentrates on pattern and design and their colour photographs are often brilliant with saturated colours. The pictures that we receive from eastern Europe are usually involved with people which, even if they are "stage managed", look spontaneous and unposed.

I would like to think that the readers of the Year Book who are interested in the art and craft of photography will not be disappointed in this year's selection of pictures, that readers who are also competent photographers will be enthusiastic enough to submit some of their work for inclusion in future editions and that newcomers to the wonderful world of photography will find the pictures in the book an inspiration to develop their own work. Who knows, it could be your picture on the cover one year.

Finally, a request to everyone who thinks that they may have suitable pictures, to submit them for next year's edition.

Peter Wilkinson, F.R.P.S.

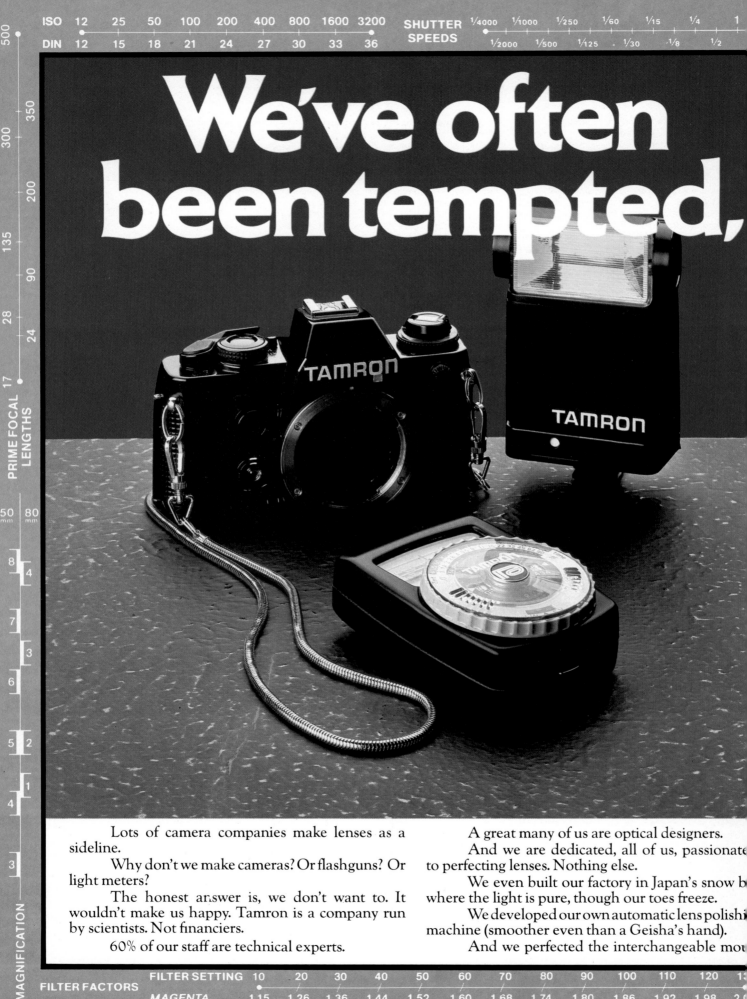

We've often been tempted,

Lots of camera companies make lenses as a sideline.

Why don't we make cameras? Or flashguns? Or light meters?

The honest answer is, we don't want to. It wouldn't make us happy. Tamron is a company run by scientists. Not financiers.

60% of our staff are technical experts.

A great many of us are optical designers.

And we are dedicated, all of us, passionate to perfecting lenses. Nothing else.

We even built our factory in Japan's snow b where the light is pure, though our toes freeze.

We developed our own automatic lens polishi machine (smoother even than a Geisha's hand).

And we perfected the interchangeable mou

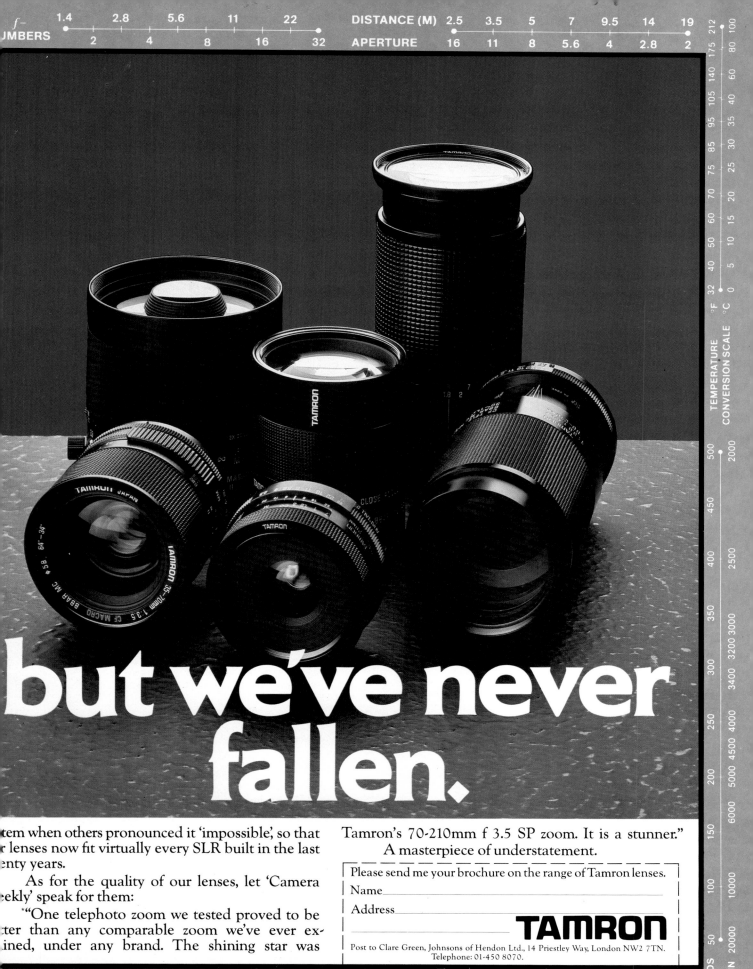

TO ALL WHO ARE INTERESTED IN PHOTOGRAPHY:

Do you know that *YOU* can become a member of the leading photographic organization in the world – THE ROYAL PHOTOGRAPHIC SOCIETY?

Membership of the Society is open to *any*one in *any* part of the world.

No qualifications are demanded but, once you are a member, you may apply for the Society's coveted distinctions of LRPS (Licentiateship), ARPS (Associateship) and FRPS (Fellowship).

The Society has twelve special-interest Groups as well – Aerial, Archaeology and Heritage, Audio Visual, Colour, Film and Video, Historical, Holography, Medical, Nature, Pictorial, Scientific and Technical, and Visual Journalism. Members may join any of these.

All members receive each month "The Photographic Journal", published continuously since 1853.

Other benefits include:

 Admission to Society meetings anywhere in the world

 Free admission to all exhibitions and facilities at the RPS National Centre of Photography in Bath

 Reduced entry fees to Society conferences, field trips, instructional workshops, etc.

 Access to the most comprehensive photographic reference library in the world

 Research facilities based on the Society's collections of photographs and apparatus

 Full club facilities – including overnight accommodation – in London

 Regular information from the RPS bookshop and mail order service

Remember: MEMBERSHIP IS OPEN TO EVERYONE and, if you would like further details and an application form, please write to:

The Secretary,
The Royal Photographic Society, Dept. YB,
RPS National Centre of Photography,
The Octagon,
Milsom Street,
Bath, England.

GOOD BOOKS ON PHOTOGRAPHY COME FROM FOUNTAIN PRESS

0871001632	A Century of Cameras
0871001365	Alternative Photographic Processes
0852423462	An Age of Cameras
2880460365	Art Director's Index No 9 (1) Europe
2880460373	Art Director's Index No 9 (2) Australia, America & Asias
2880460441	Art Director's Index No 10 (1) Europe
288046045X	Art Director's Index No 10 (2) Australia, Asia & Americas
093511209X	Alfred Stieglitz
0863430228	Art of Scenic Photography
0852426402	A Short History of the Camera
0871001713	Barbara Morgan Photomontage
0895862603	Basic Guide to Colour Darkroom Tech.
0960435220	Blue Book Price Guide-First Master Ed.
2880460123	Christian Vogt Photos
2880460271	Christian Vogt In Camera
0871000210	Colour Primer I and II
0863430201	Complete Photobook
0895861763	Complete Guide to Cibachrome
0851427115	Creative Colour Transparencies
0871001039	Dictionary of Contemporary Photography
091265628X	Do It In The Dark
0871000237	Enrico Natali Monograph
0863430007	Essential Darkroom Book
0863430422	Experimental Photography
0871000016	101 Experiments in Photography
085242762X	Exposure Manual
2904838007	French Photographers Annual I
0863430708	Focus on Special Effects
0852427514	Four Seasons of Nature Photography 1
0895861437	High Contrast Images
0871000148	History & Practice of the Art of Photography
0871000474	Hole Thing, The
0894960172	Holography Handbook
0895860597	How to Control & Use Photographic Lighting
0912656980	How to Create Photographic Special Effects
0895860686	How to Photograph Flowers, Plants and Landscapes
0895862735	How to Photograph Water Sports & Activities
0895862085	How to Photograph Landscape and Scenic Views
0895862123	How to Photograph Pets & Animals
0895861453	How to Photograph Sports & Action
0895860570	How to Photograph Weddings, Groups and Ceremonies
0912656565	How to Select & Use Canon SLR Cameras
0895860449	How to Select & Use Minolta SLR Cameras
0912656778	How to Select & Use Nikon and Nikormat SLR Cameras
0895860155	How to Select & Use Olympus SLR Cameras
0912656573	How to Select & Use Pentax SLR Cameras
0895860430	How to Select & Use Photographic Gadgets
0912656263	How To Take Great Pictures with you SLR
0895862262	How to Use & Display Your Pictures
0895861445	How to Select & Use Electronic Flash
0852426682	Illustrated Dictionary of Photography
0843601388	Magic of Instant Photography, The
0895860465	Medium Format Cameras
0852425112	Microscope Techniques
0871001217	Movies Begin, The
0852426704	Nature Photography
0871001780	New American Nudes
0871001691	Nude 1900
0871001543	Nude 1925
2880460255	Paris – Essence of an Image
0852426321	People in My Camera
0895862697	People Photography
0863430368	Perfect Nude Photography
0871000156	Photographic Analysis
0871000660	Photographic Chemistry
0863430600	Photographic Composition
0871000369	Photographic Filters
085242504X	Photographic Know How
0871001853	Photo Lab Index – Compact Edition
0852423861	Photographic Lenses
095860325	Photographic Materials & Processes
0852427050	Photographic Retouching
0871001802	Photographic Sensitometry
071001179	Photographic Tone Control
0863430503	Photography Year Book 1984
0863430279	Photography Year Book 1985
0871000822	Photo Researches of Hurter & Driffield
0852423101	Practical Sensitometry
085242356X	Reproduction Of Colour
0871001861	Rising Goddess
0871001500	Russell Lee Photos
288046028X	Jan Saudek, The World of
0871001012	Silver Meditations (Jerry Uelsmann)
091265659X	SLR Photographer's Handbook
087100017Z	Stereoscope (Pub. 1856)
0871001063	Theatre of the Mind
0912656247	Understanding Photography
0895861410	The Zone System for Fine B & W Photography

SEND FOR PRICE LIST AND ORDER FORM TO:
FOUNTAIN PRESS LTD., 45 THE BROADWAY, TOLWORTH, SURREY KT6 7DW

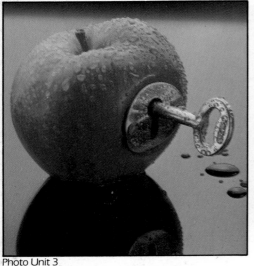
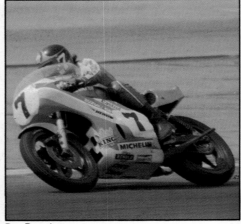
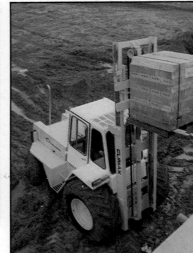
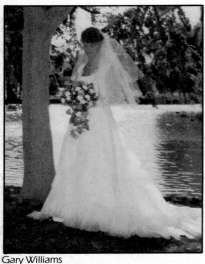
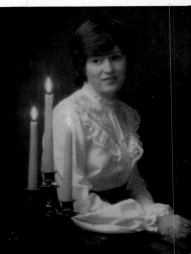
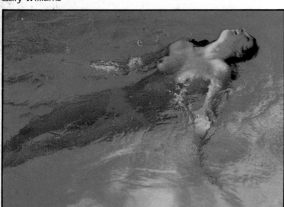

It's what it has up top that makes the T70 so exciting.

The T70 is a highly 'intelligent' camera. With its micro-computer, it will give you more automatic and electronic functions than any previous camera.

This new design with its eight modes, three of which are Programs can be very easily controlled, at the touch of a button.

All the technology is there simply to help you realise your full photographic potential.

Make the T70 work for you.

Canon T70
So advanced, it's simple.

Canon – Manufacturers of Cameras, Calculators, Copiers, Computers, Copyphones, Typewriters and Micrographics.

The Photographers

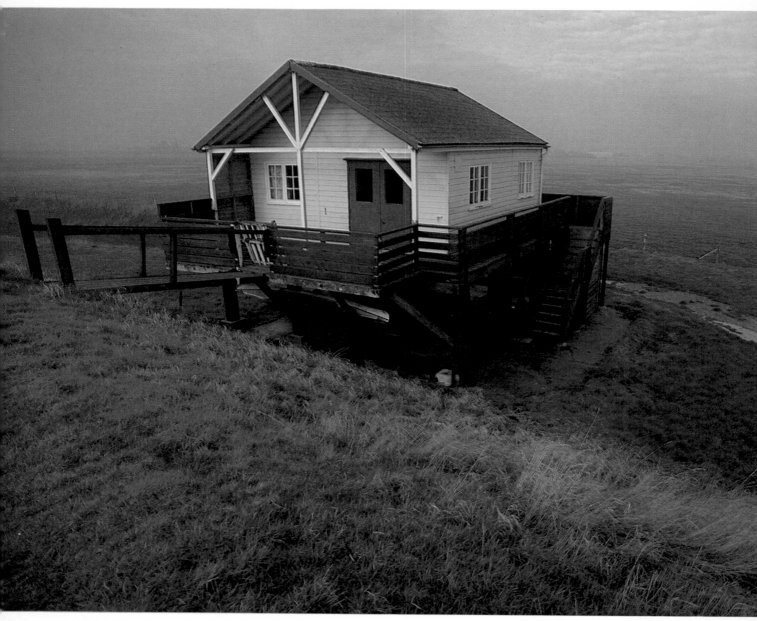

Den Reader

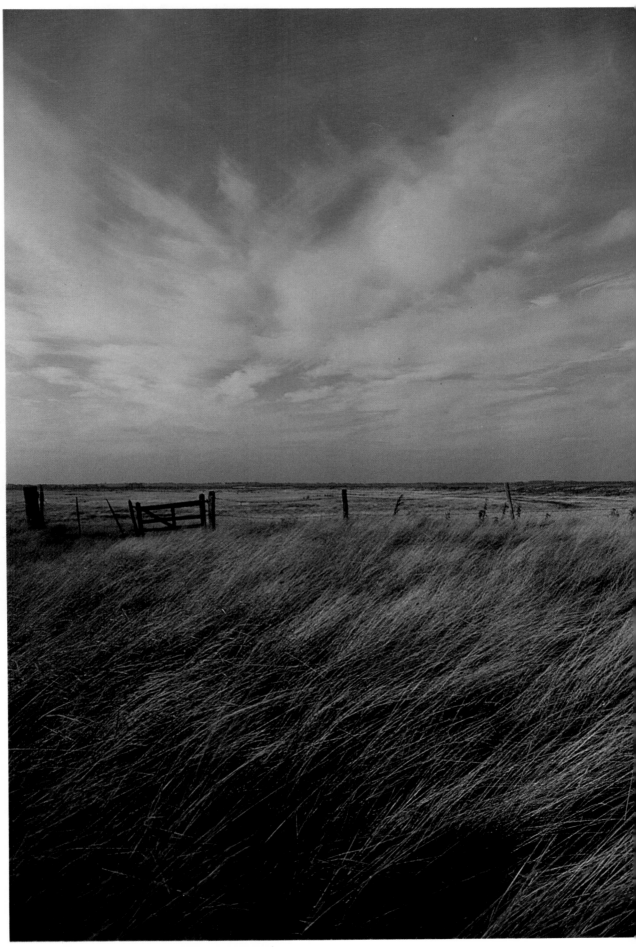

Den Reader

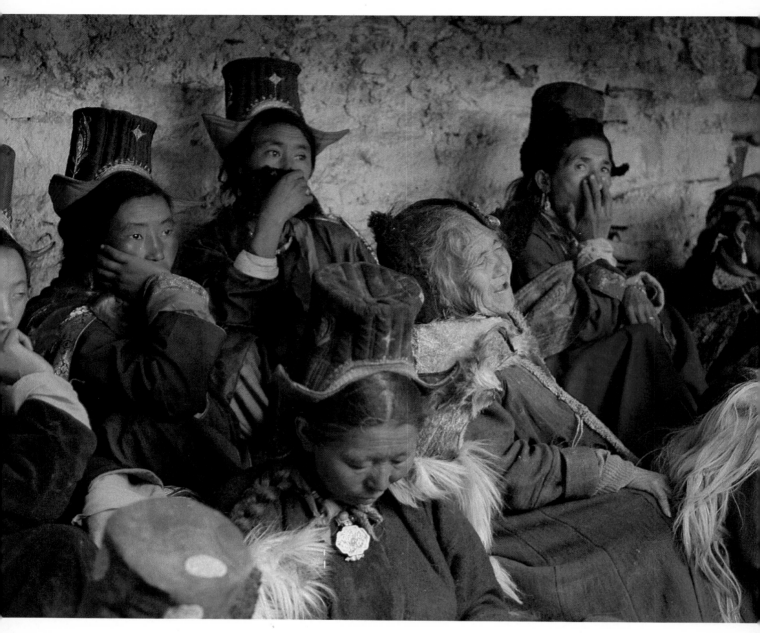

Philip Long

20

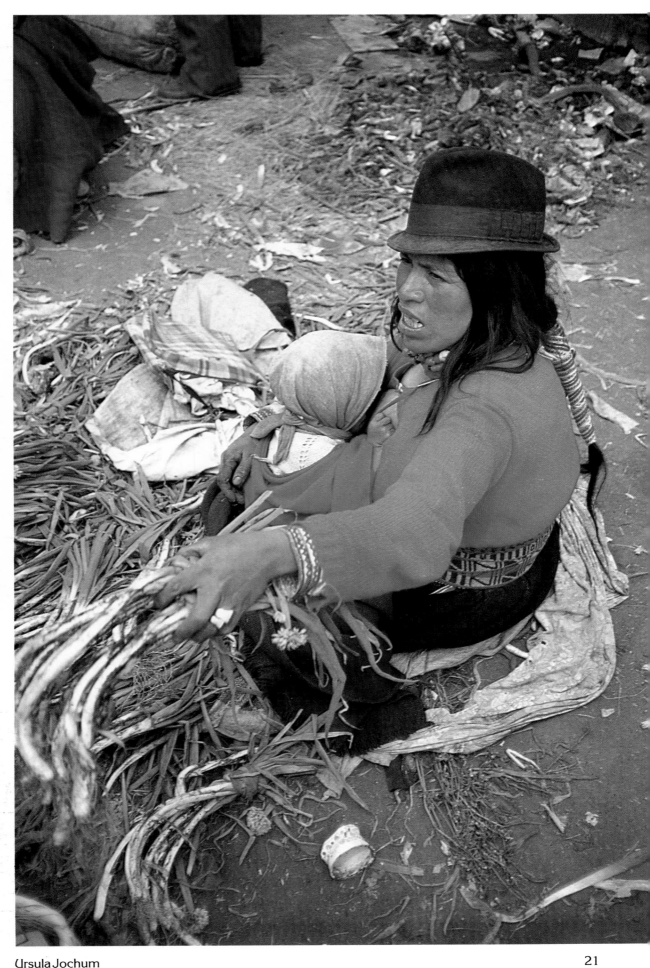

Ursula Jochum

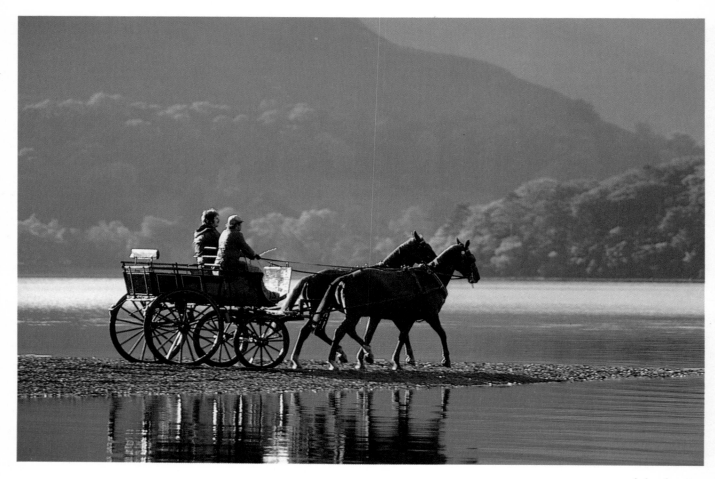

John Jerstice

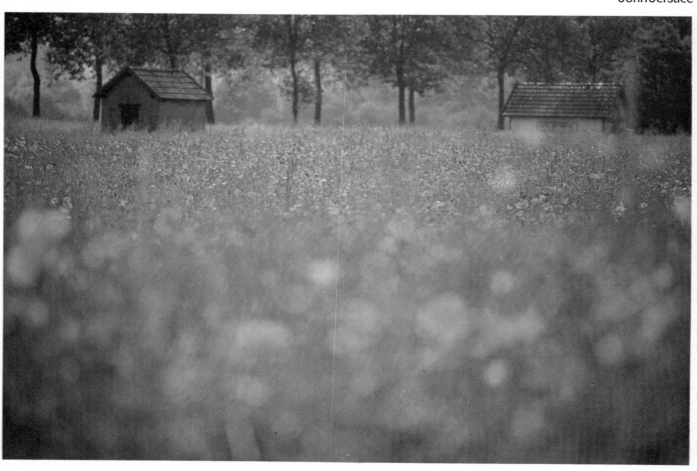

Manjul K. Agarwal

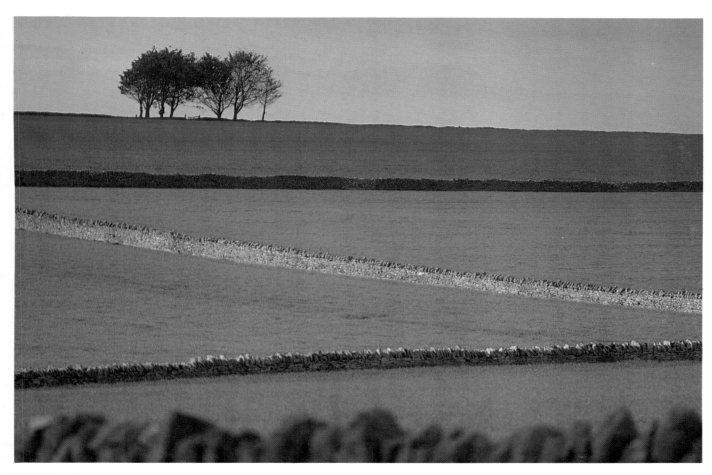

D.C. Wheeler

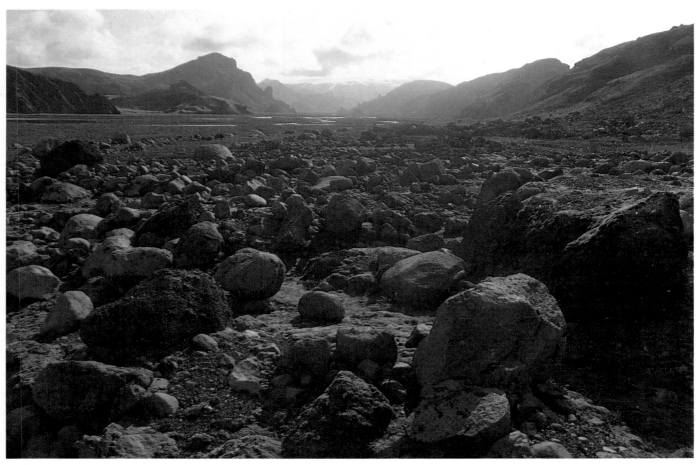

Richard Tucker

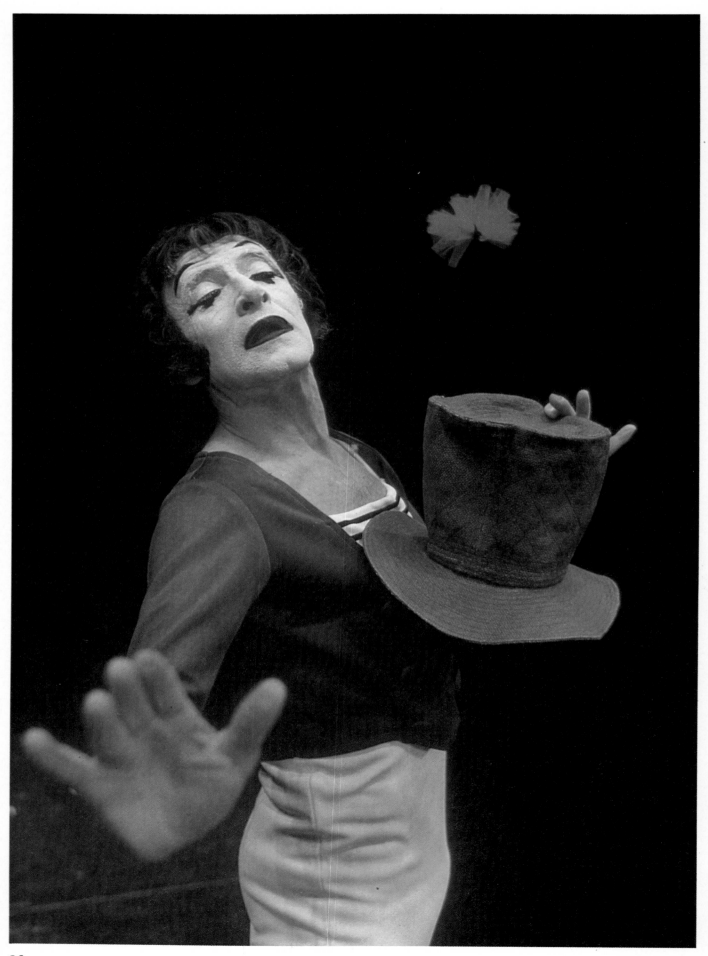

Patrick Duzer

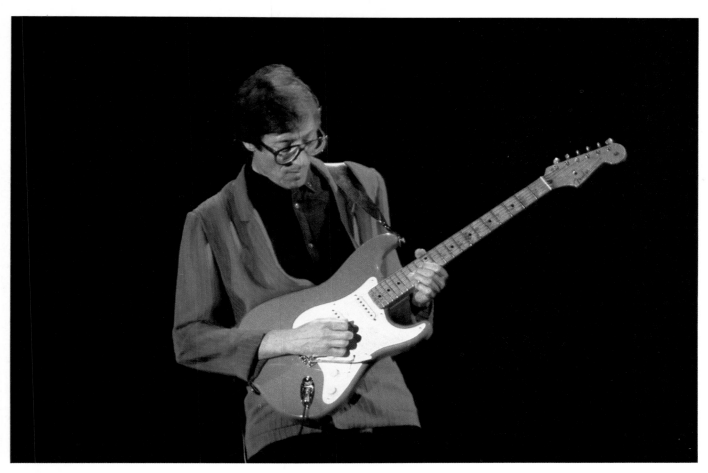

Peter Underhay

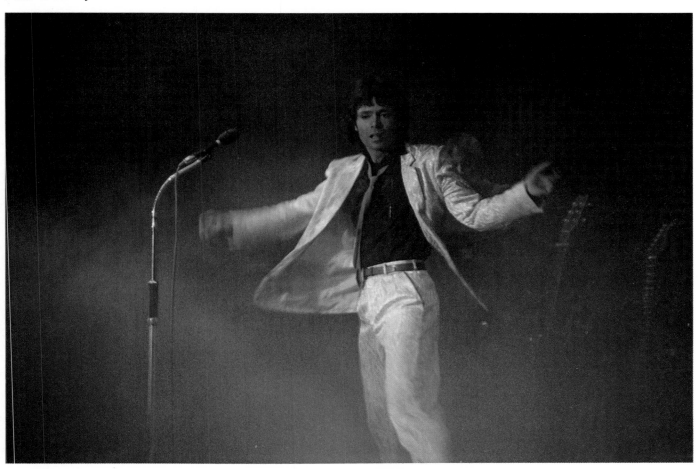

Peter Underhay

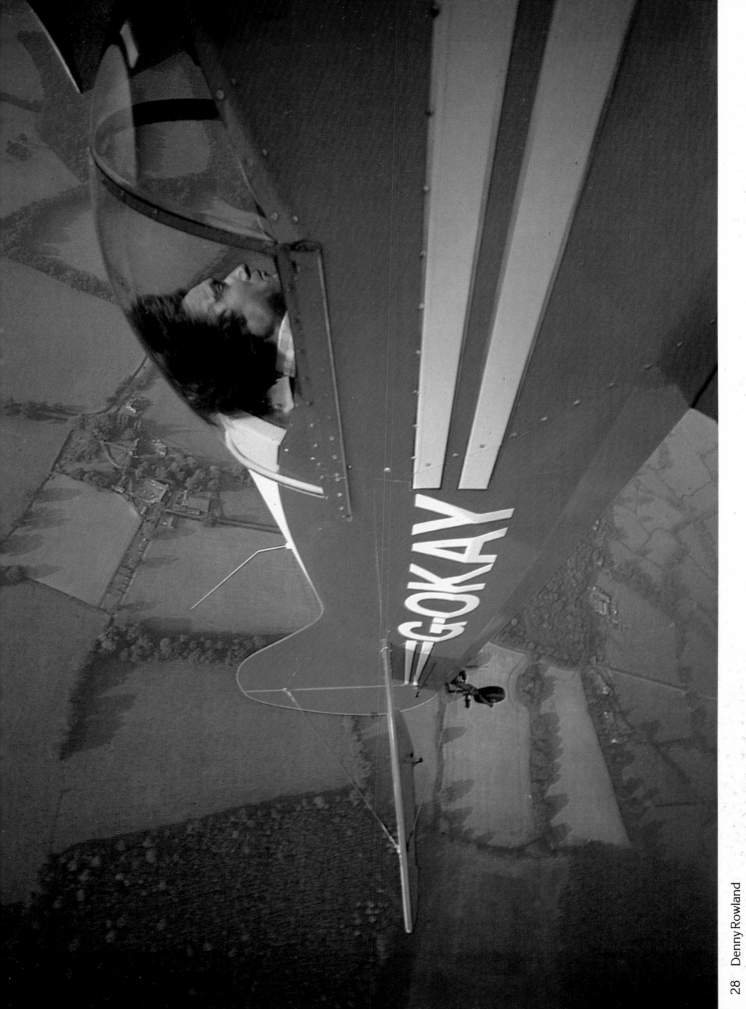

Denny Rowland

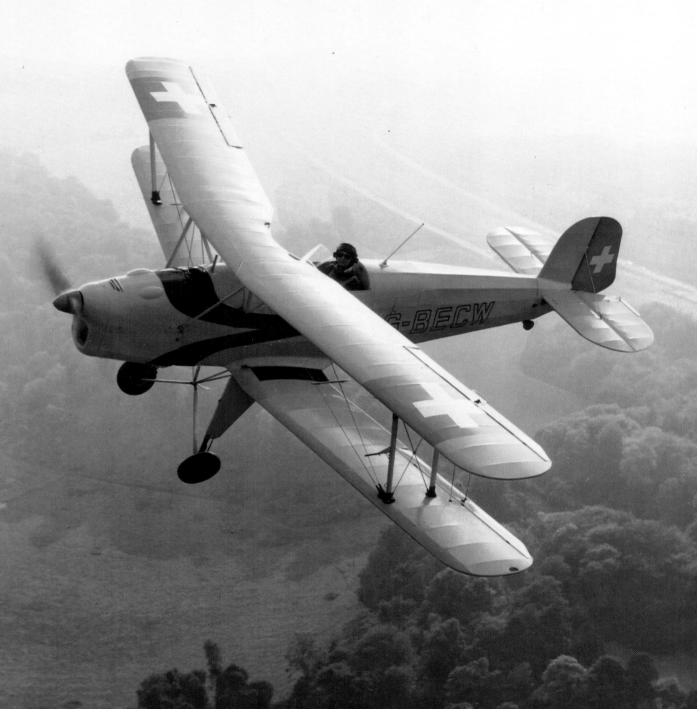

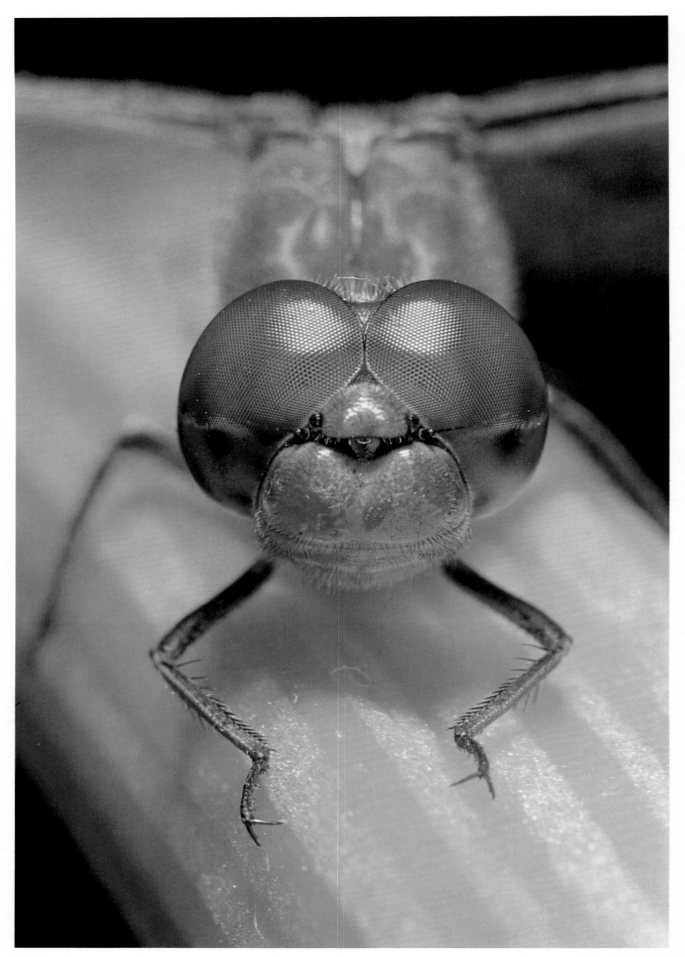

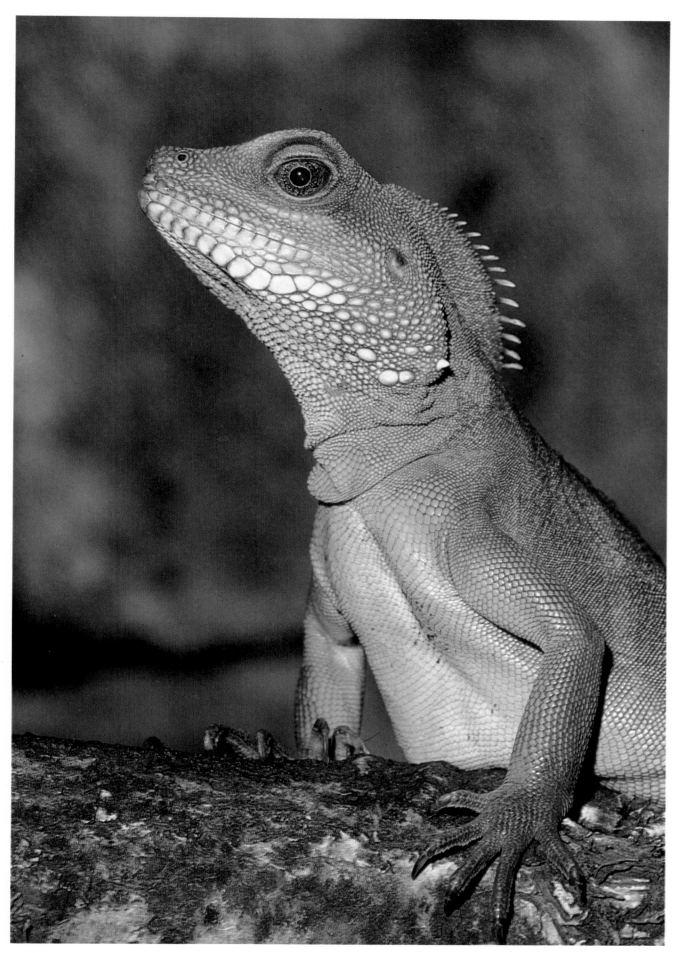

Ed Over

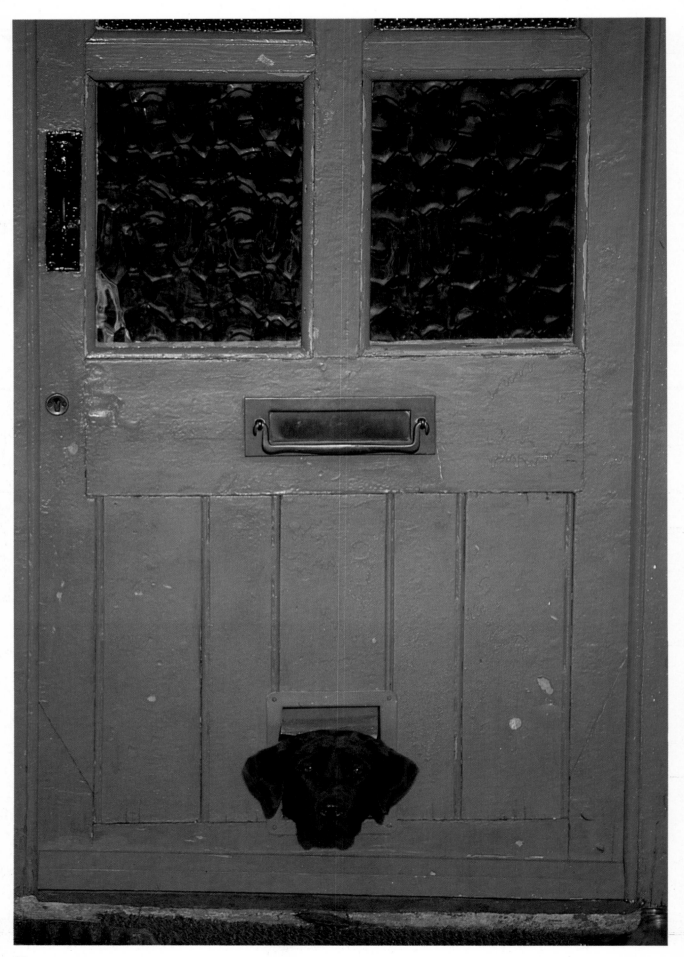

Denis Kennedy

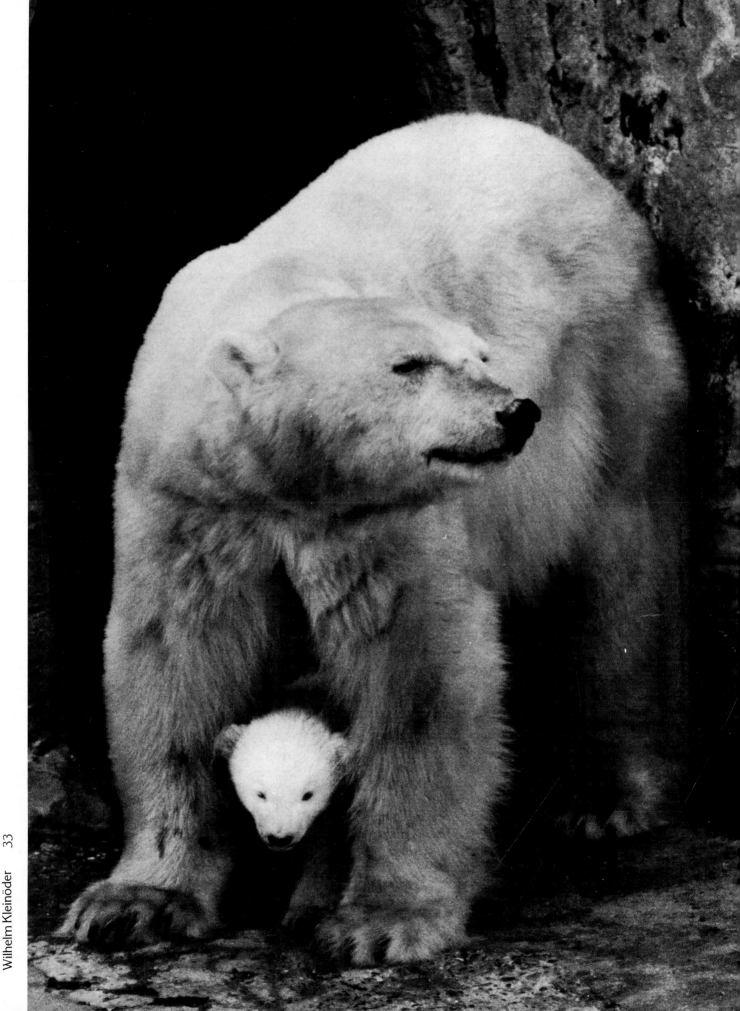

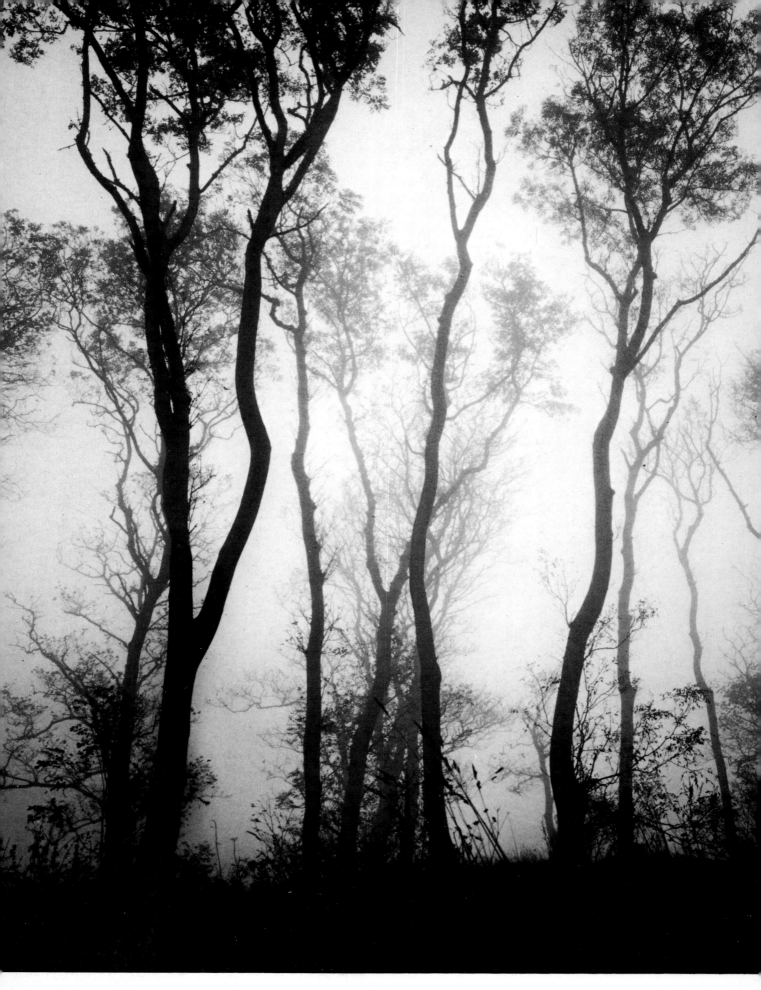

34

L. McLean

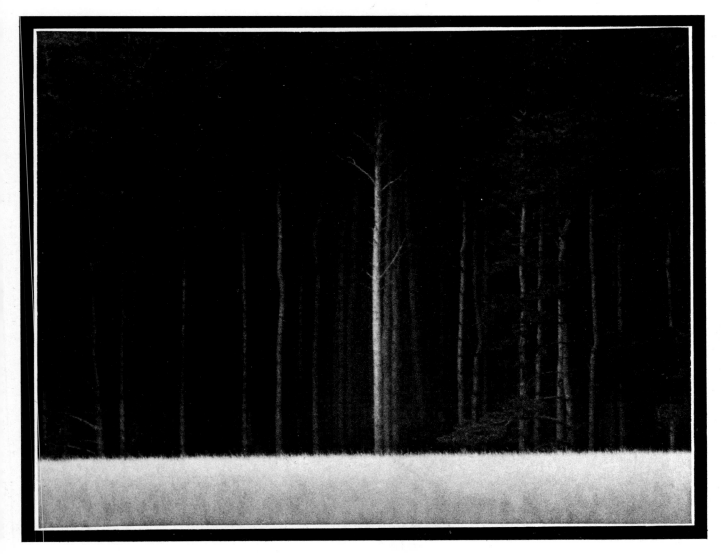

L. McLean

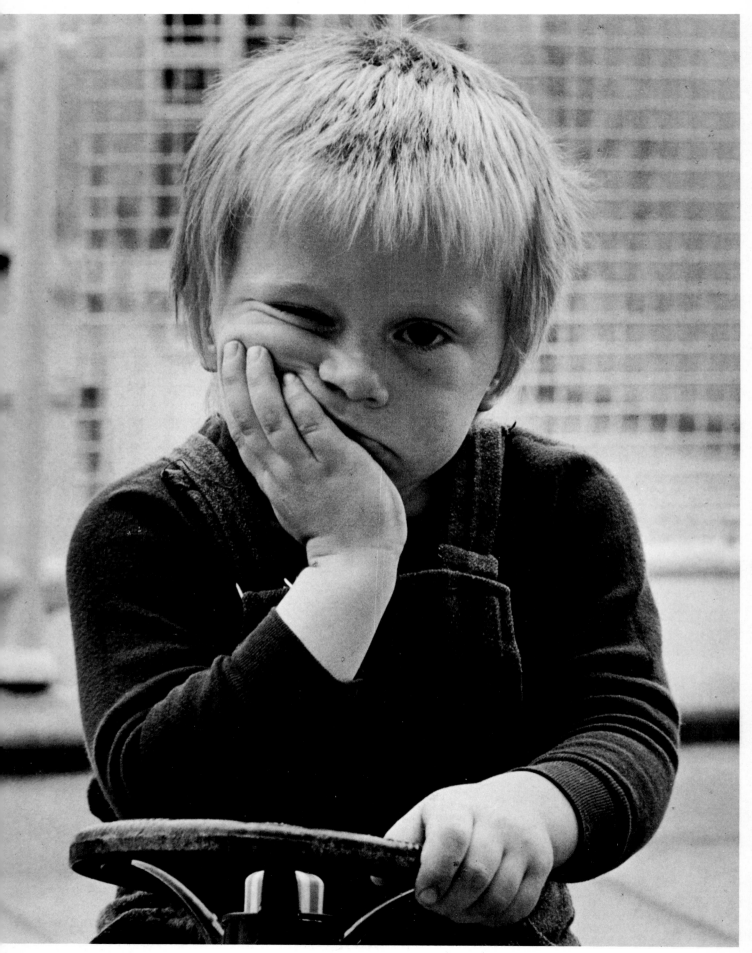

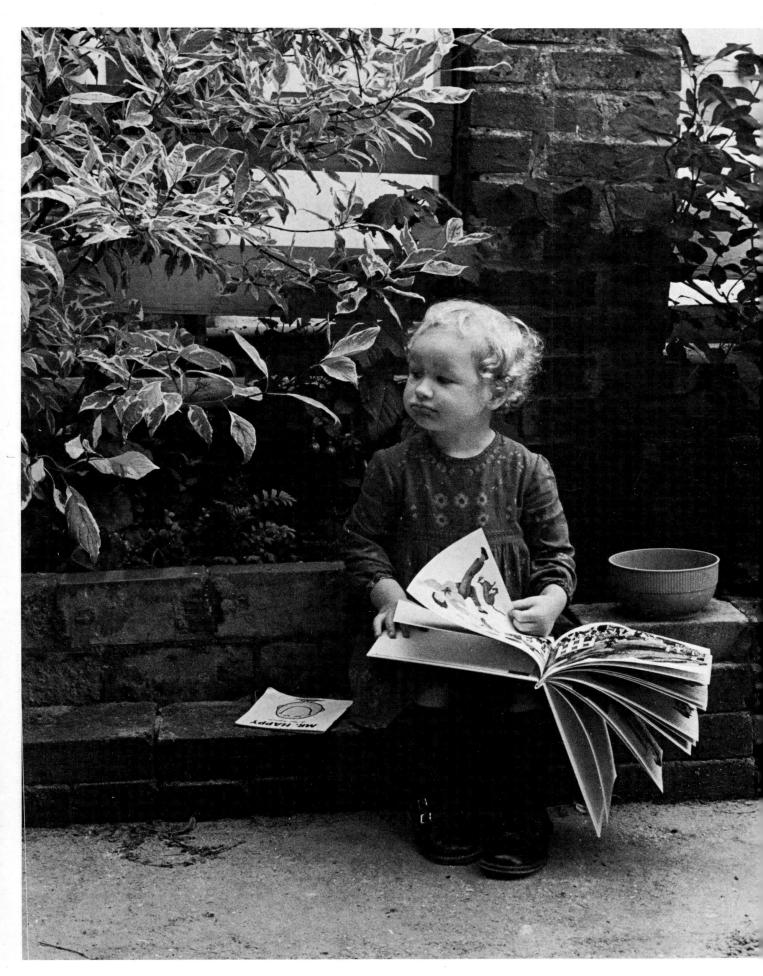

John Timbrell

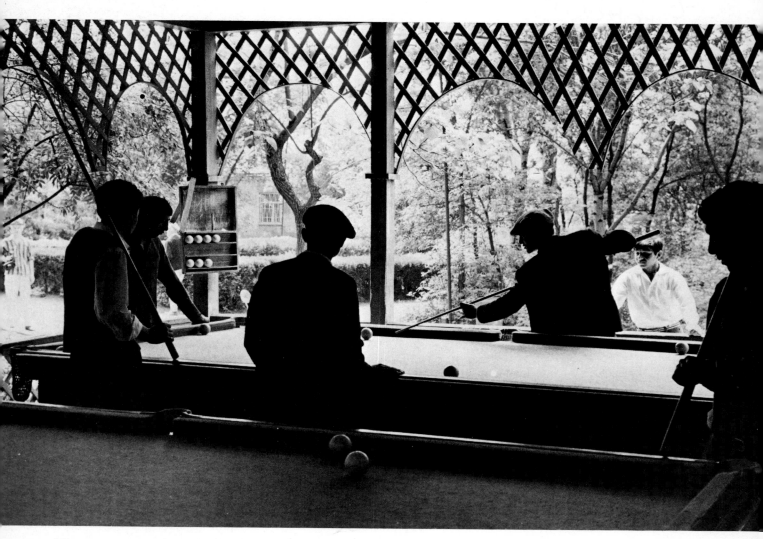

Douglas Jardine

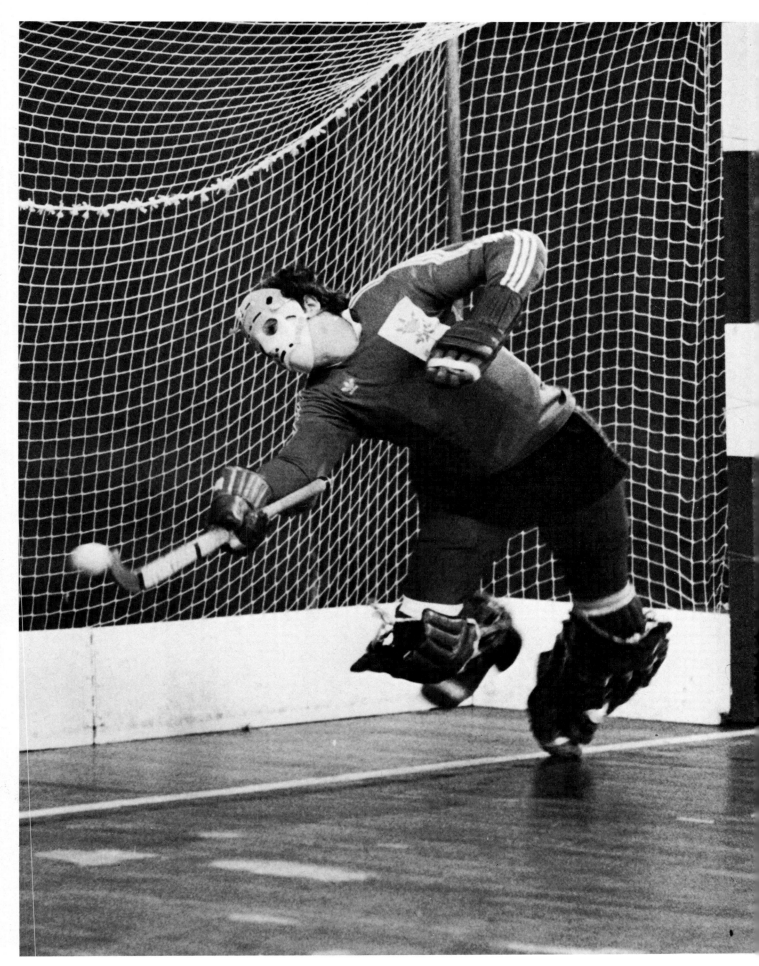

Juergen Hasenkopf

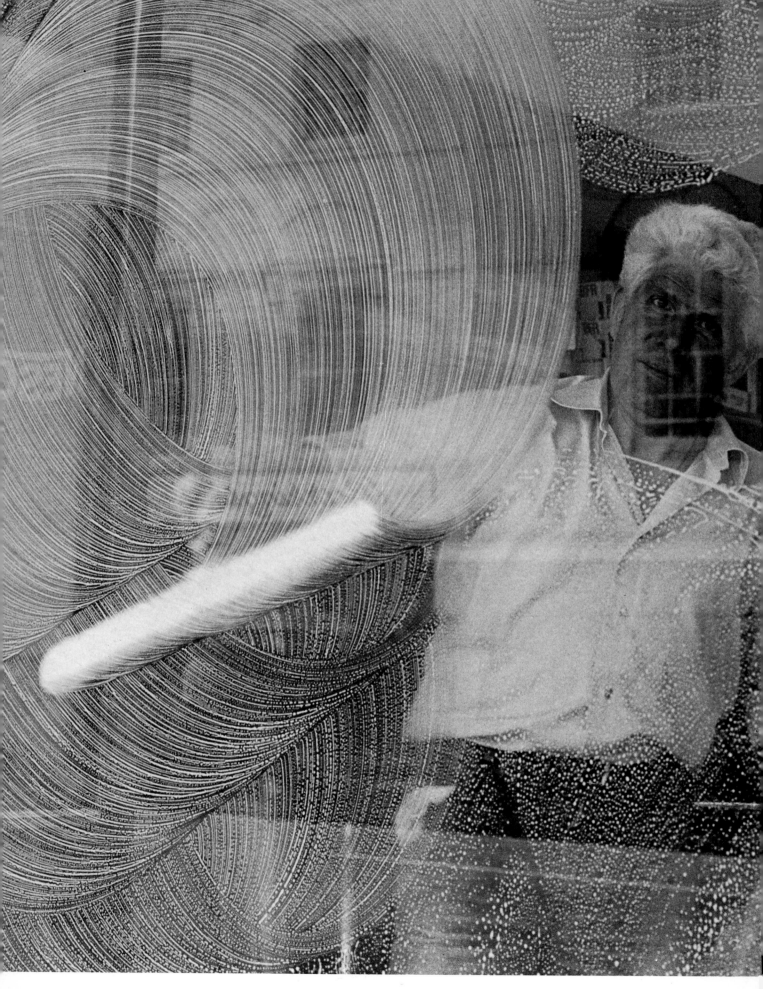

J.E. Durham

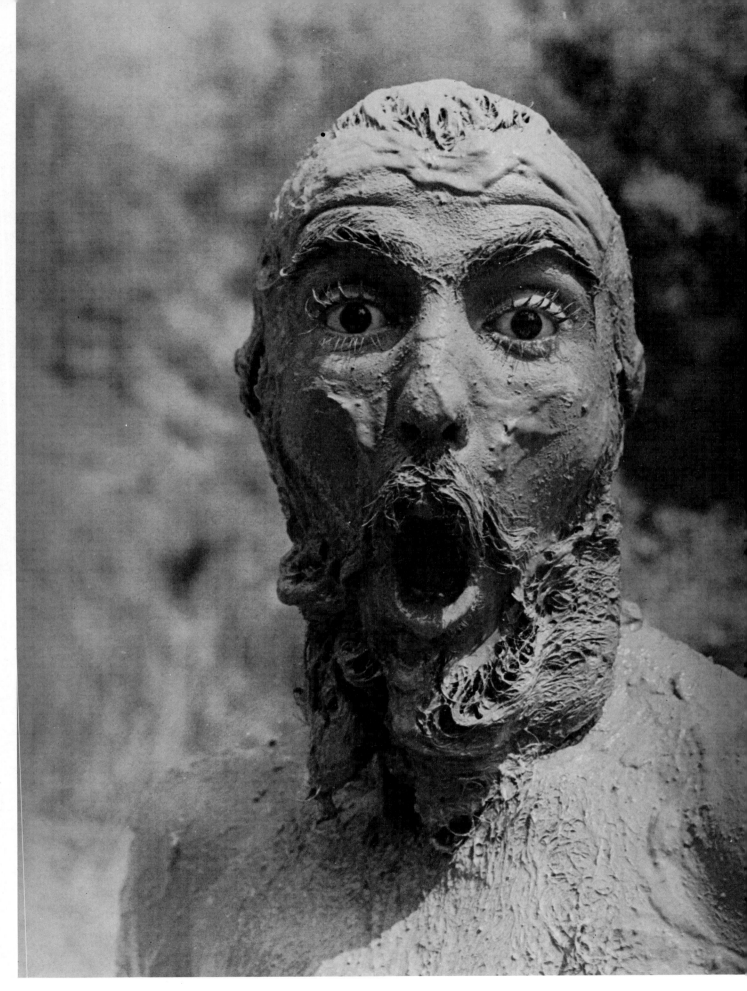

Hernandez Irquierdo

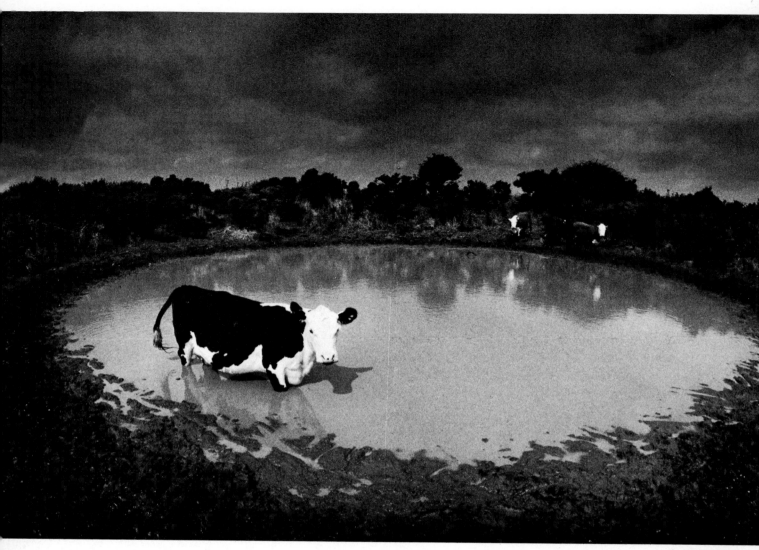

Bill Wisden

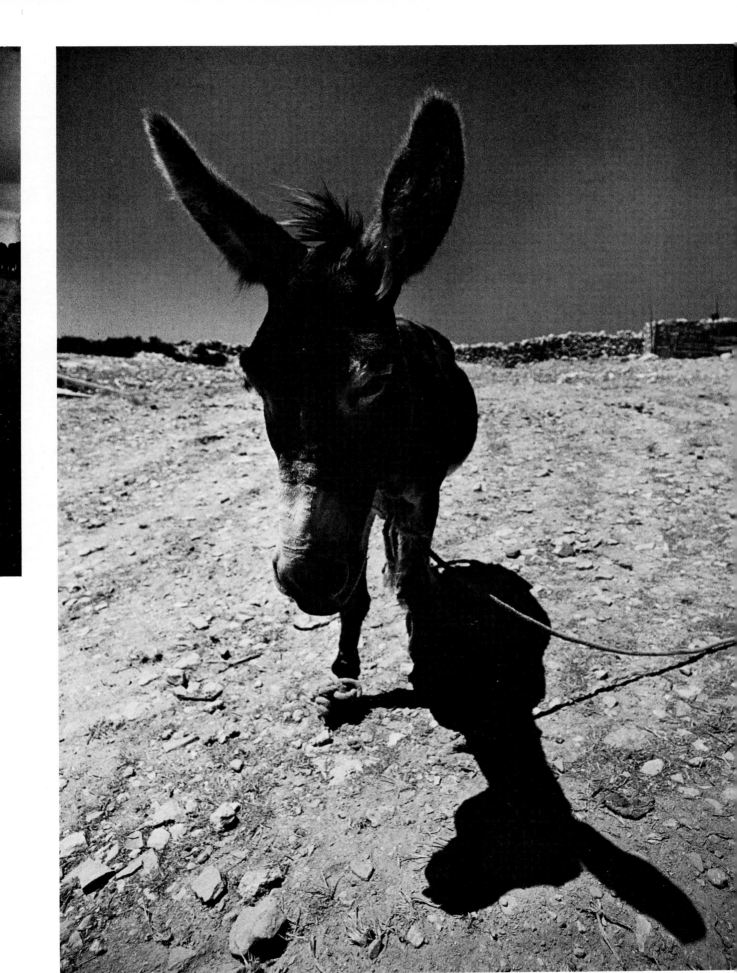

Gerd Romahn

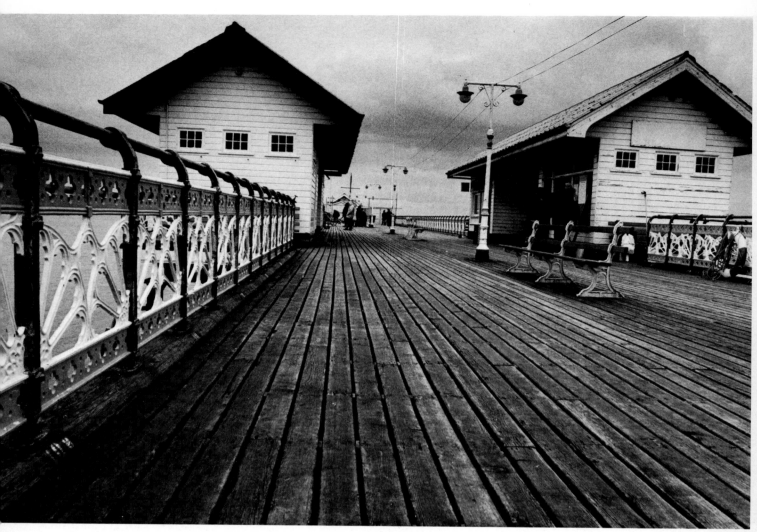

Ian Rodger

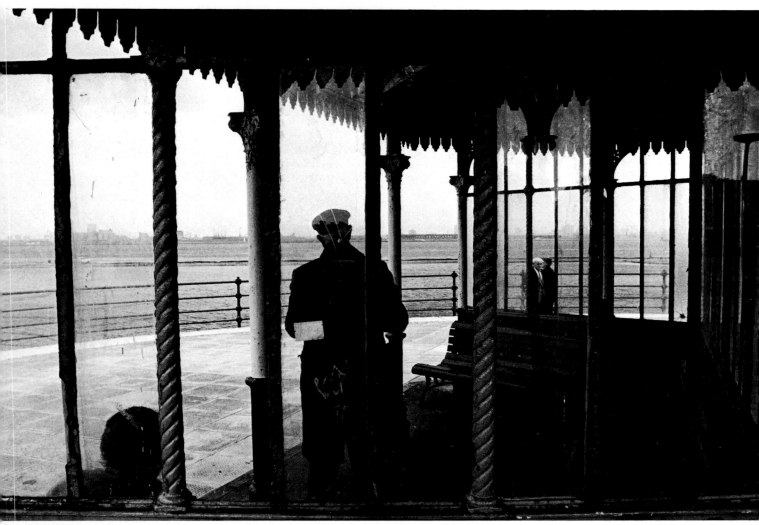

David Townend

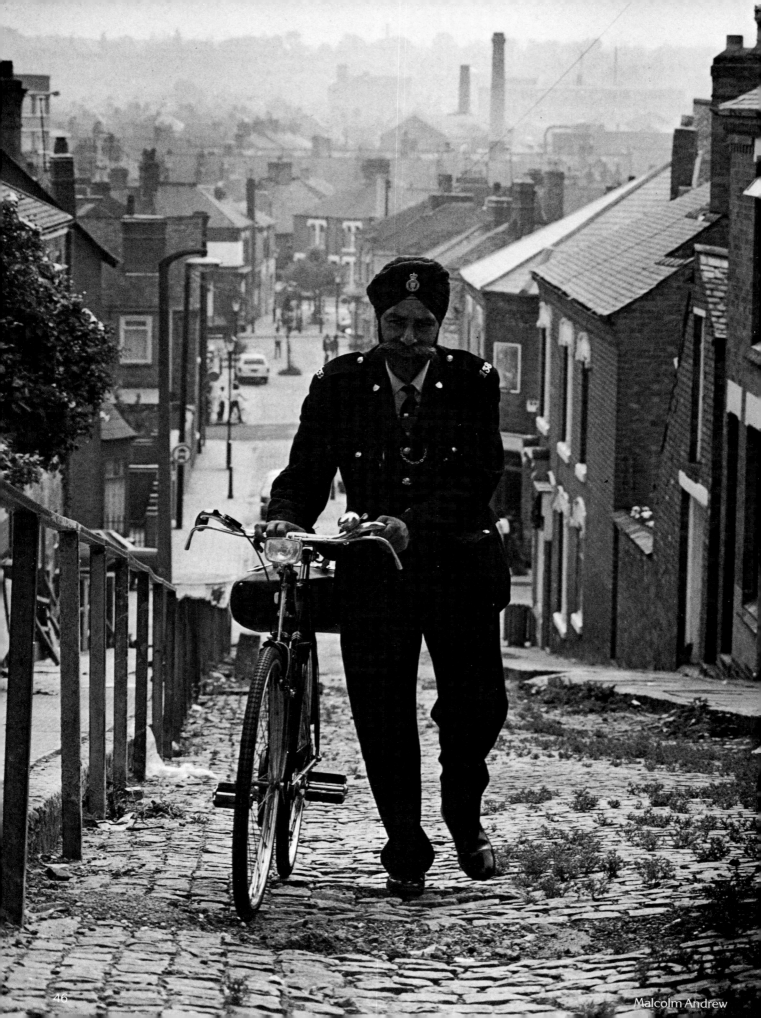

46

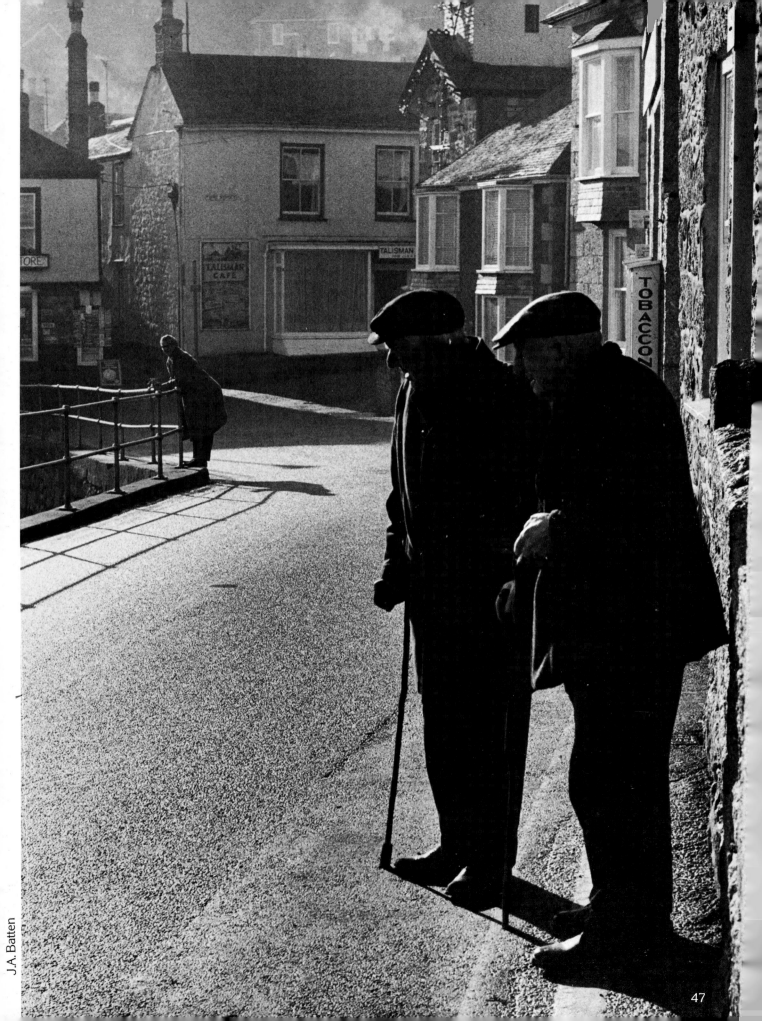

J.A. Batten

47

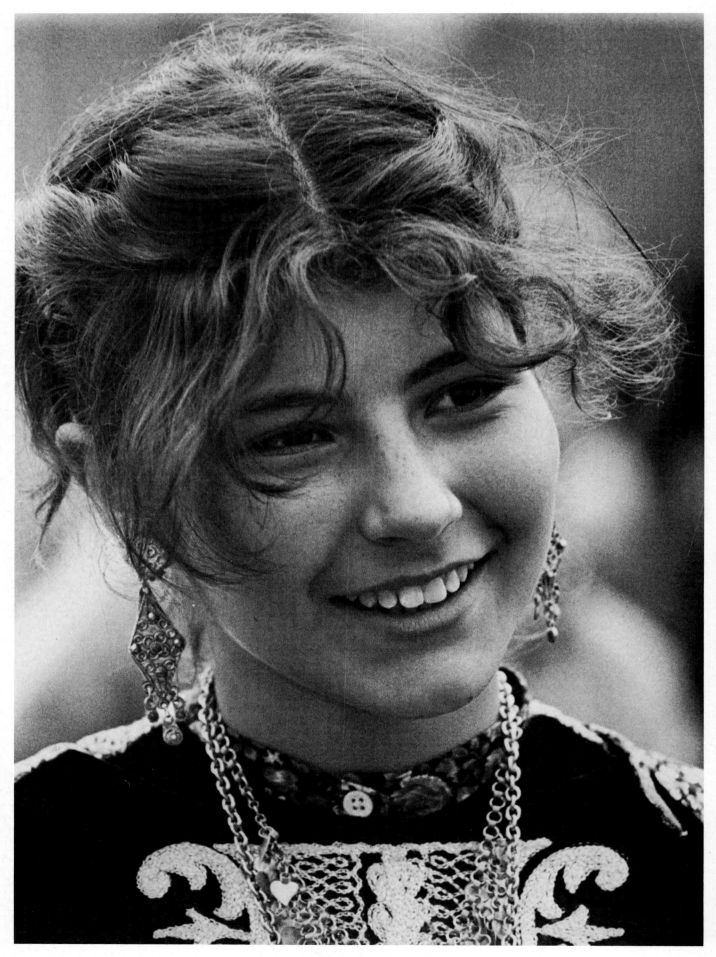

48

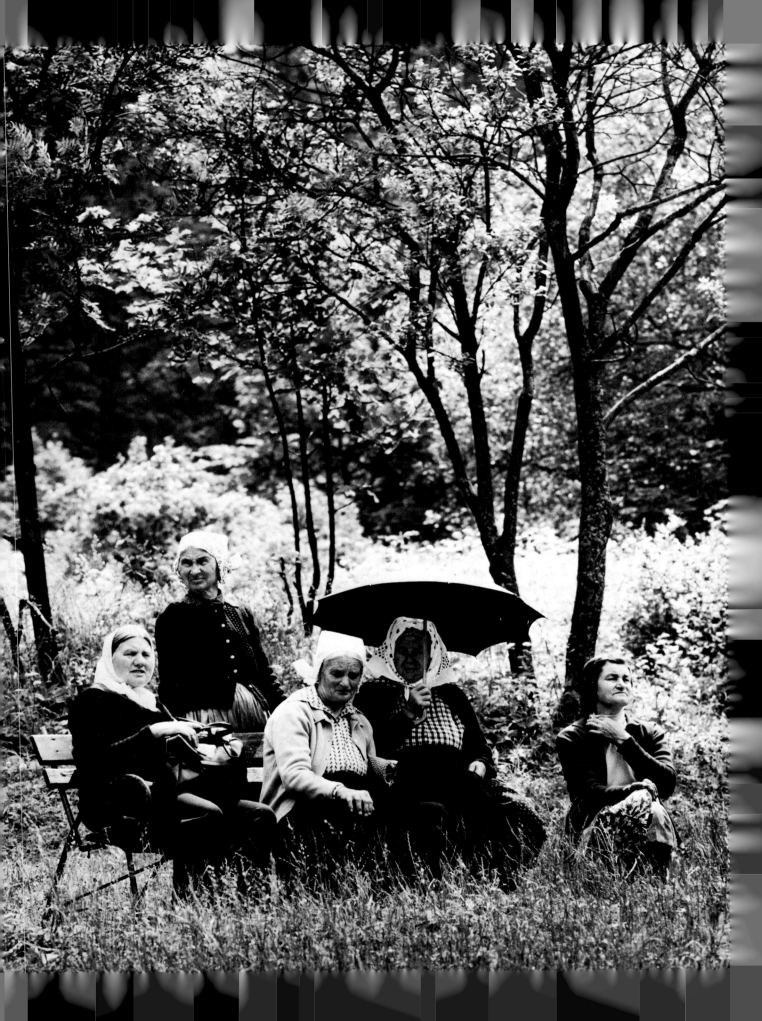

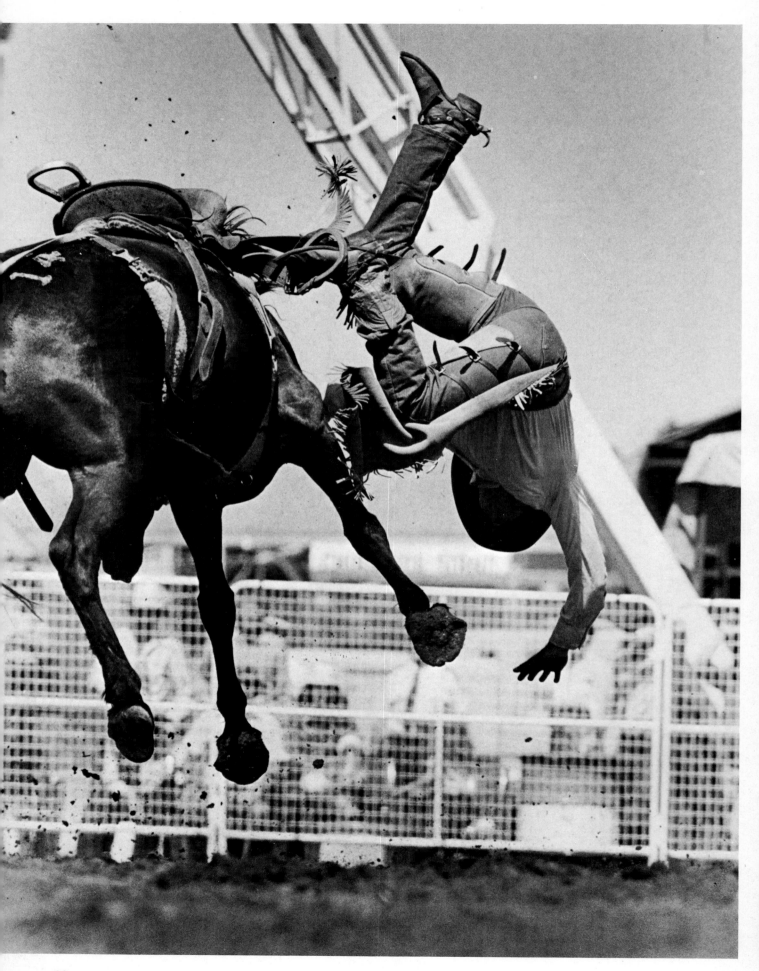

Patric Duzer

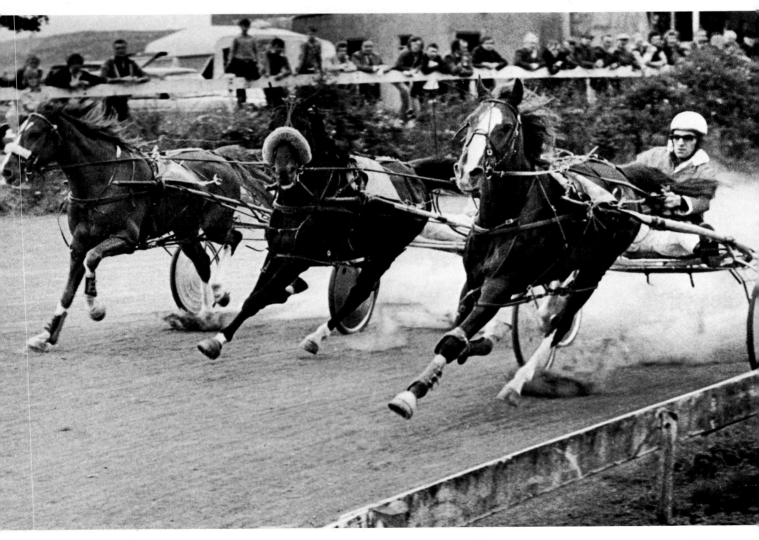

Stanley Matchett

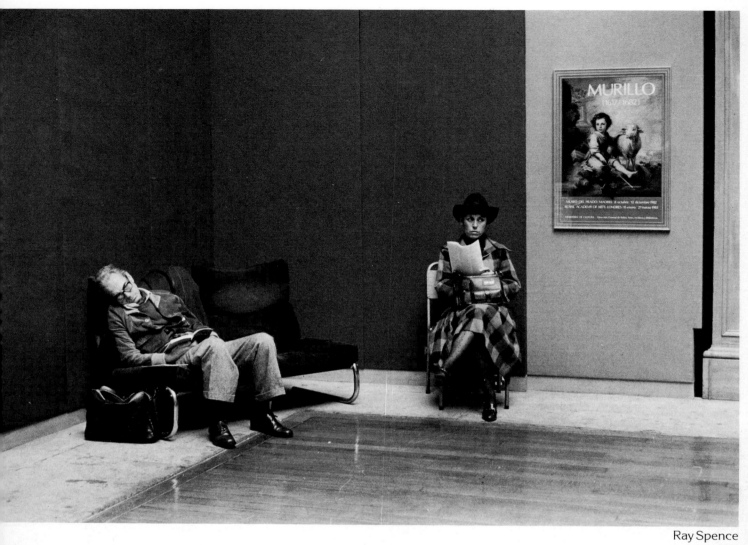

Ray Spence

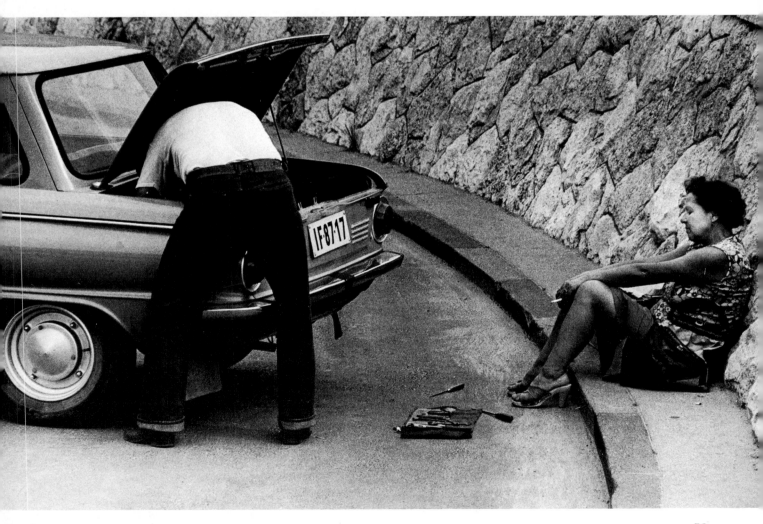

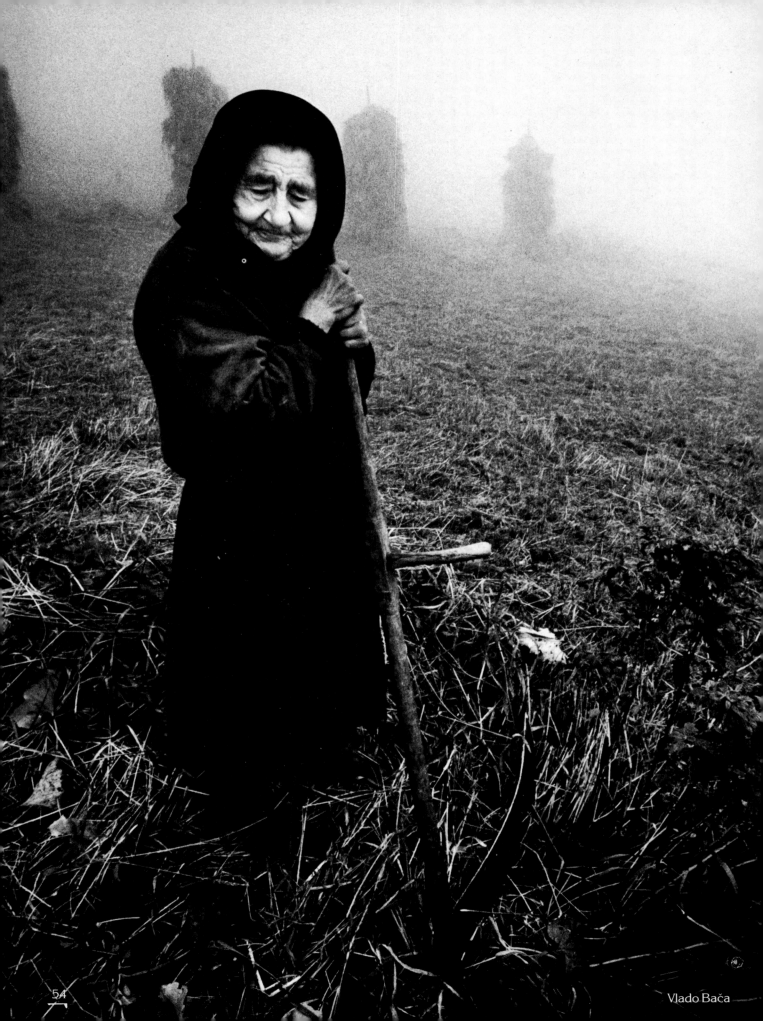

Vlado Bača

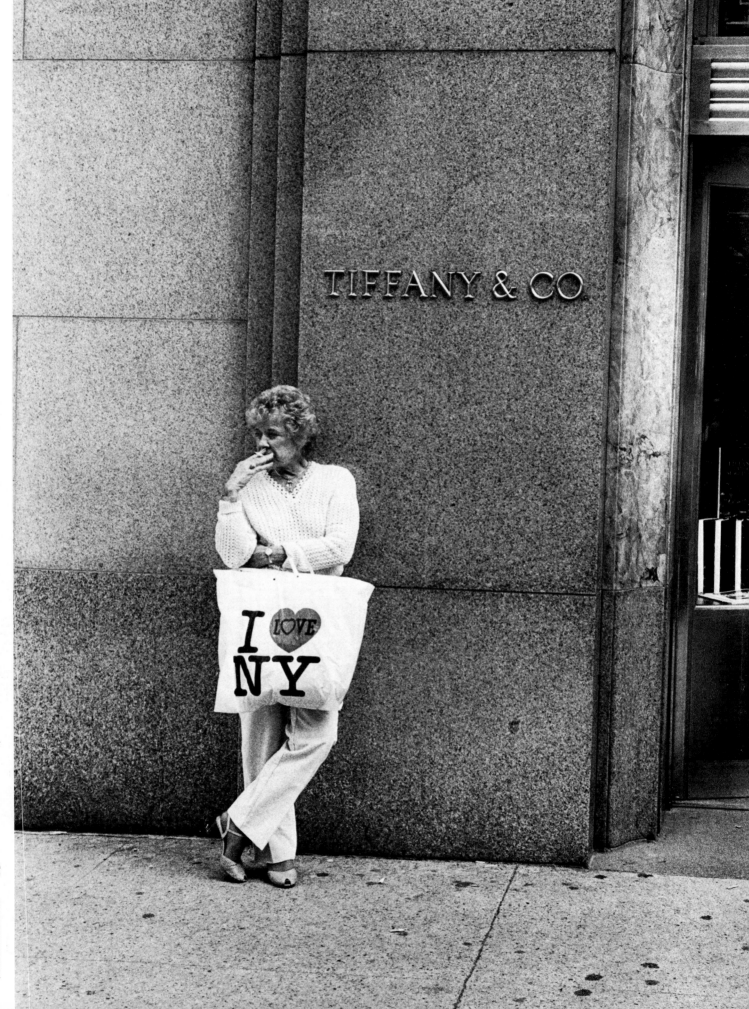

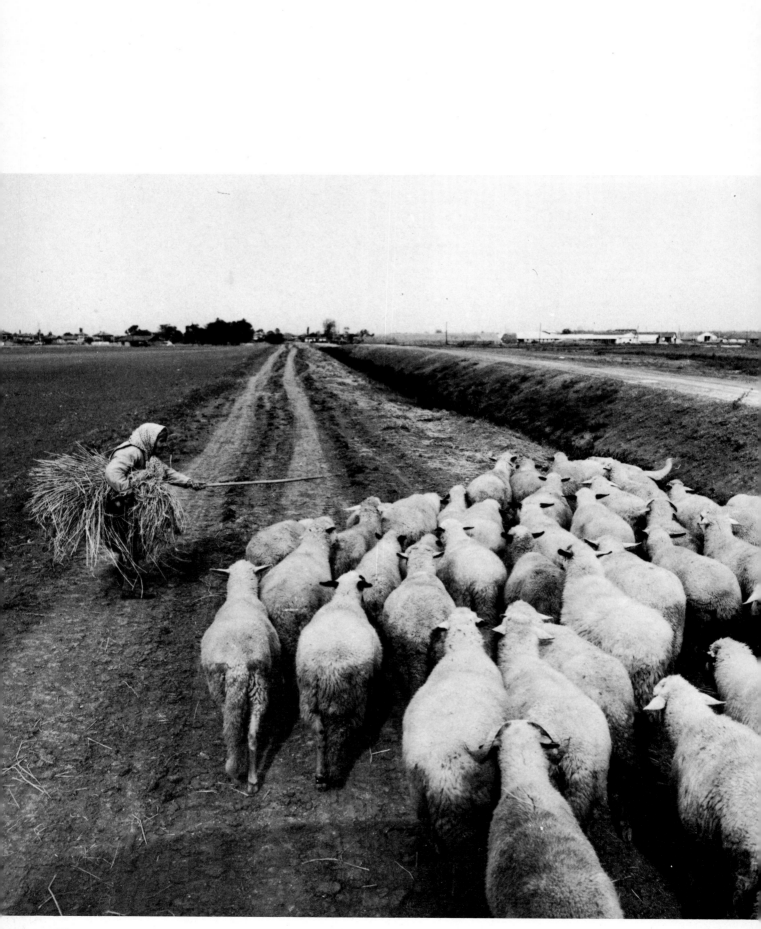

A. Sutkus

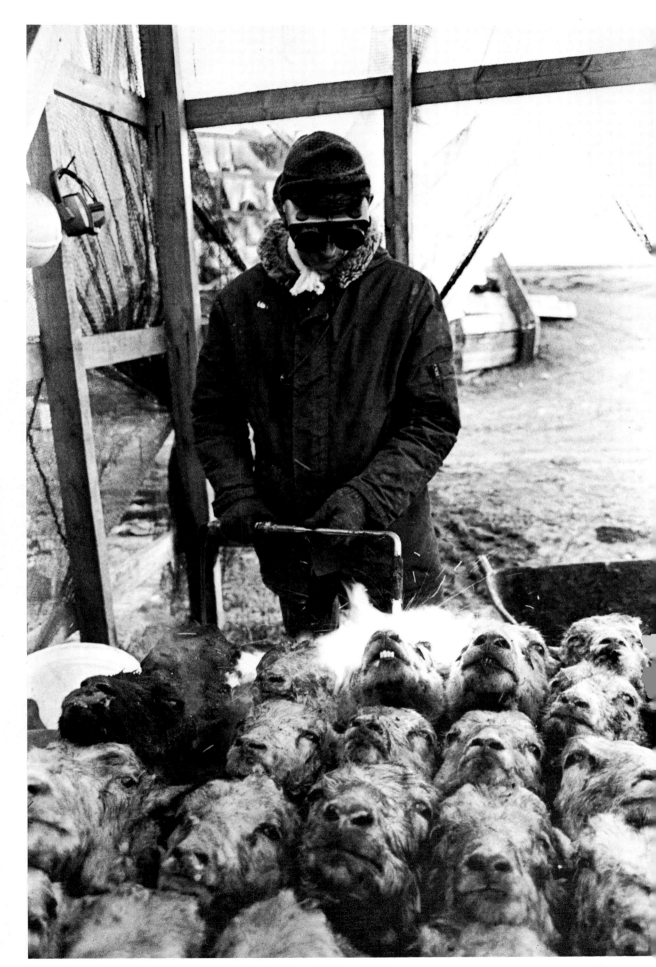

David Thorsteinsson

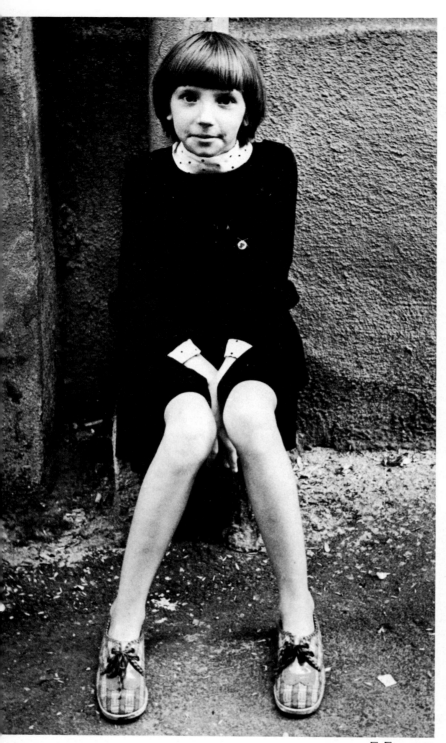

E. Freeman

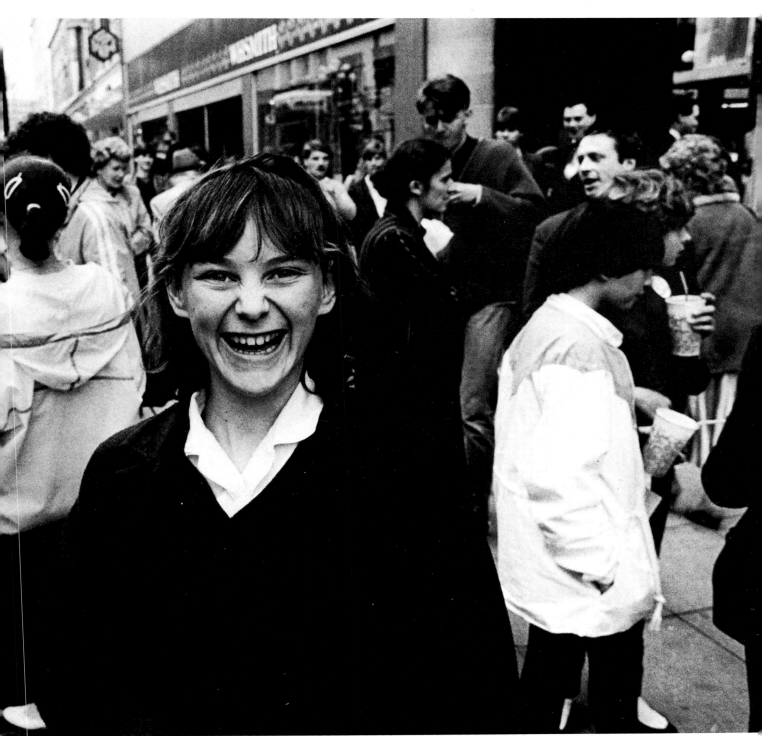

David Townend

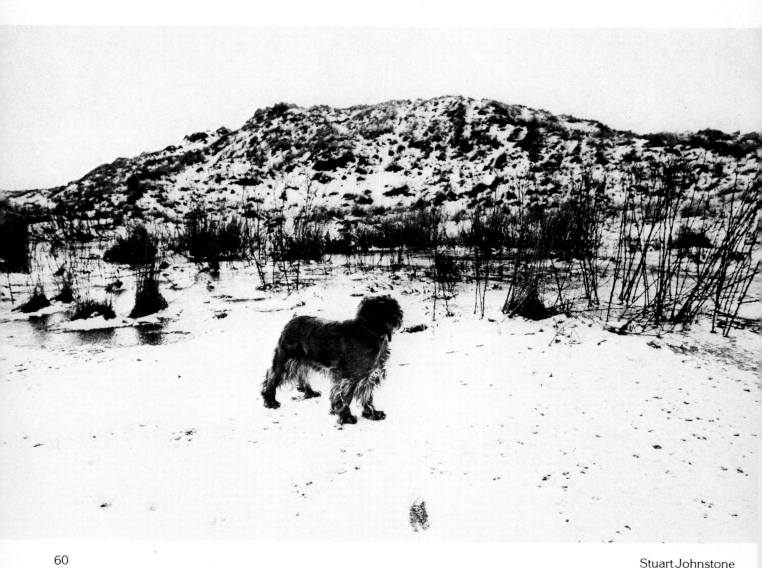

Stuart Johnstone

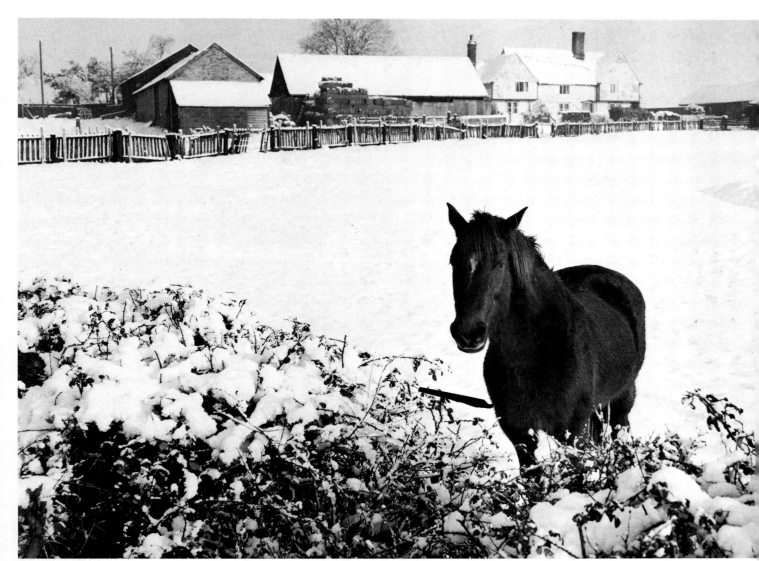

Dennis Mansell

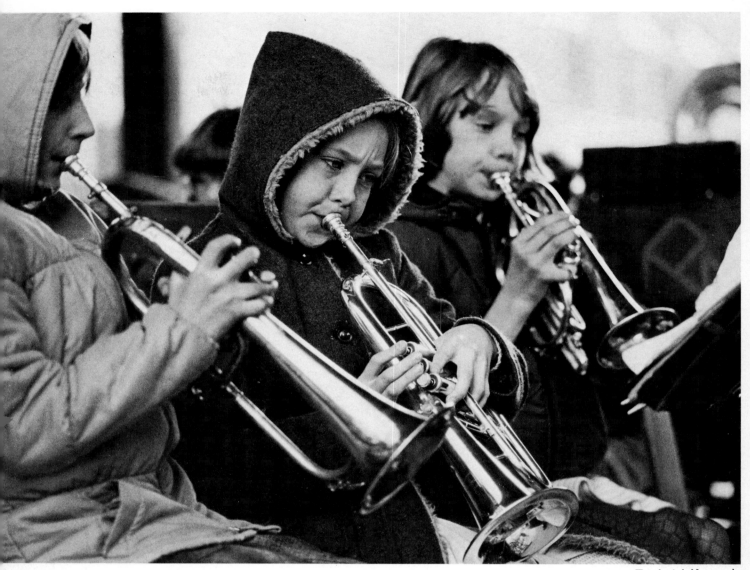

Frederick Kennedy

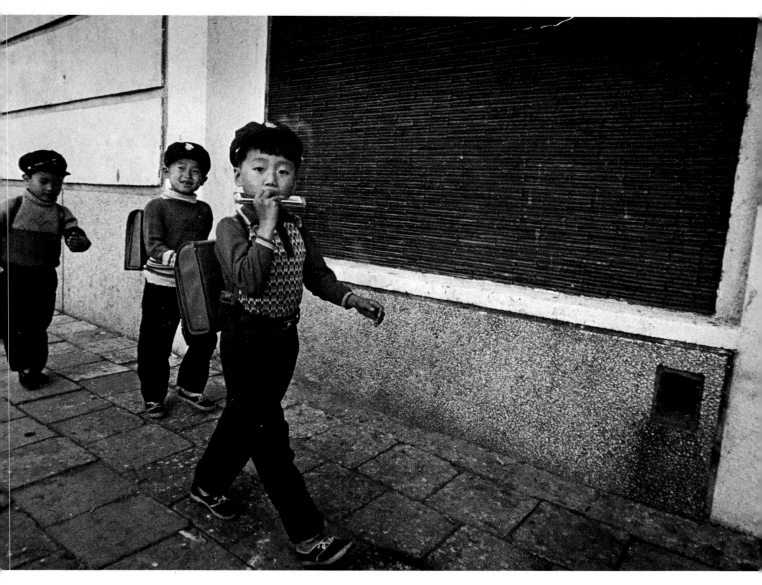

Peeter Tooming

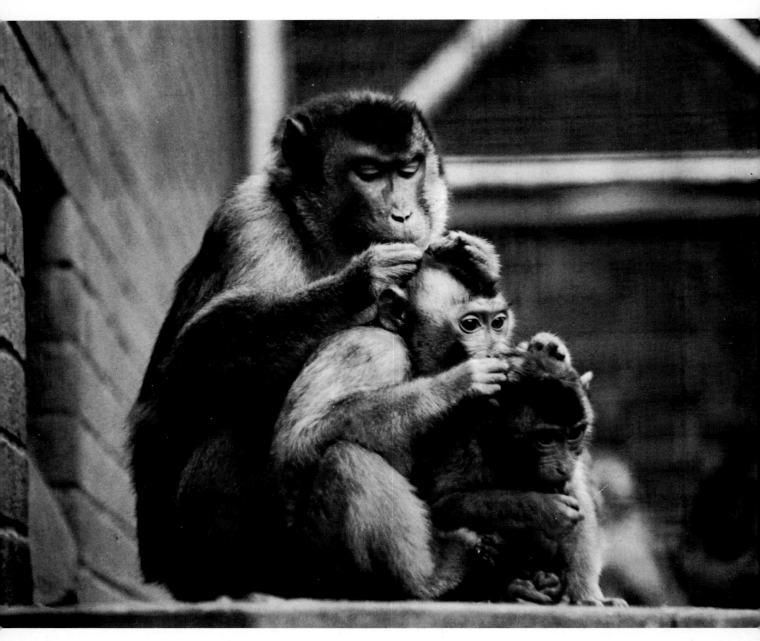

Mike Jesson

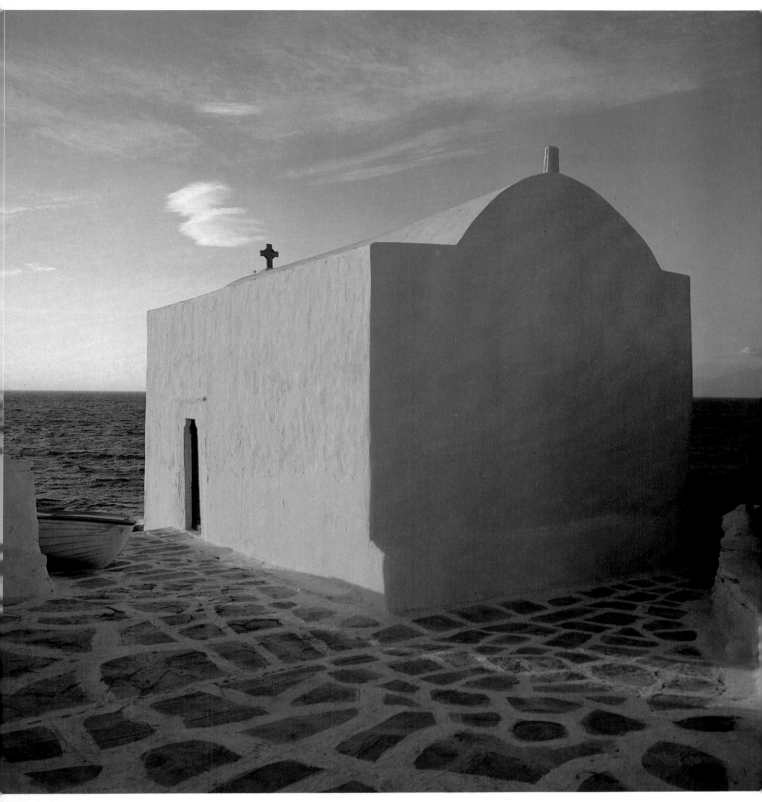

Bob Tanner

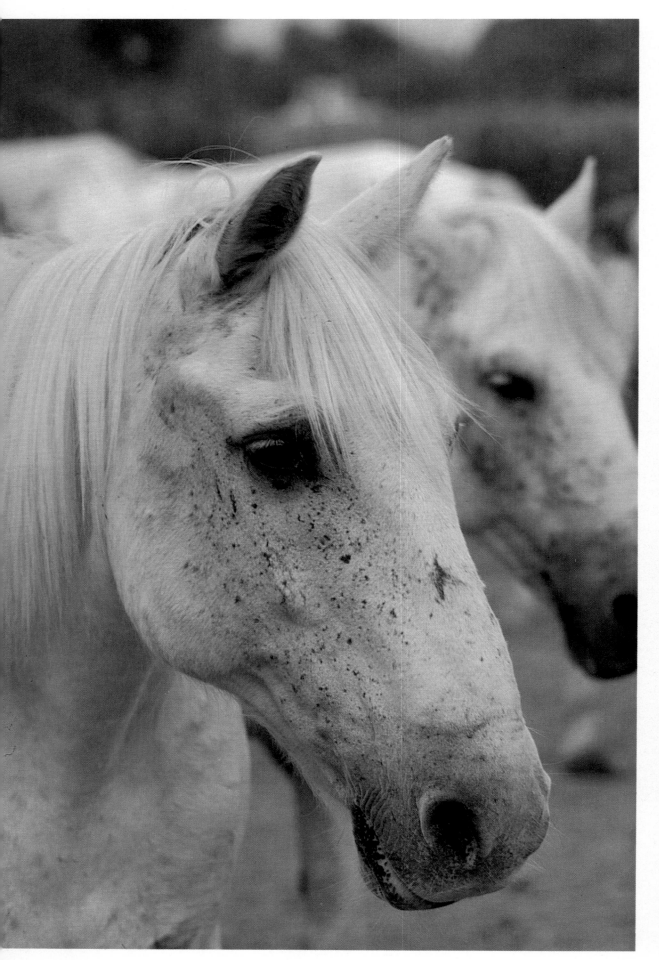

J.A. Dick

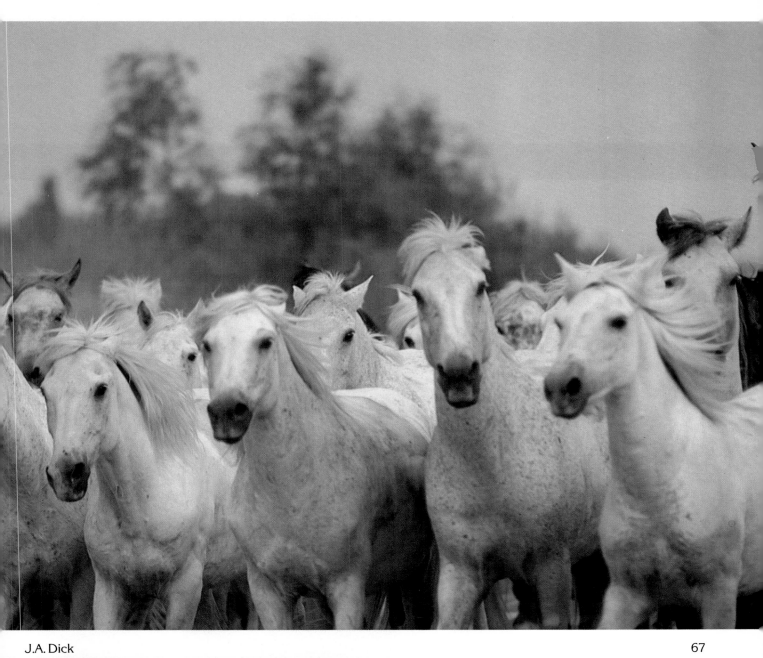

J.A. Dick

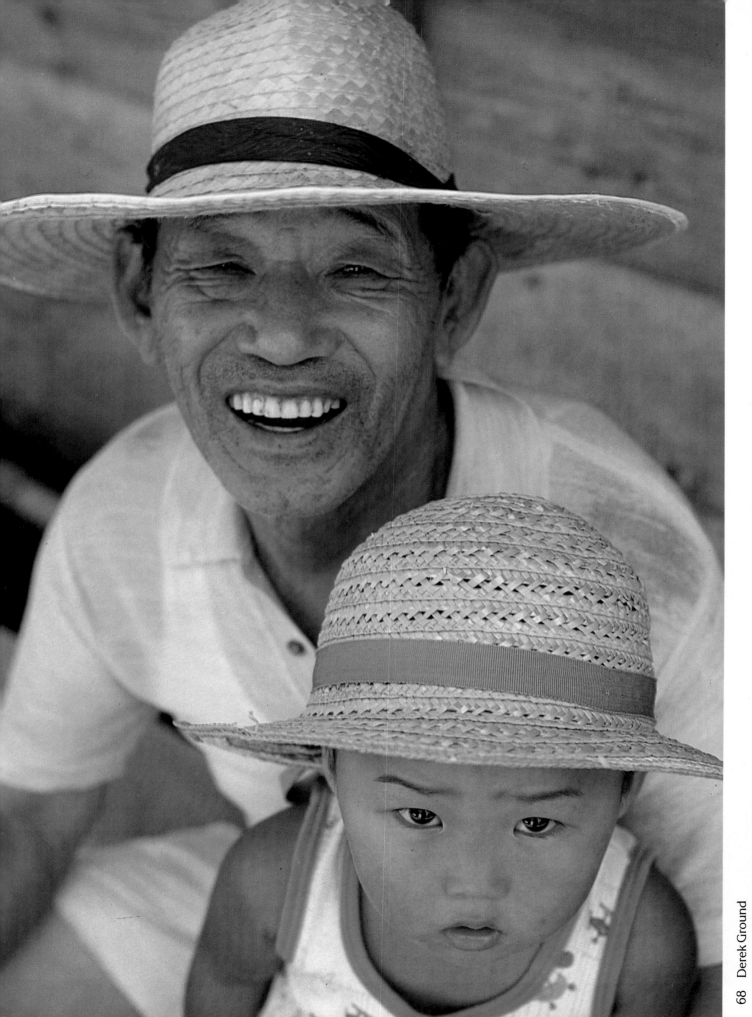

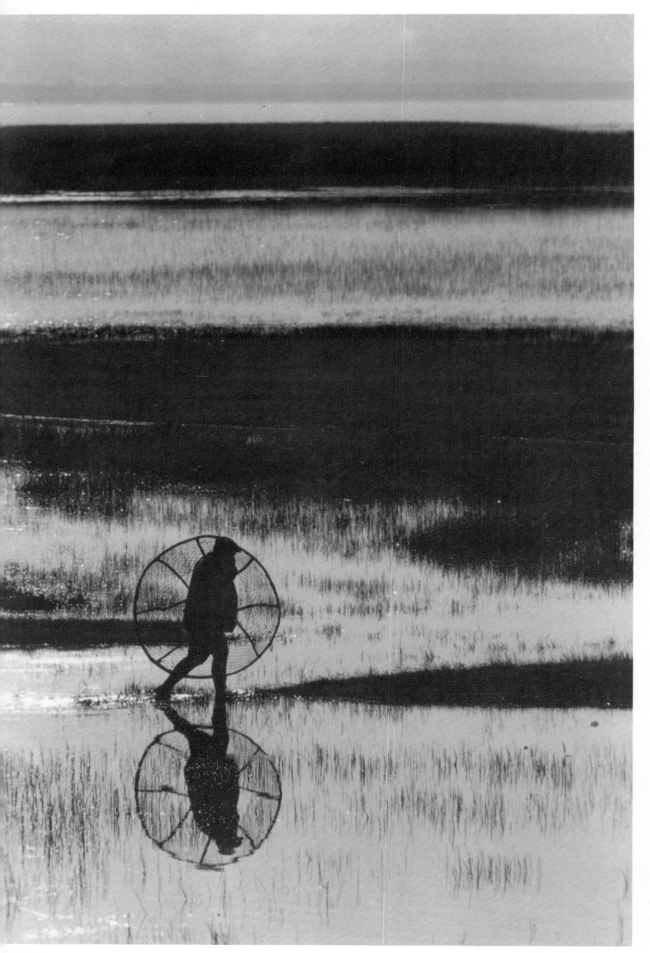

Nusret Eren

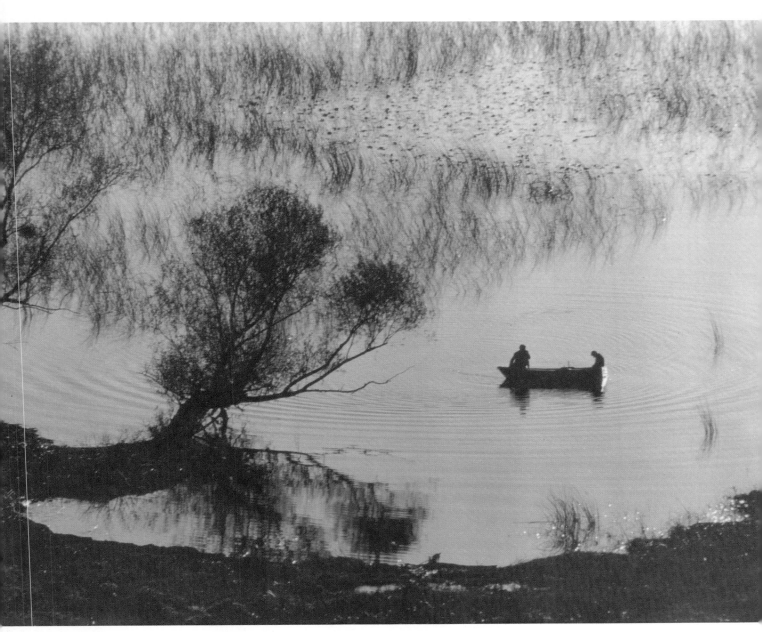

Nusret Eren

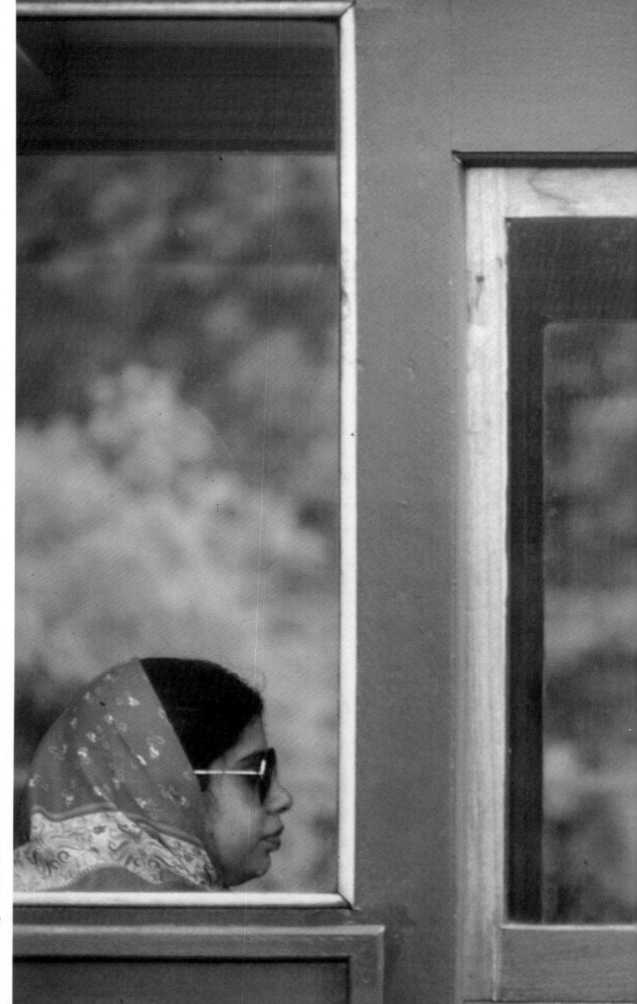

Derek Grant

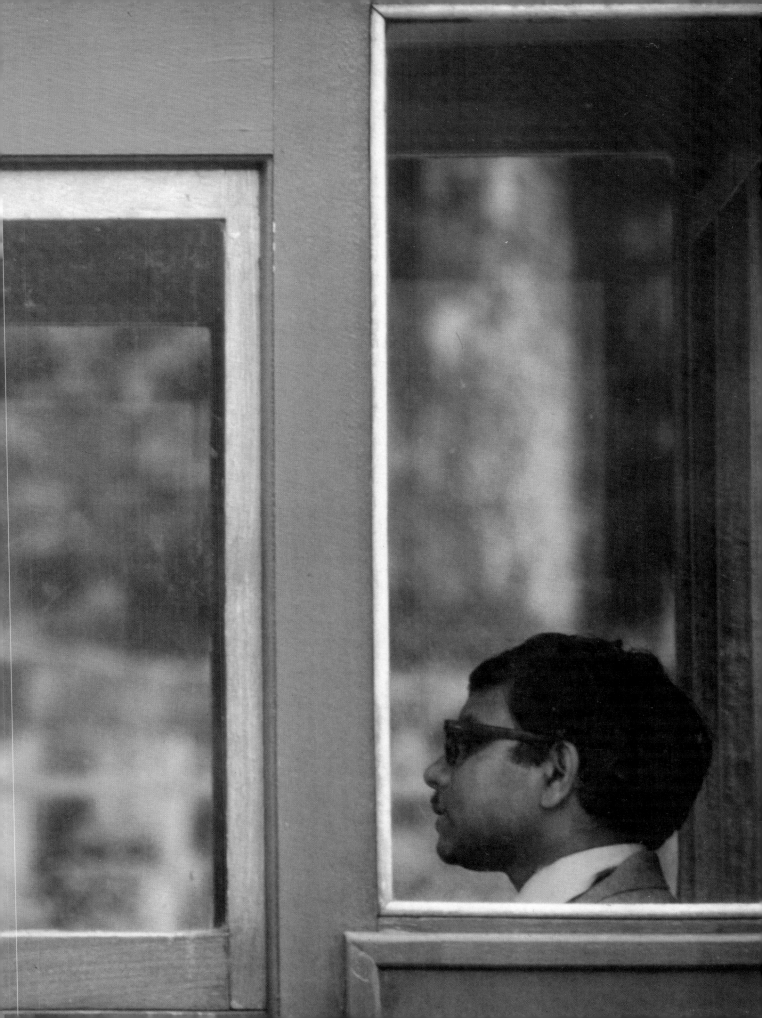

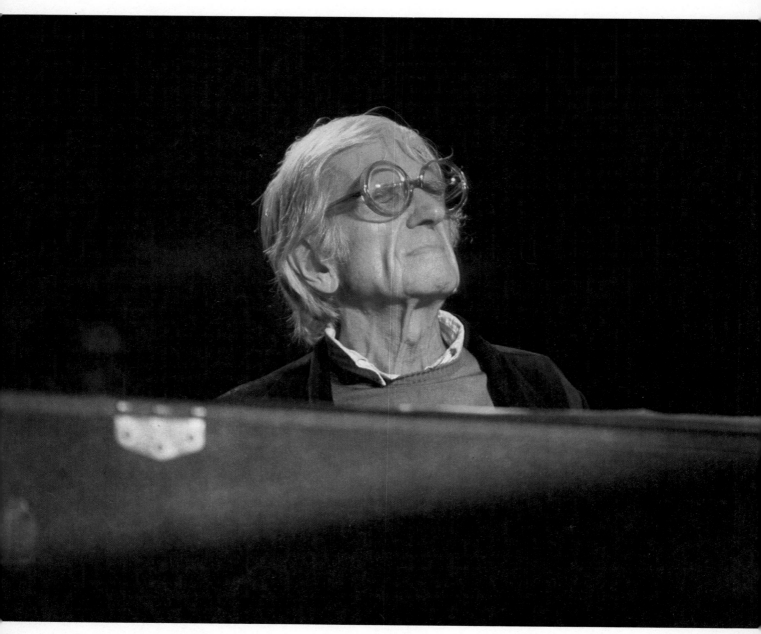

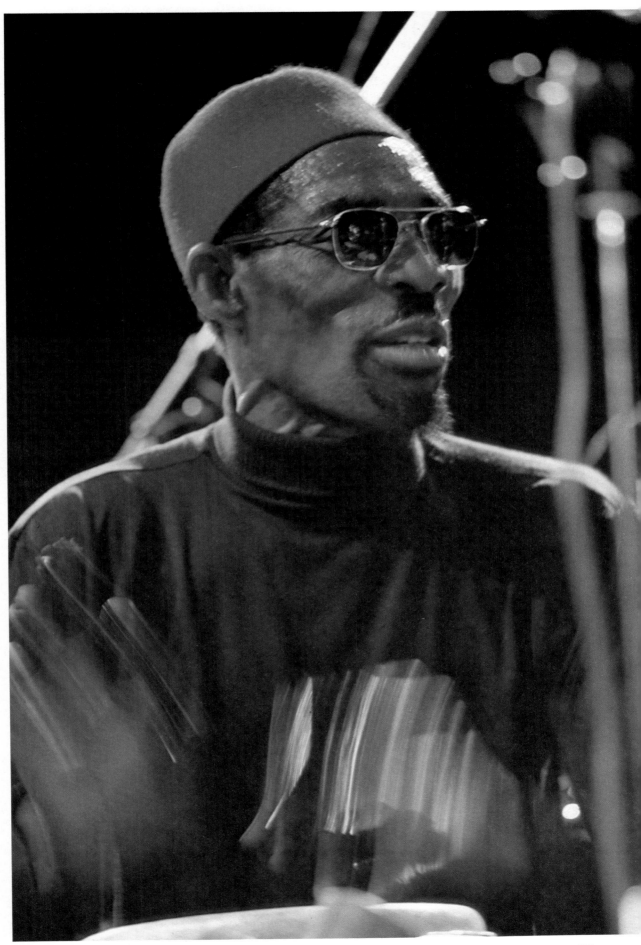

Christian Him

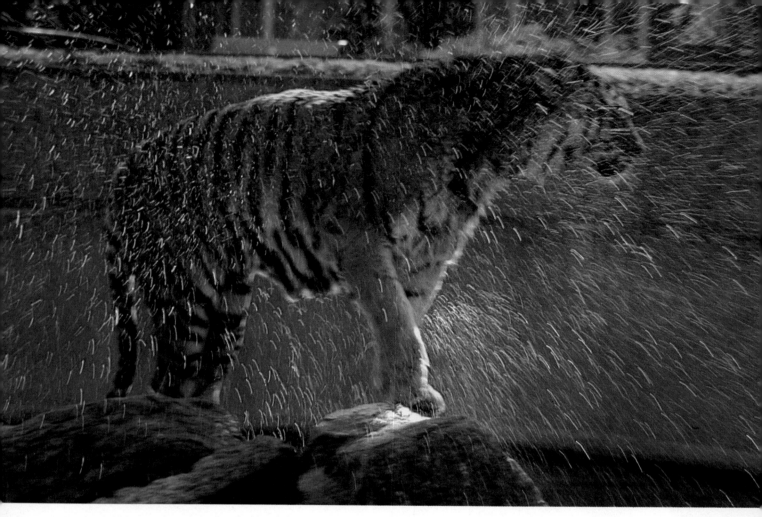

Peter Karry

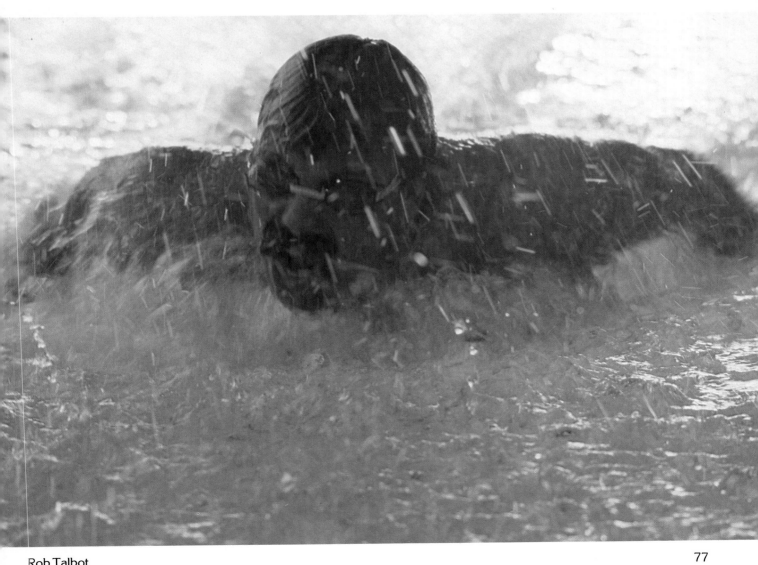

Rob Talbot

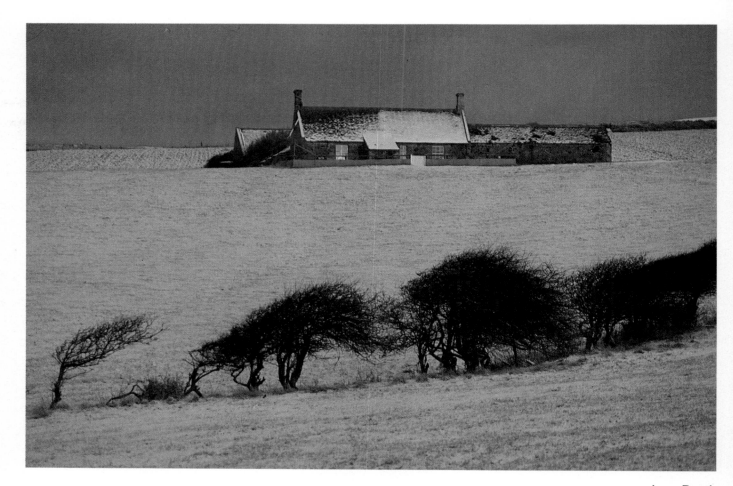

Irene Booth

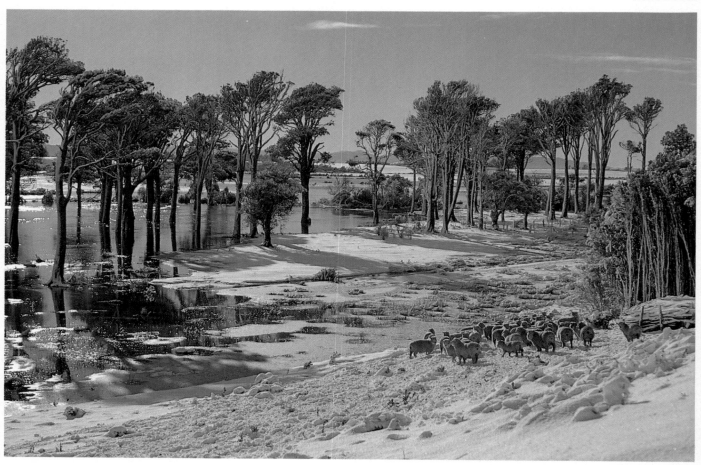

C.E. Barwell

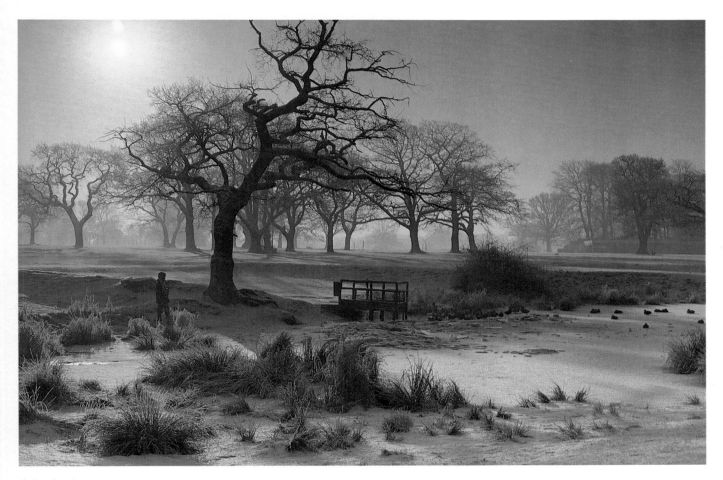

John Jertice

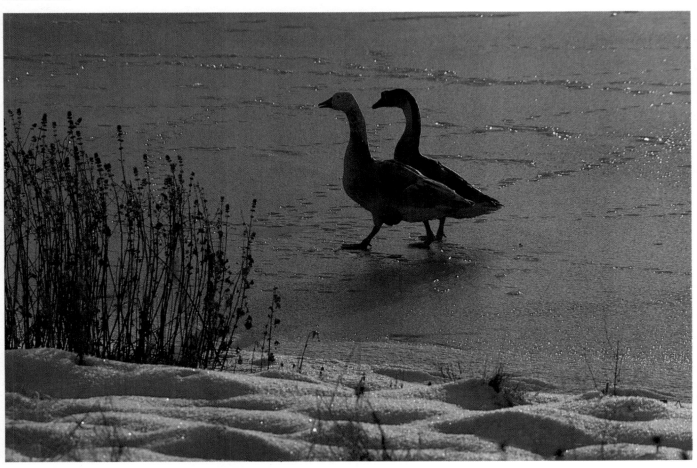

Fayek Salama

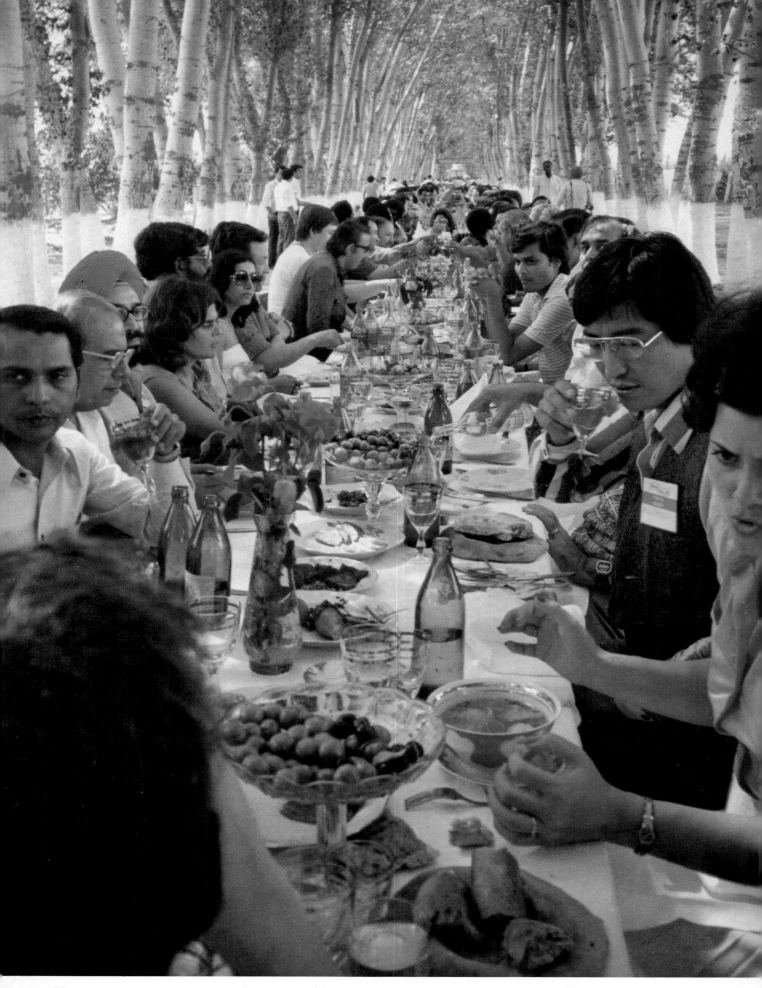

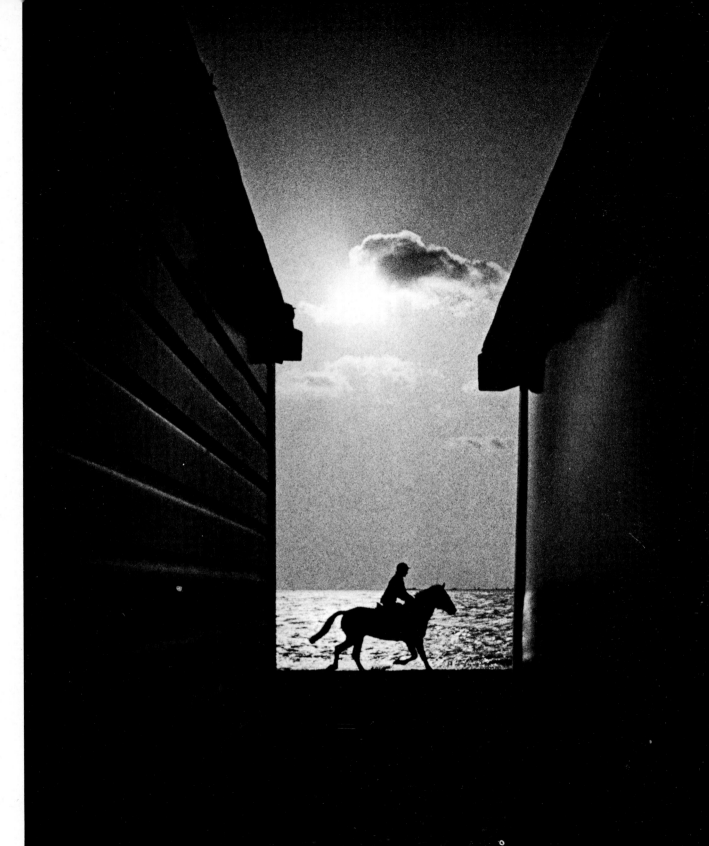

William Cheung

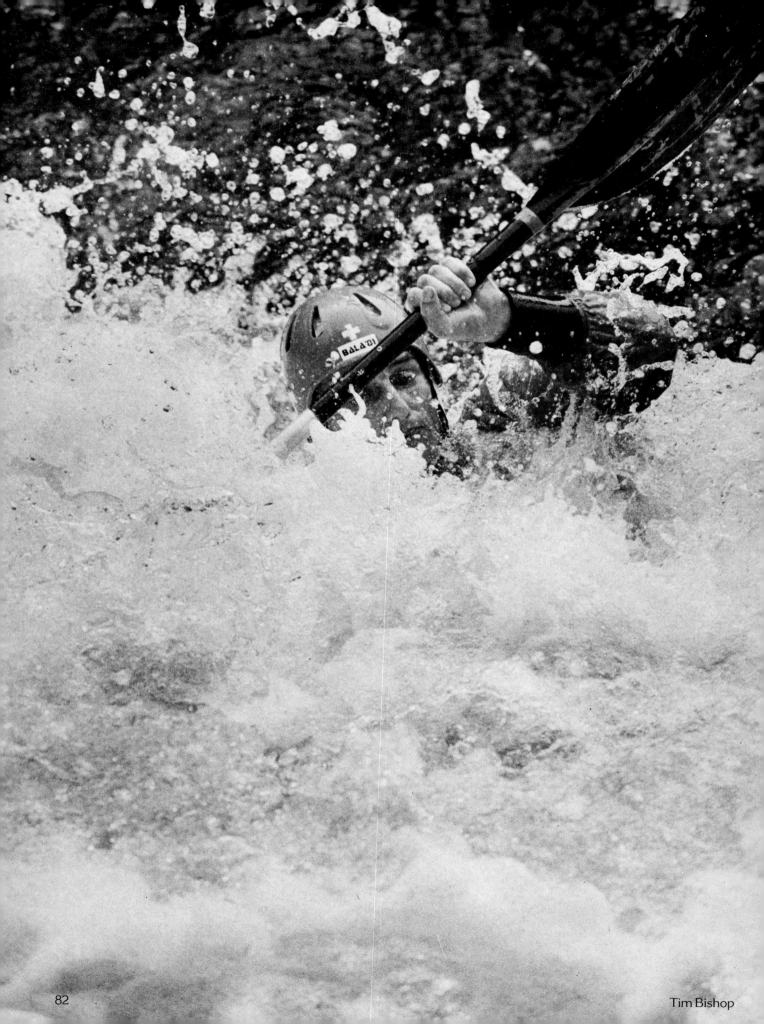

Tim Bishop

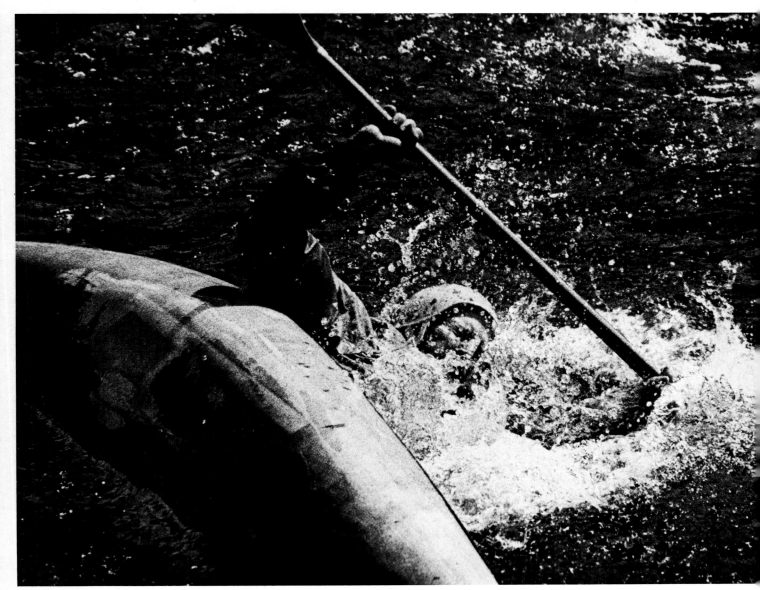

Alex Cleland

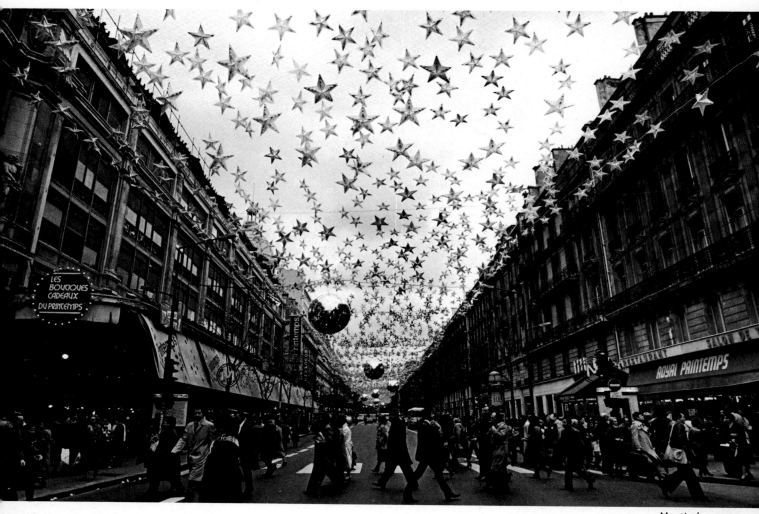

Martin Langer

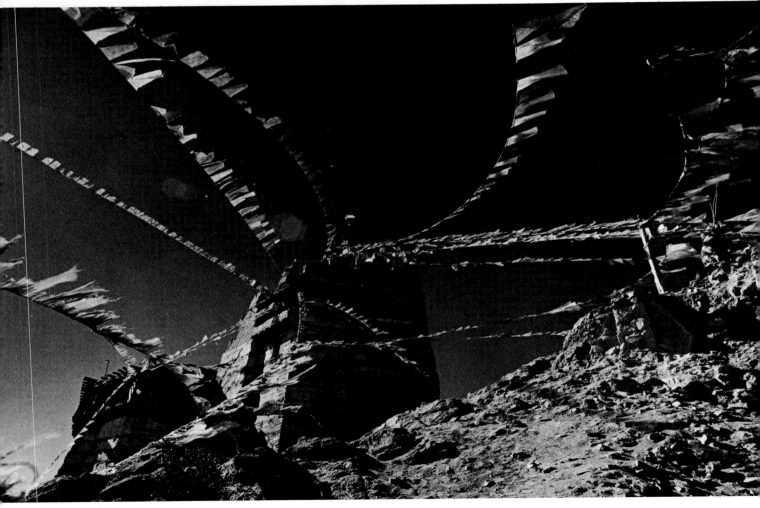

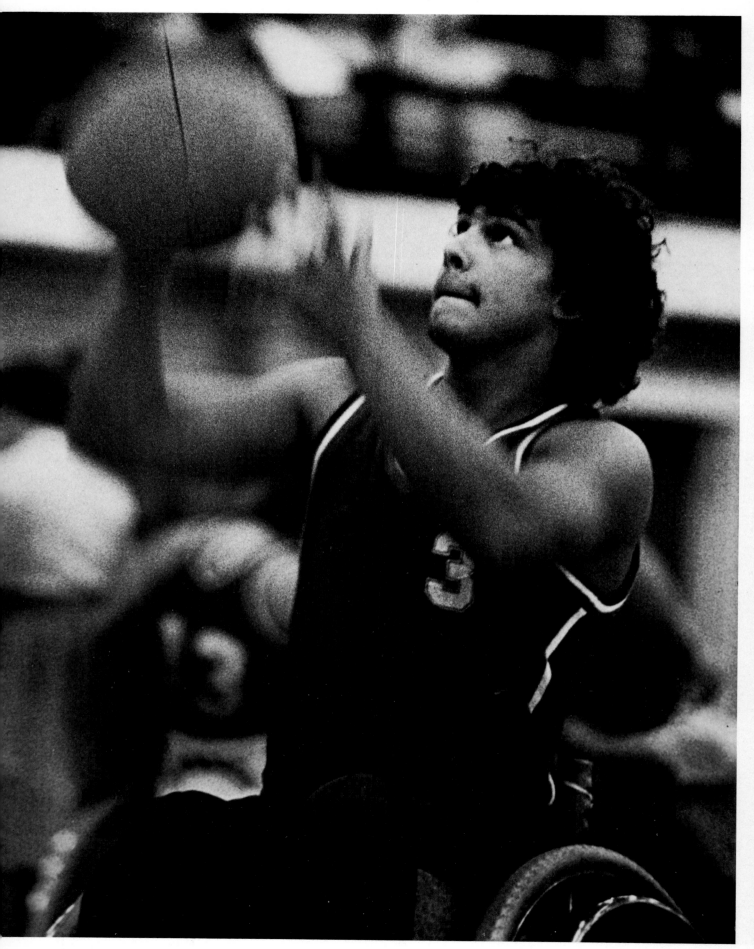

Peter Upton

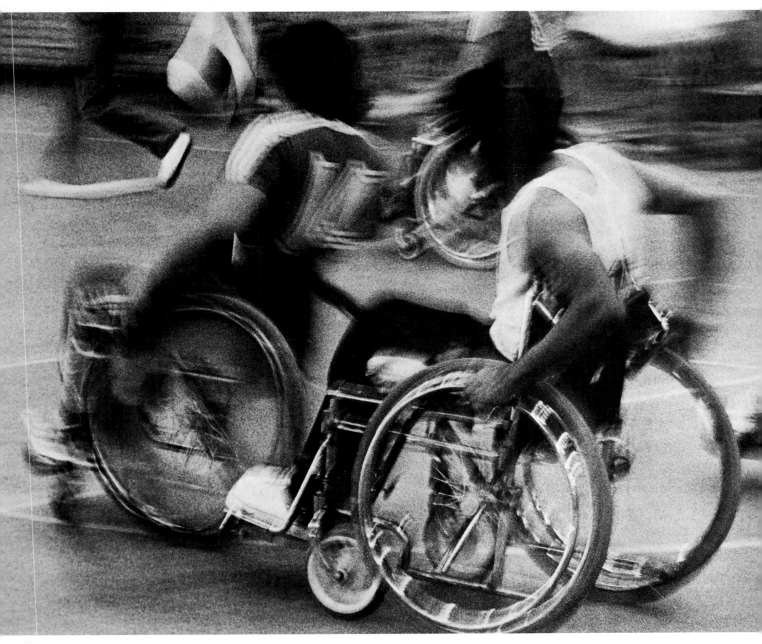

Peter Upton

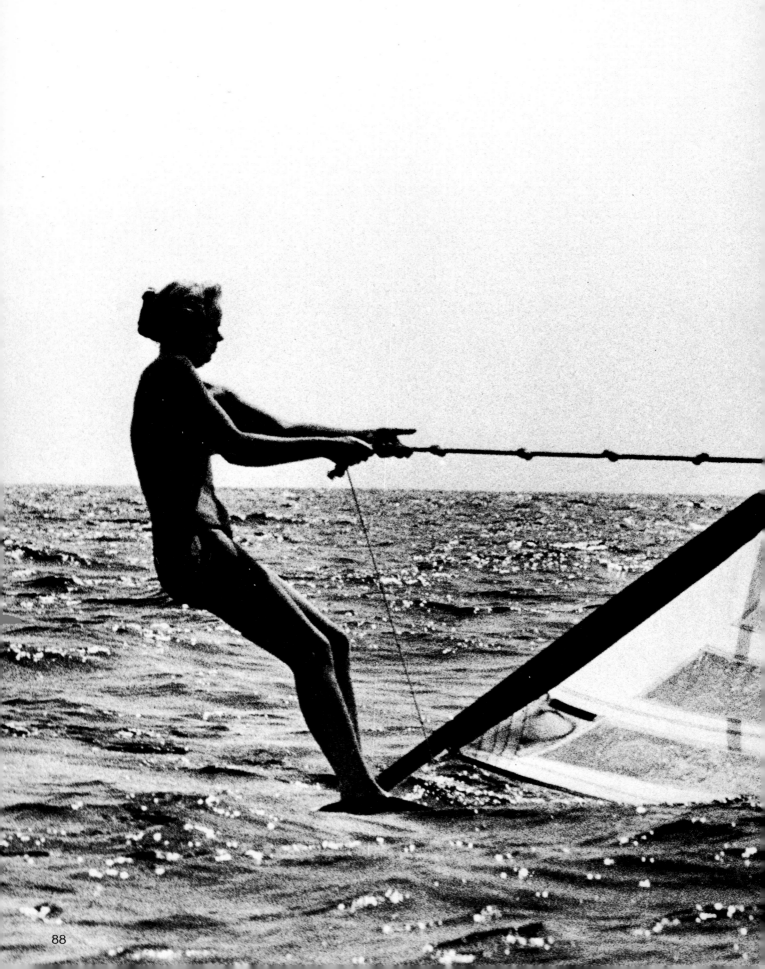

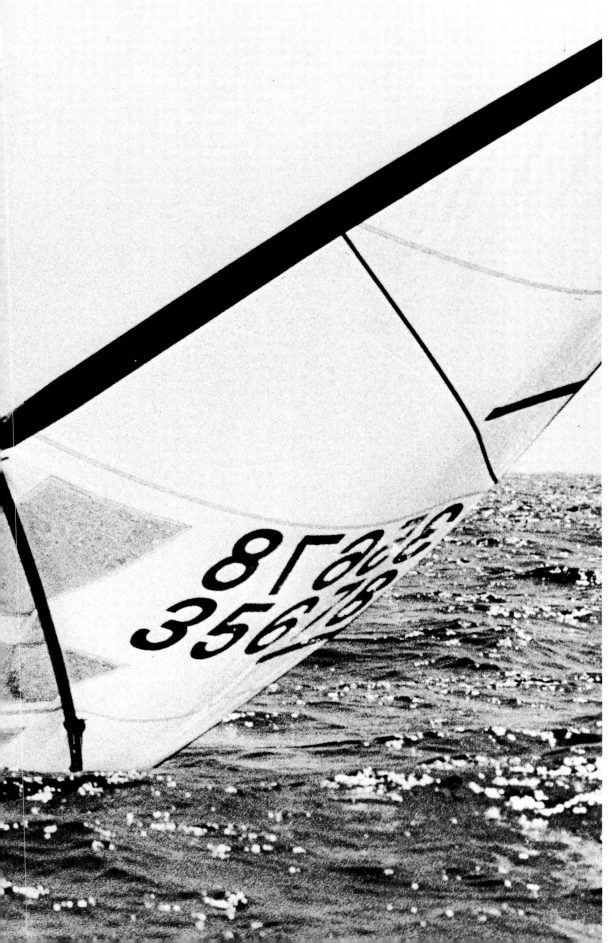

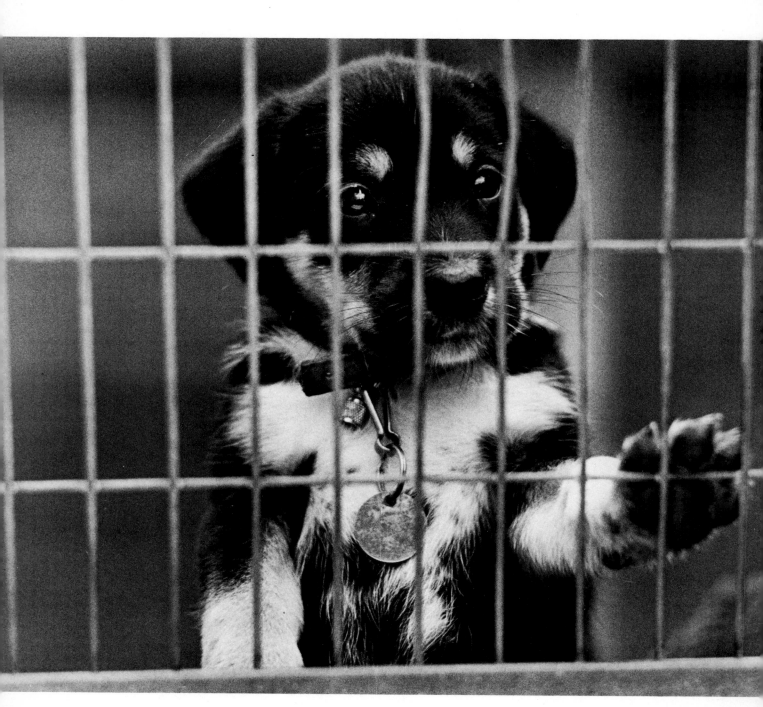

Mike Hollist

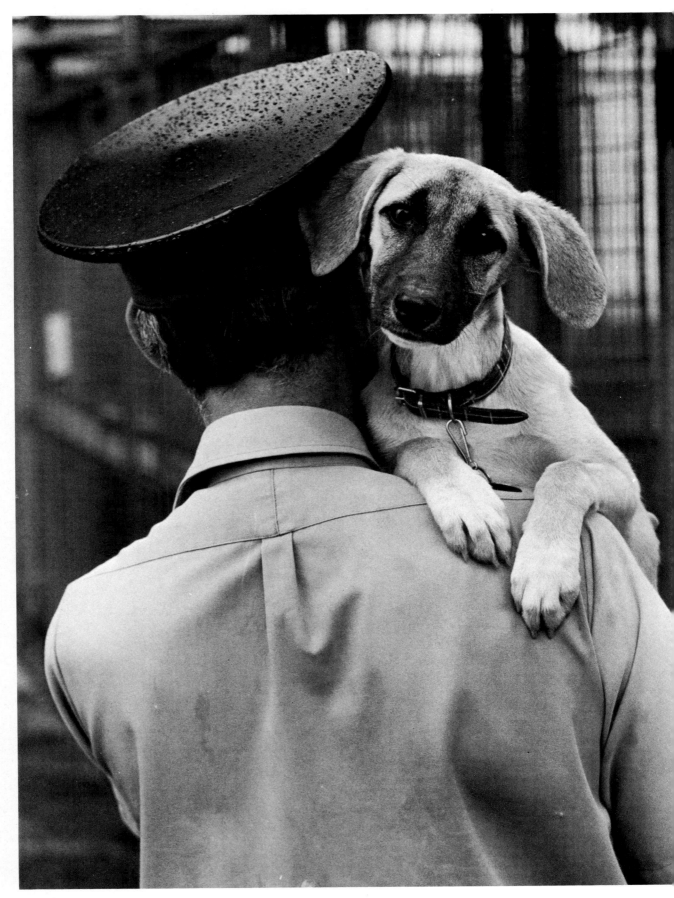

Mike Hollist

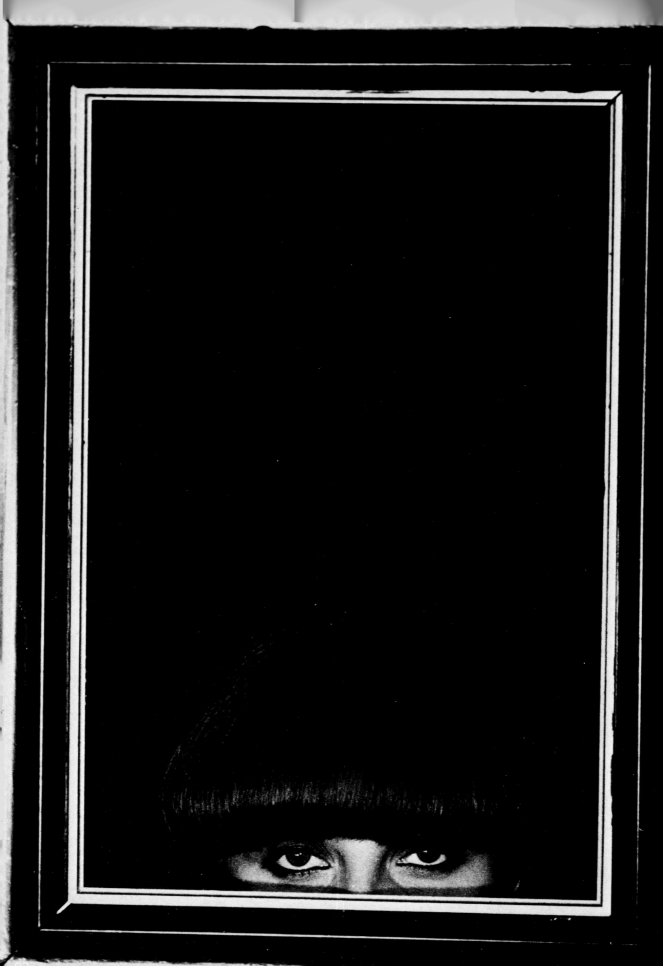

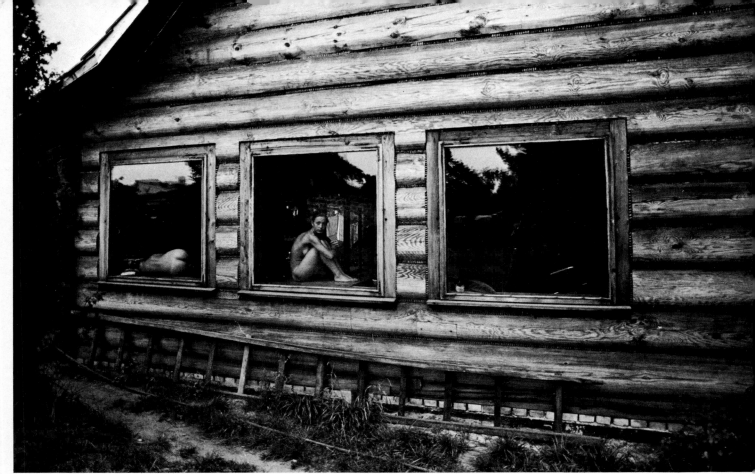

S. Trzaska

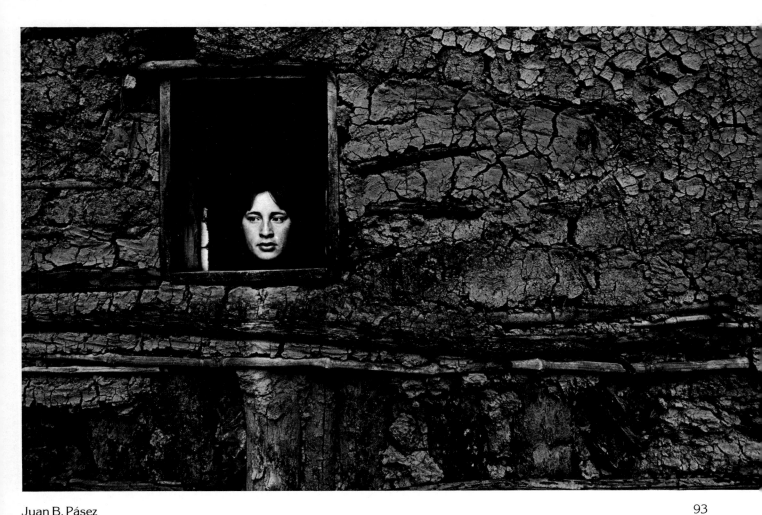

Juan B. Pásez

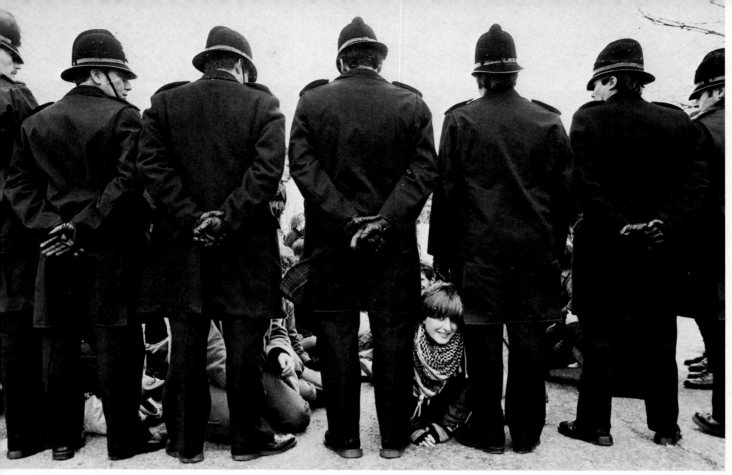

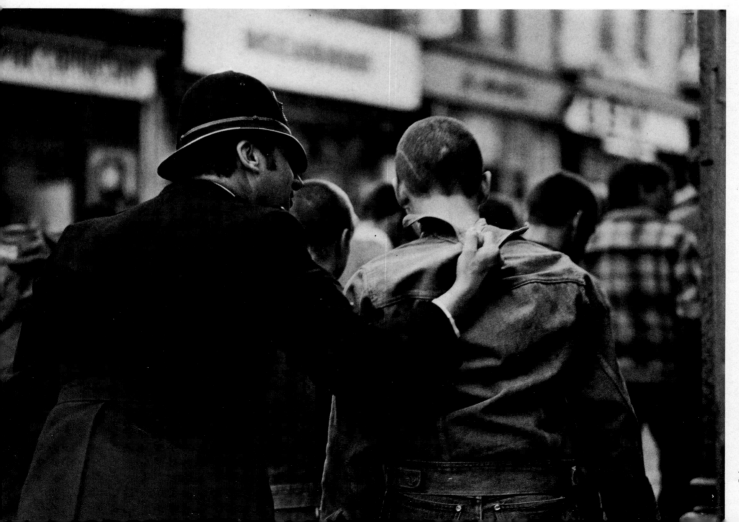

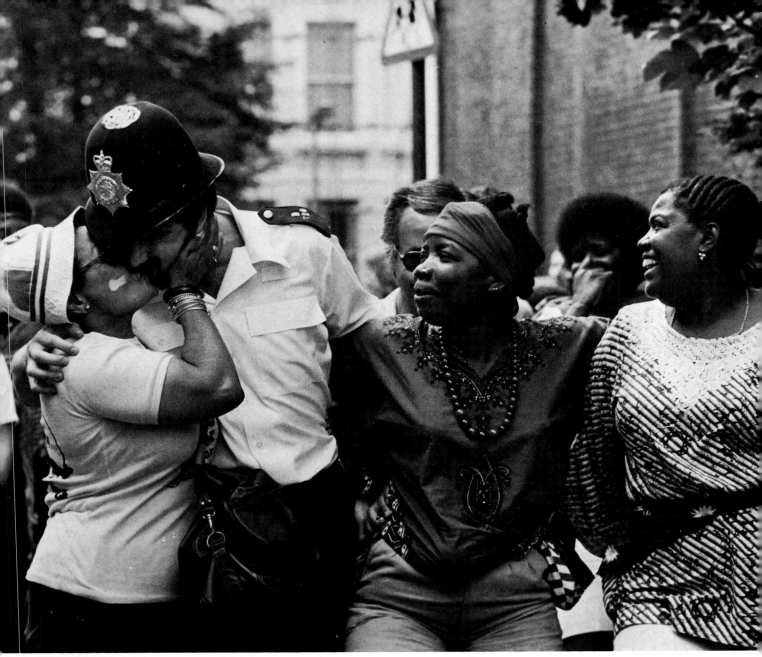

Tim Bishop

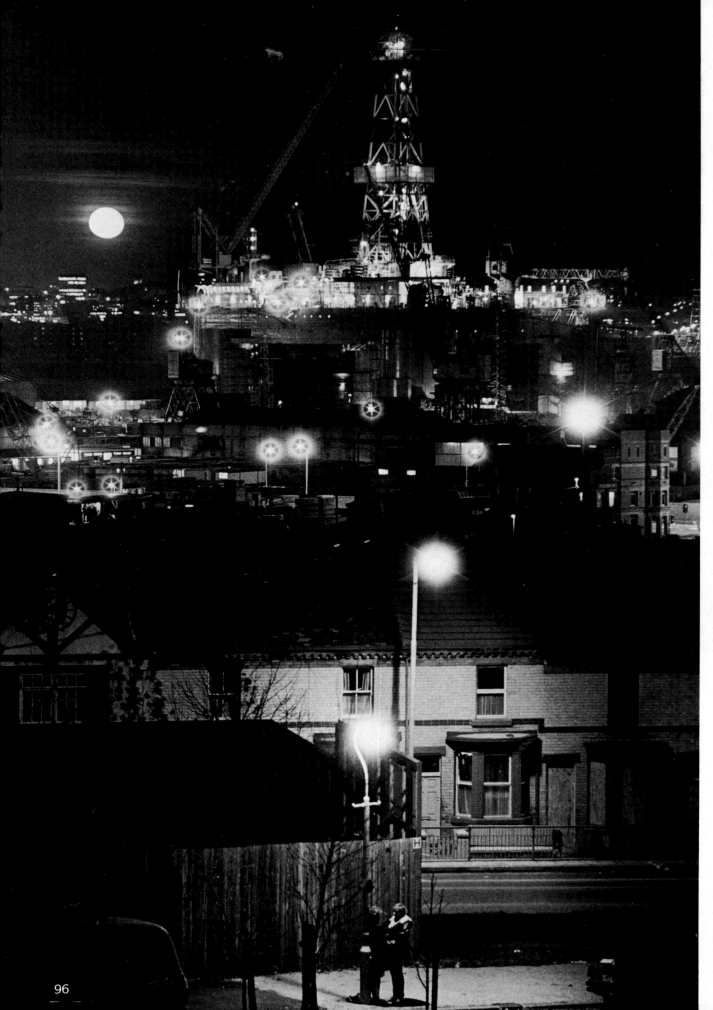

John Davidson

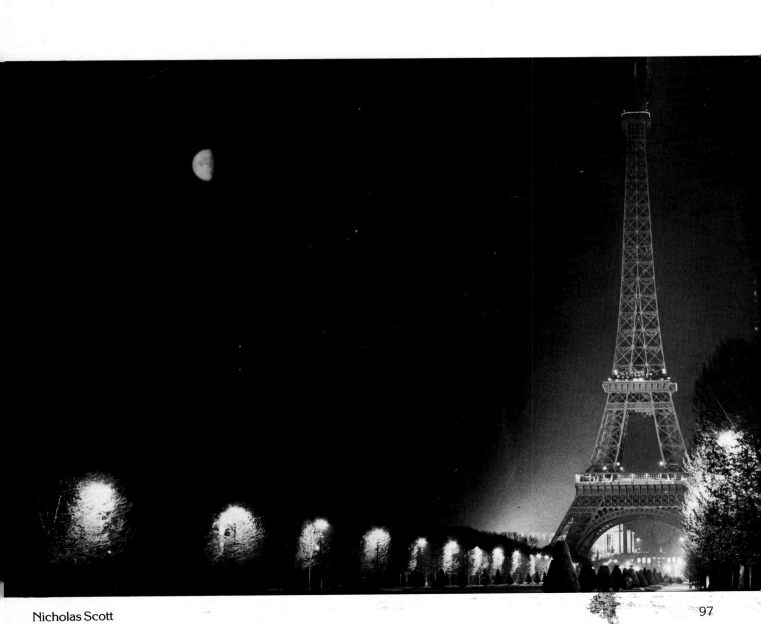

Nicholas Scott

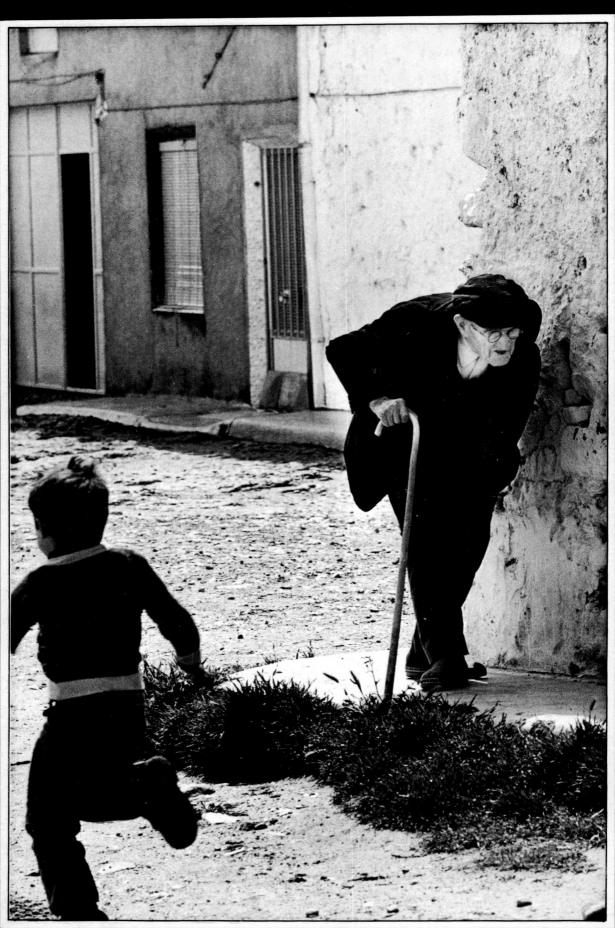

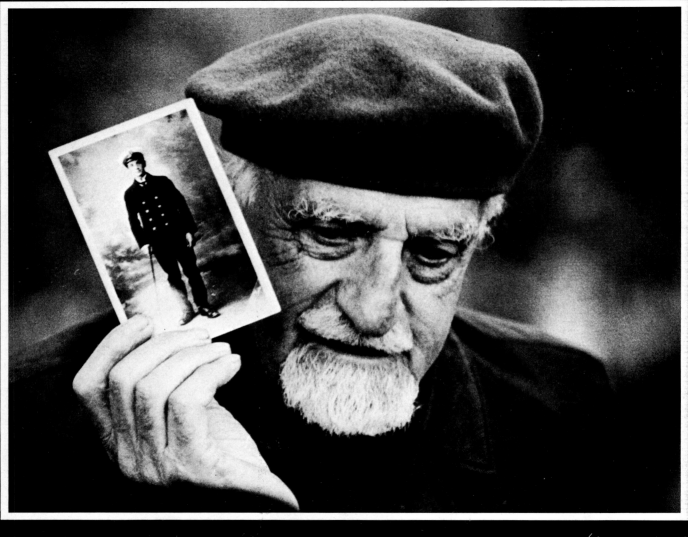

Neale Davison

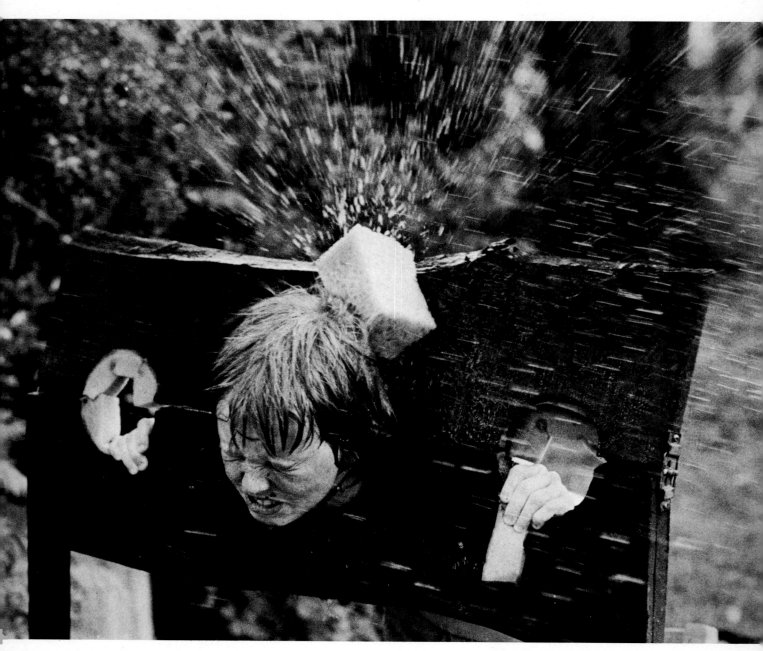

Reg Cooke

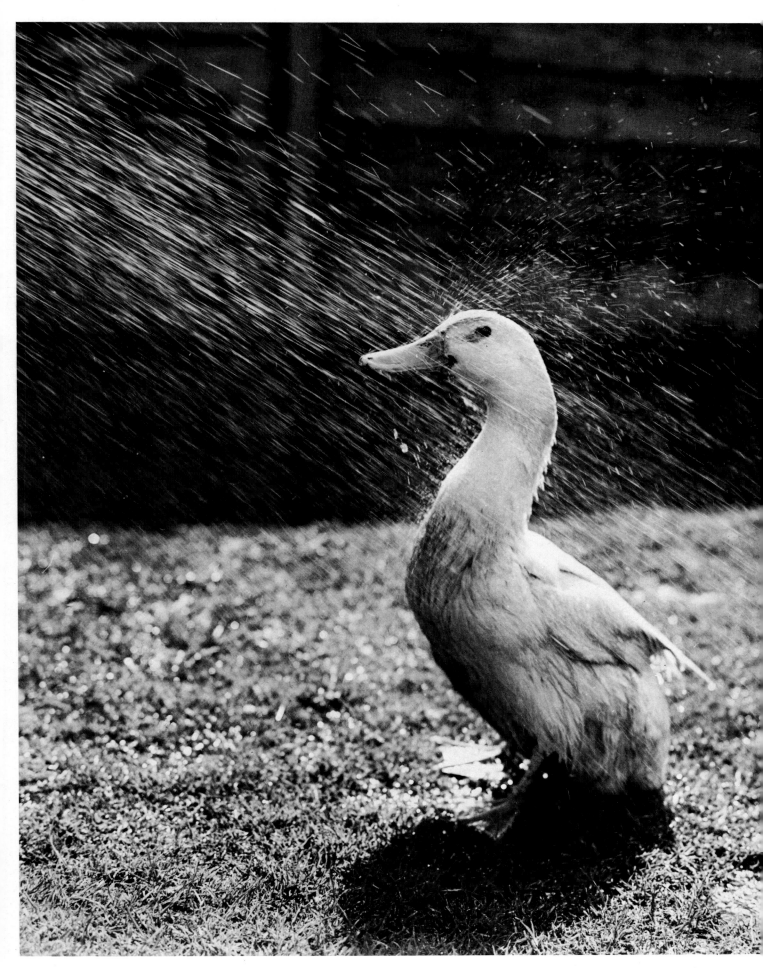

John Walker

101

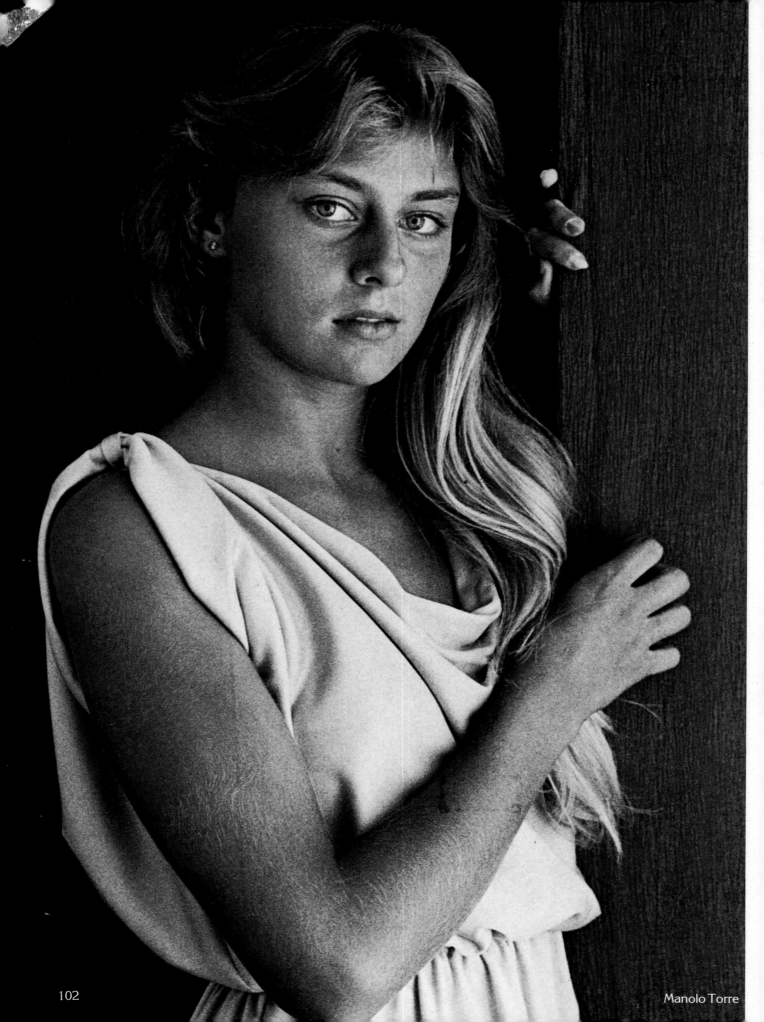

102

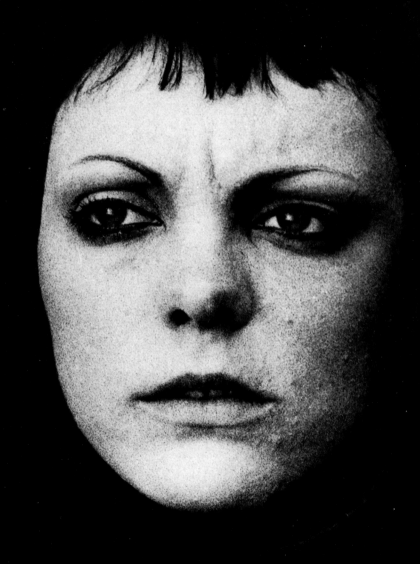

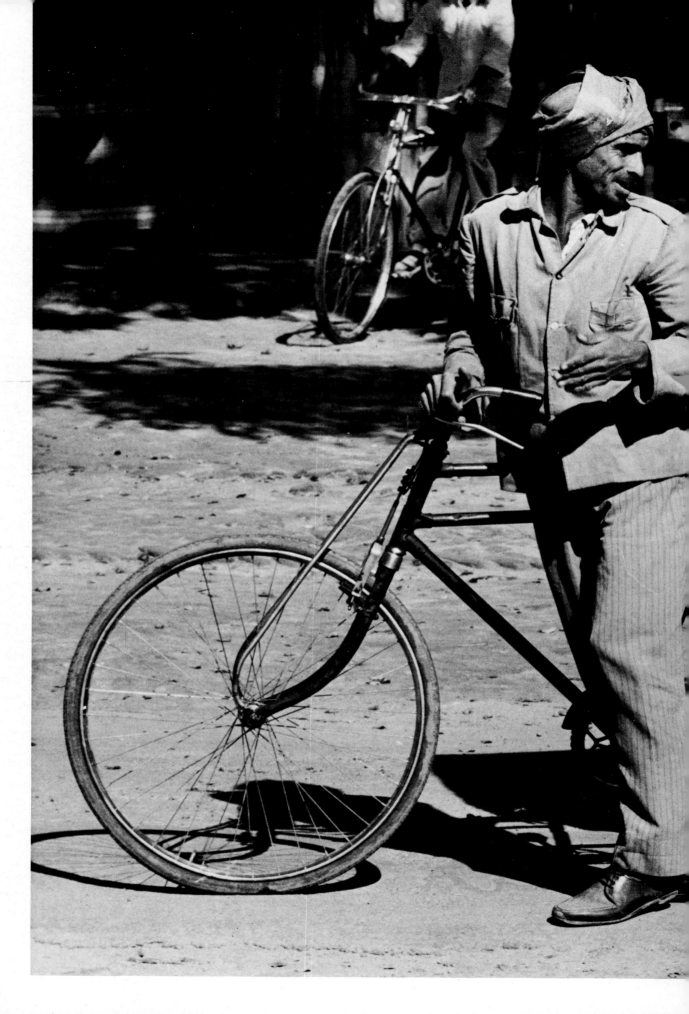

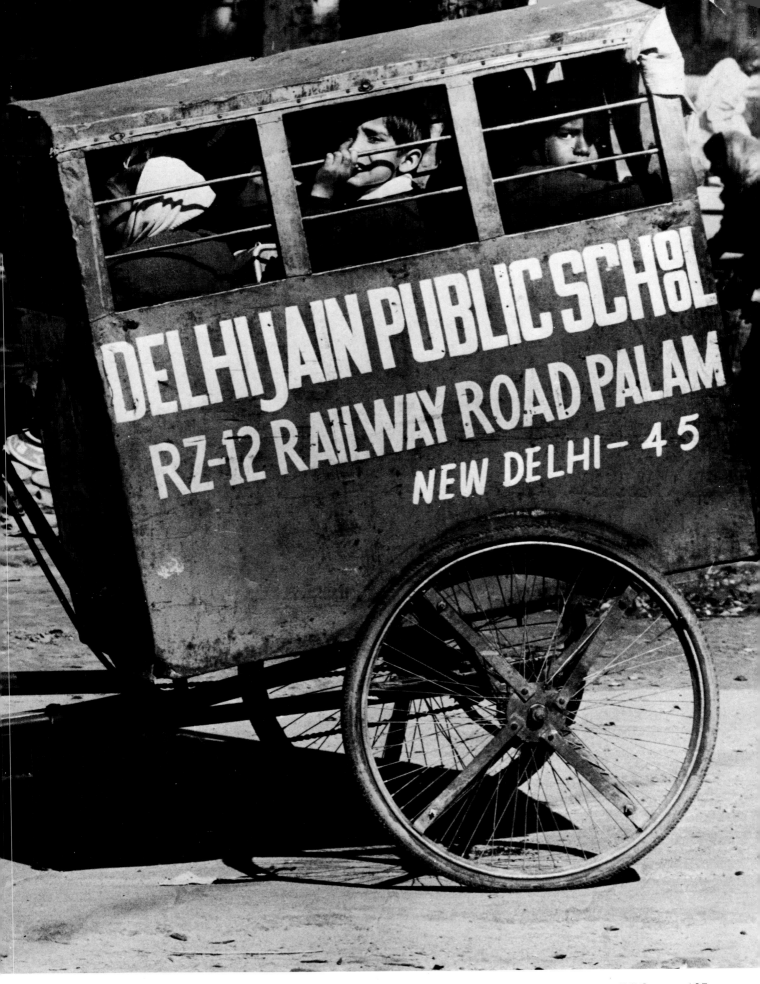

DELHI JAIN PUBLIC SCHOOL
RZ-12 RAILWAY ROAD PALAM
NEW DELHI- 45

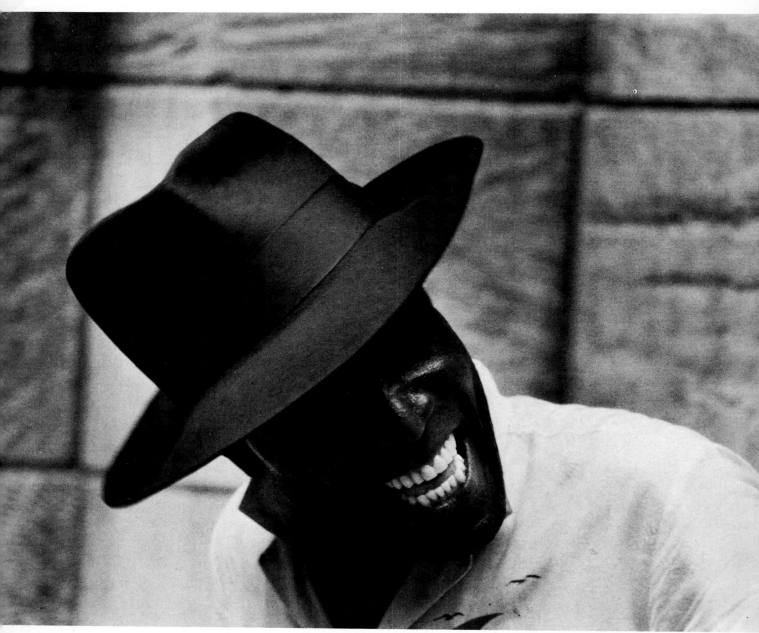

John Renwick

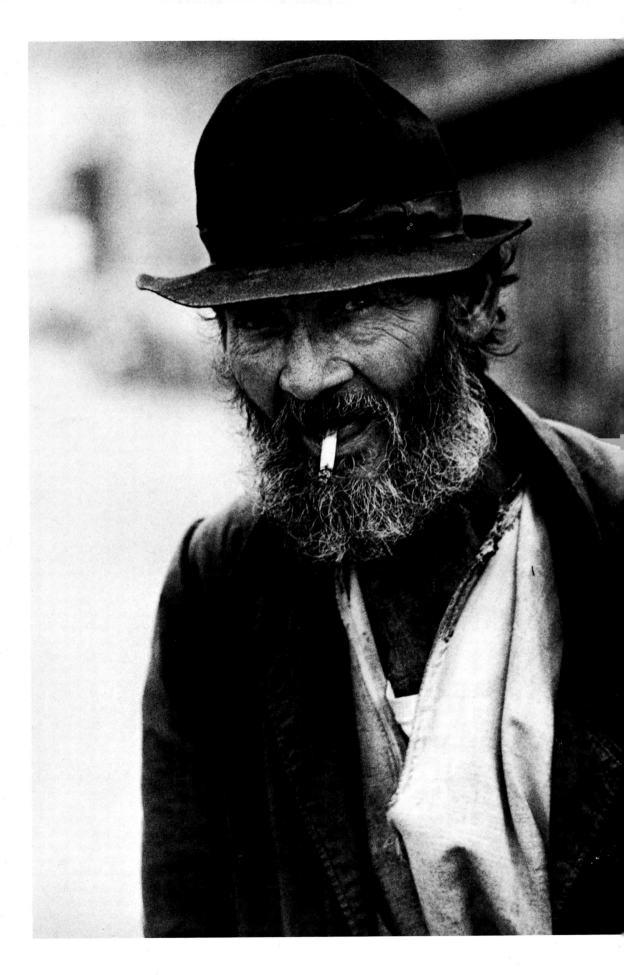

Gunther Prator

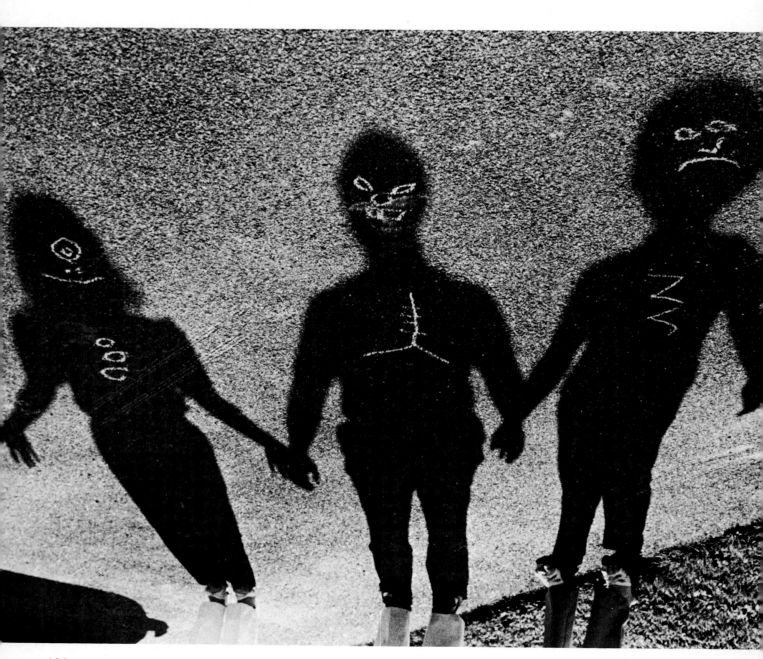

Kenneth Deitcher

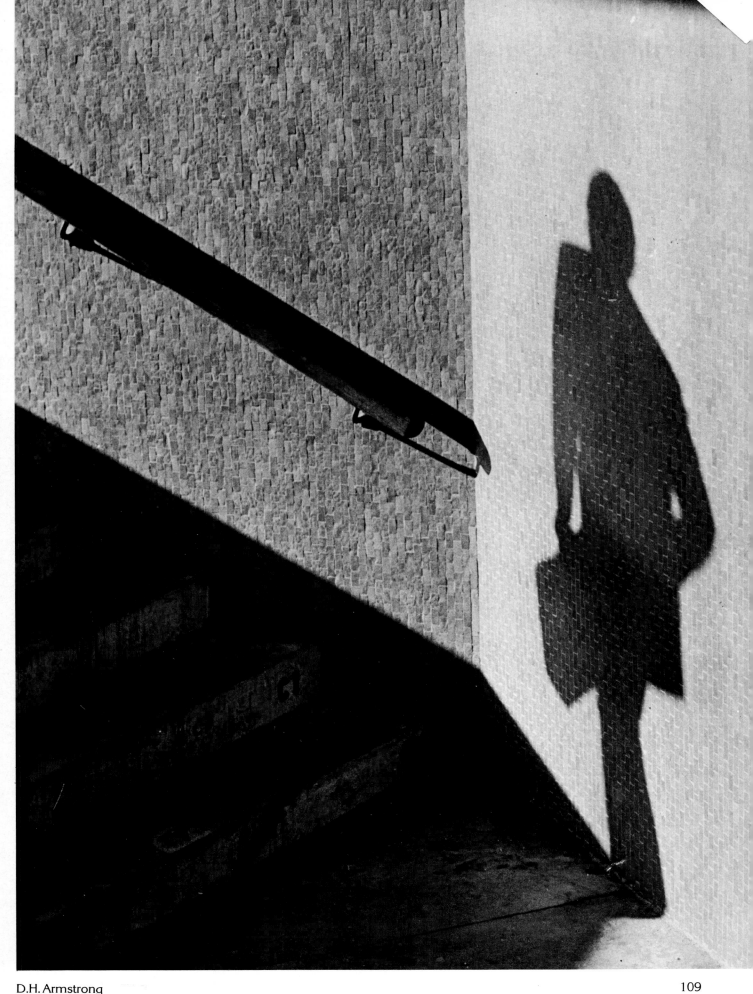

D.H. Armstrong

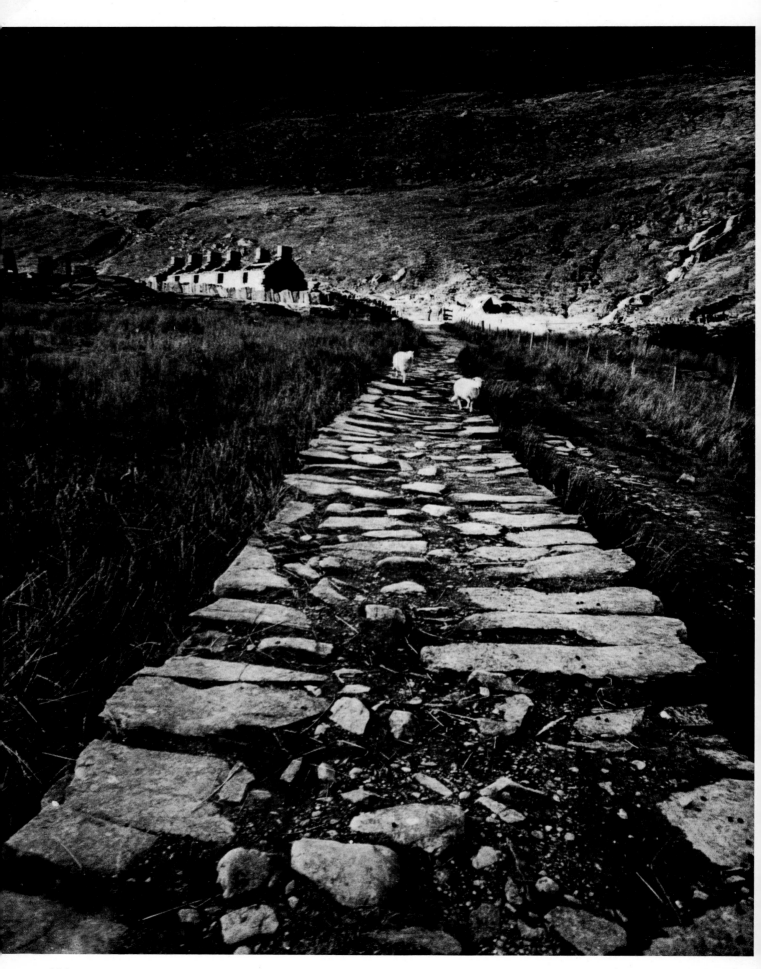

Margaret Salisbury

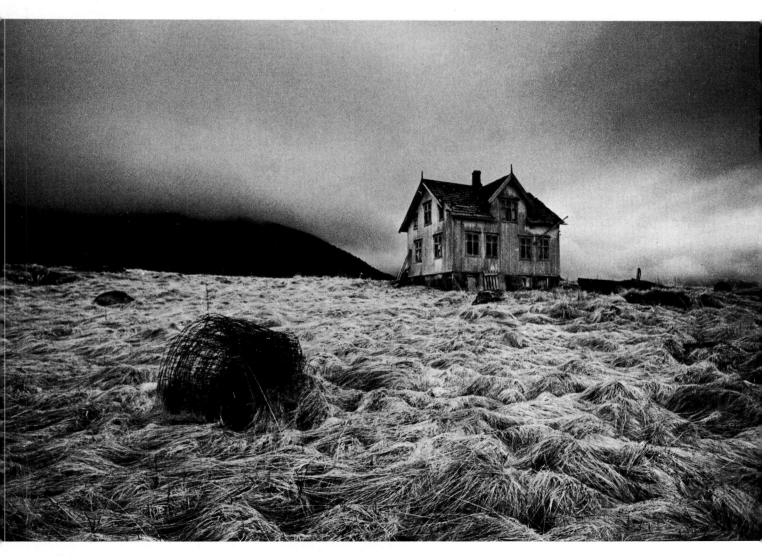

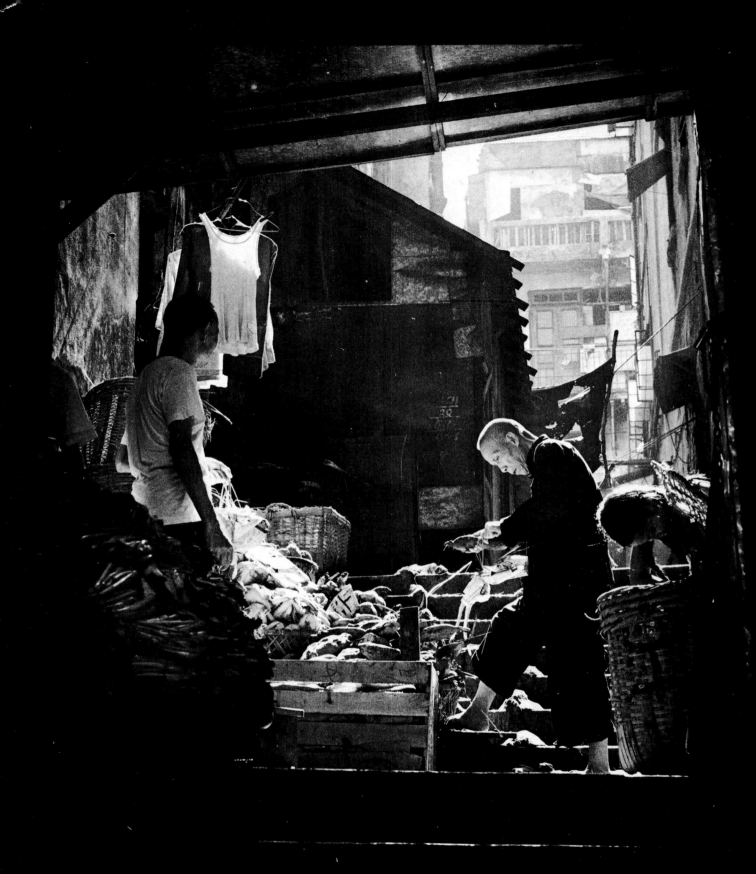

Michael Armstrong

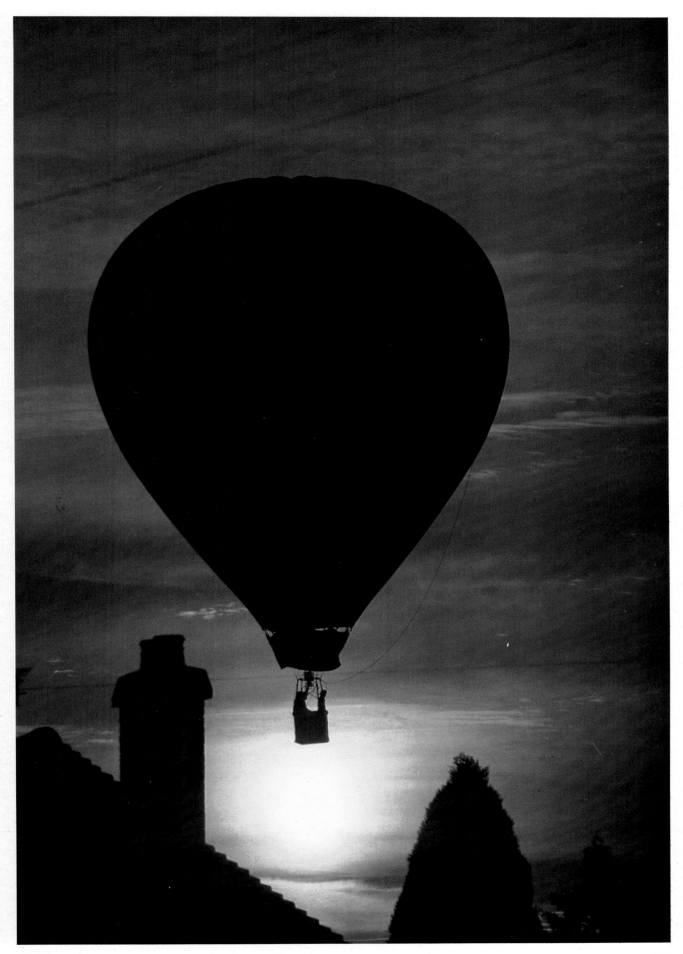

A.J. Stimpson

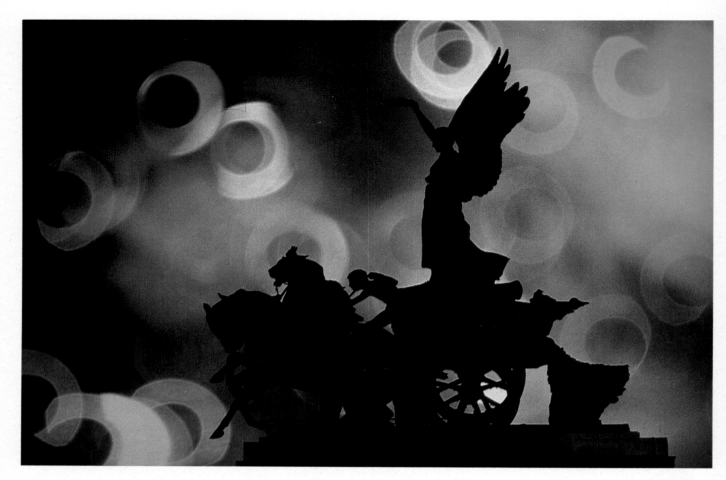

Peter Upton

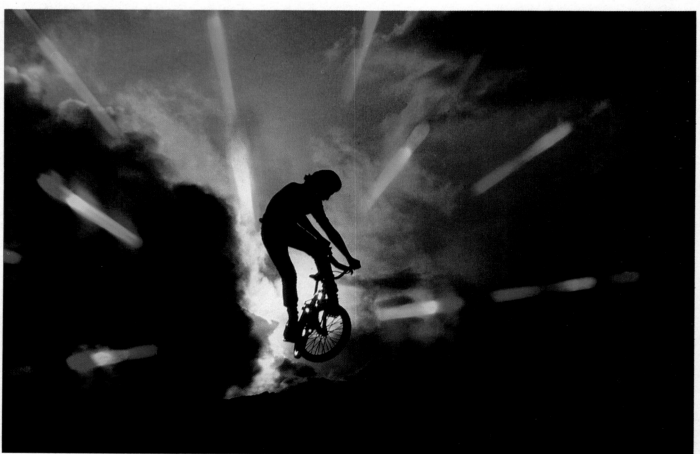

G.I. Ratcliffe

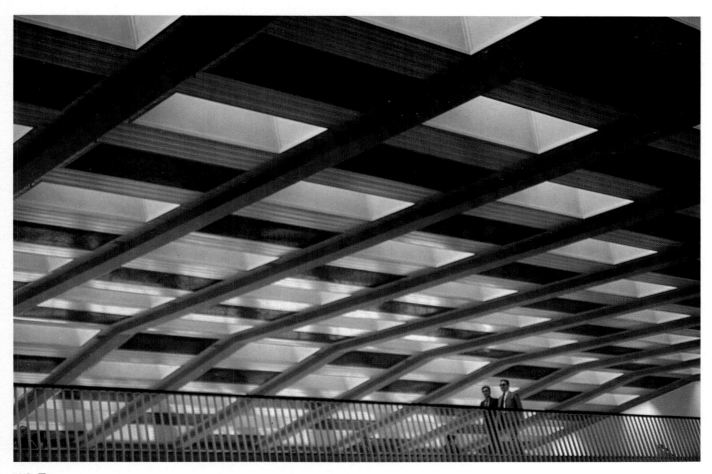

H.S. Fry

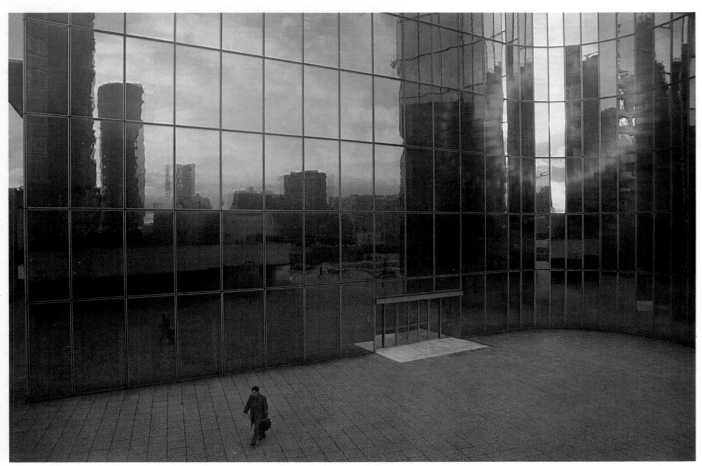

George Pollock

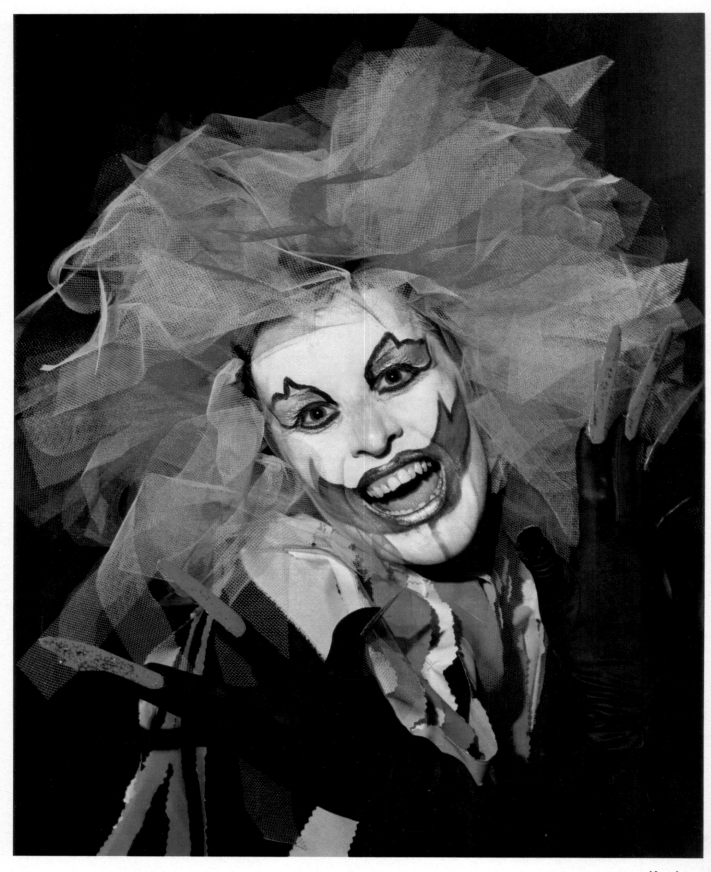

Kurt Lang

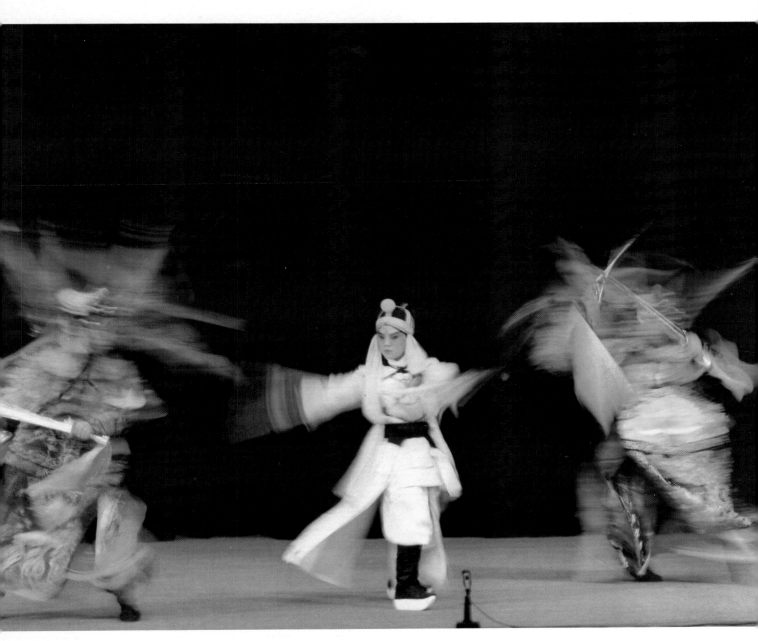

Sung Ming

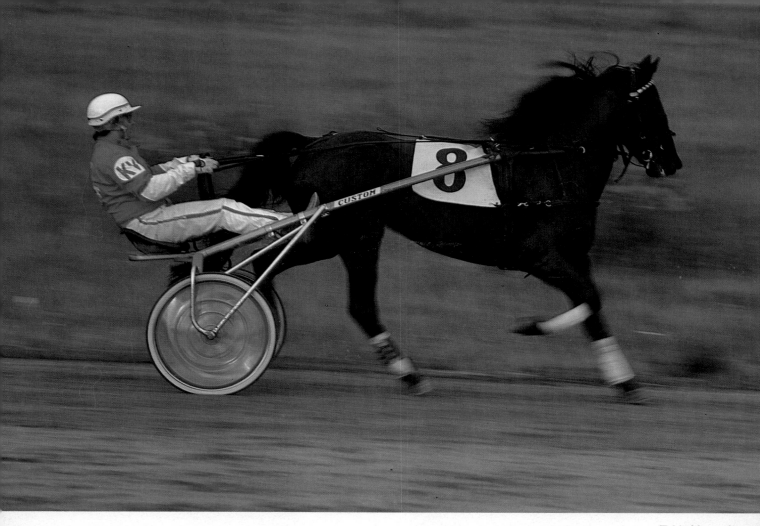

Erkki Niemelä

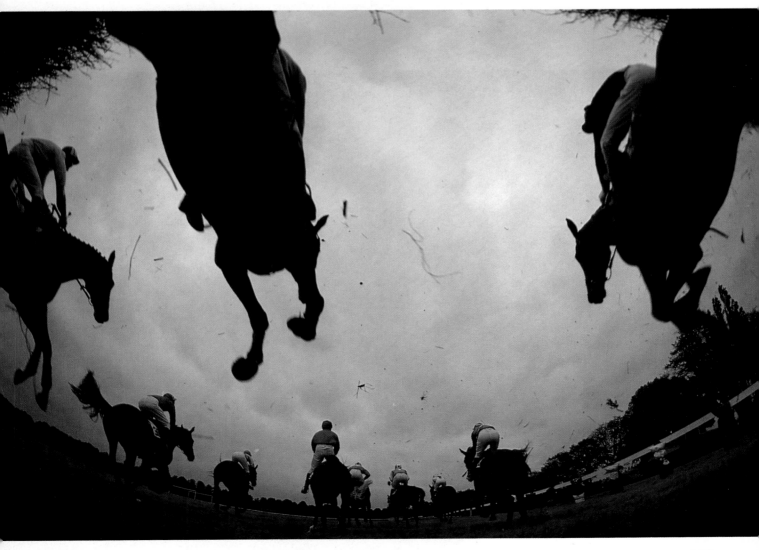

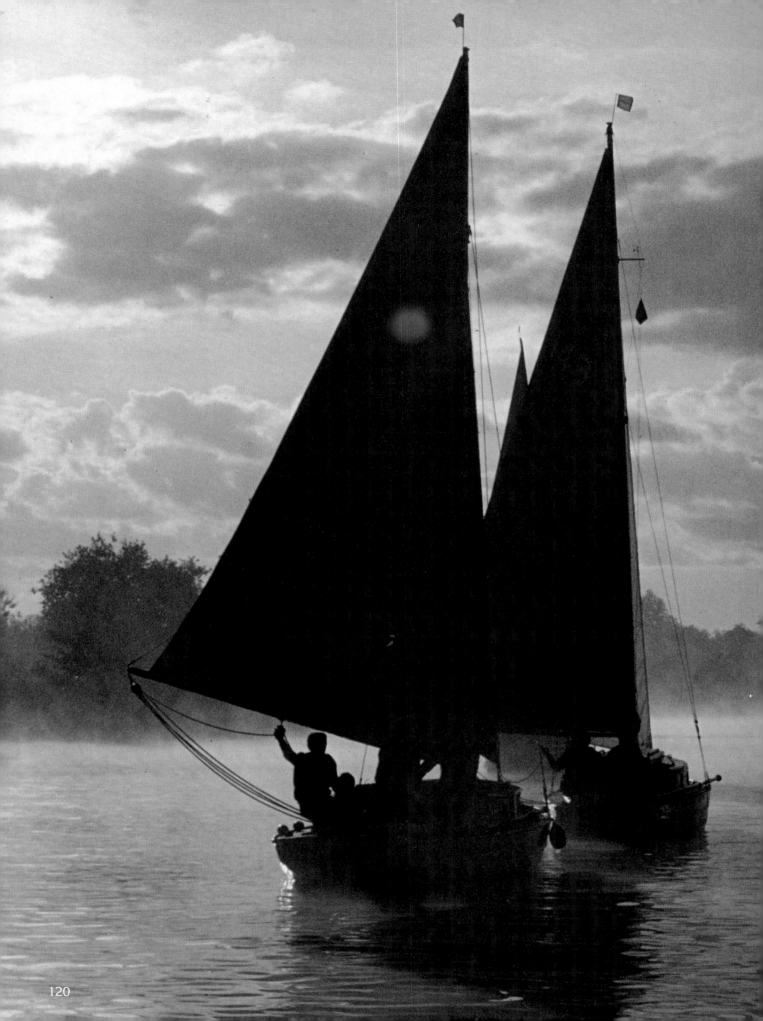

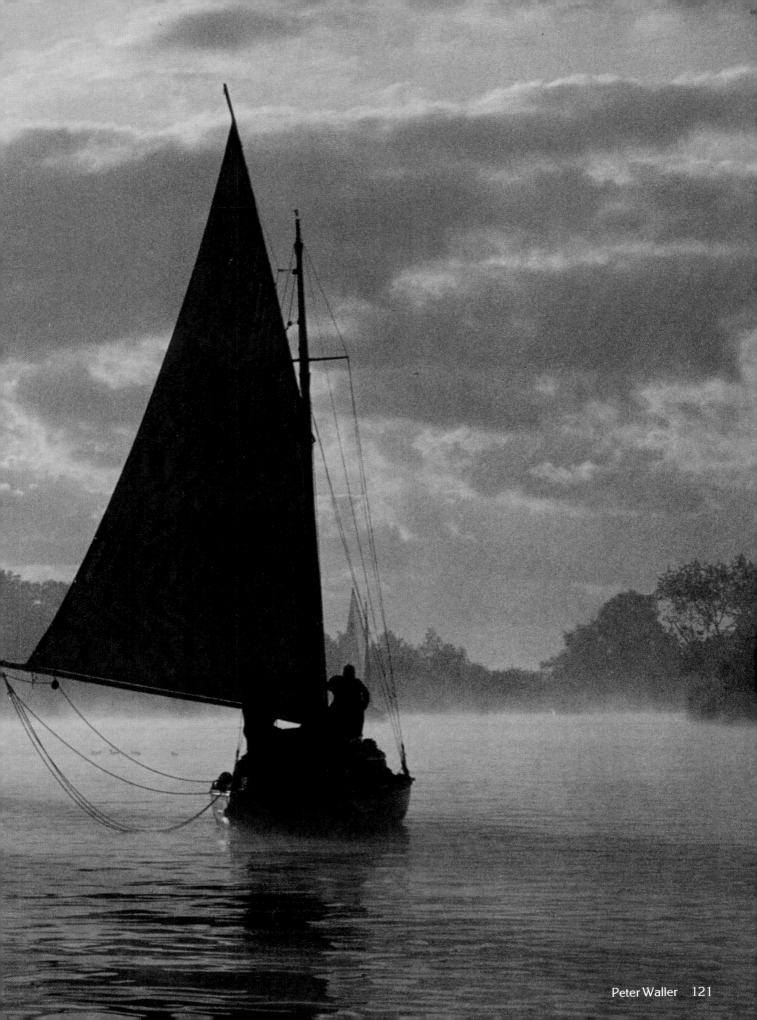

Roger Lane

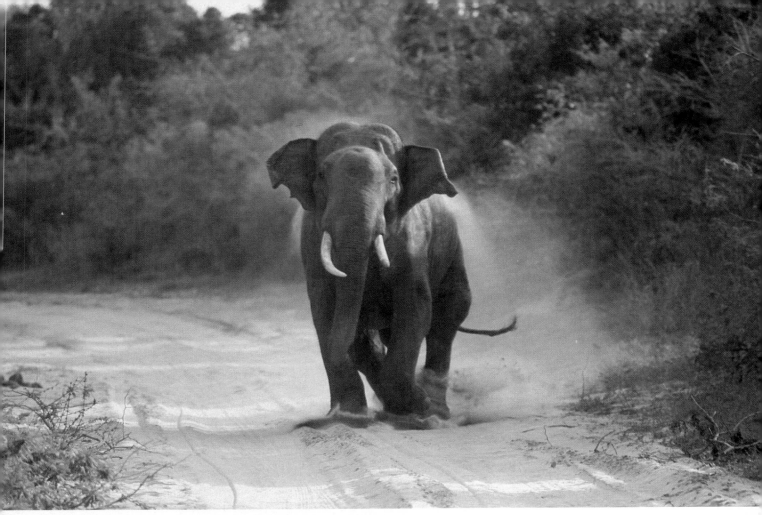

Heather Angel

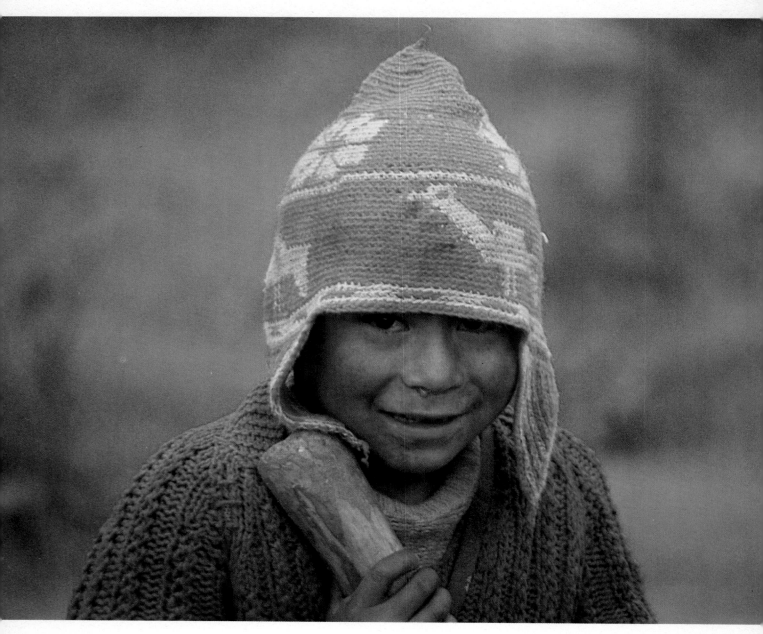

David Horwell

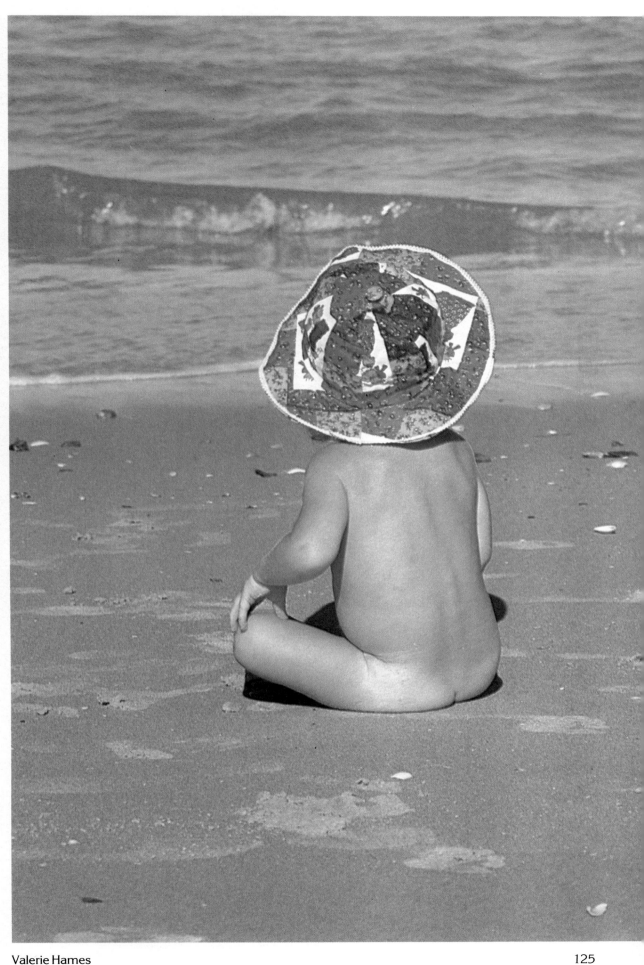

Valerie Hames

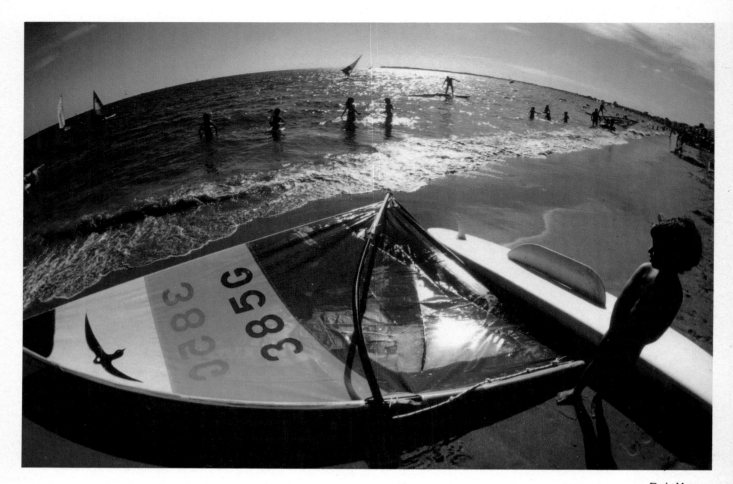

Bob Moore

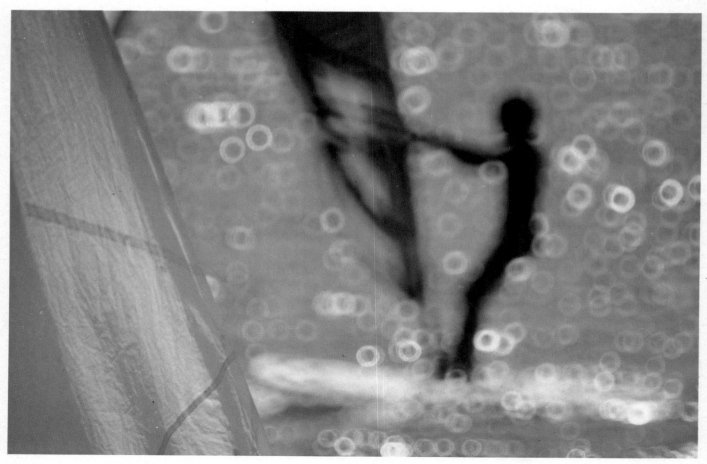

Bob Moore

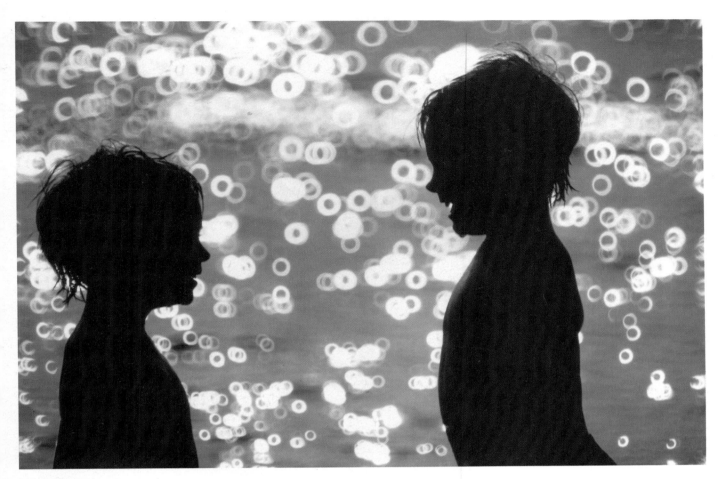

Edwin Appleton

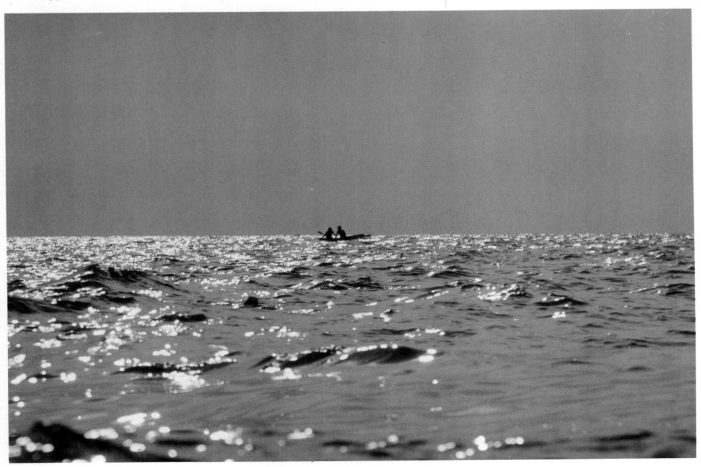

Ulrich Kloes

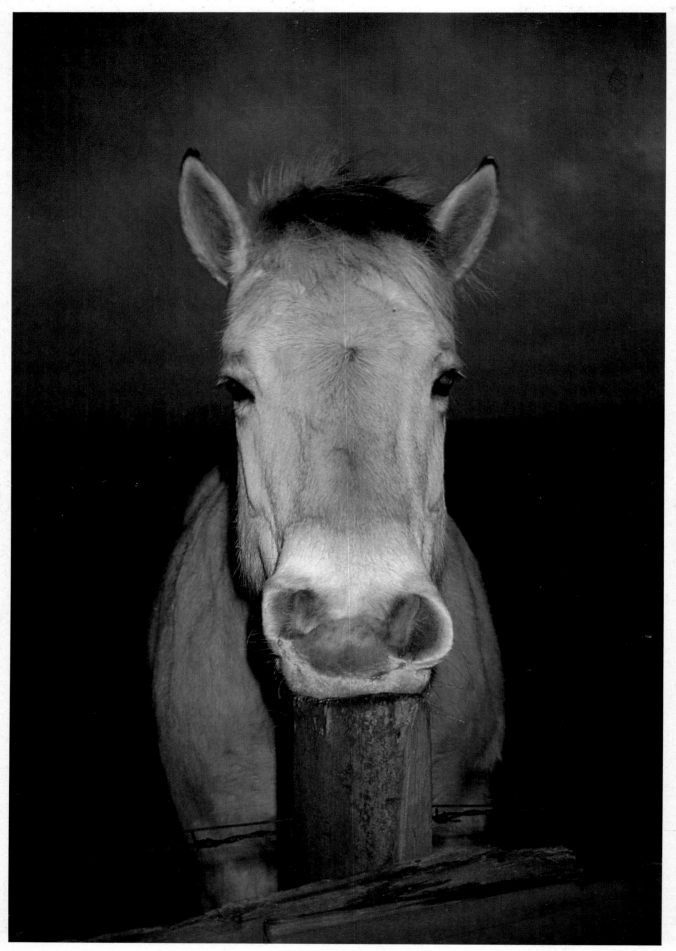

Thomas Beyer

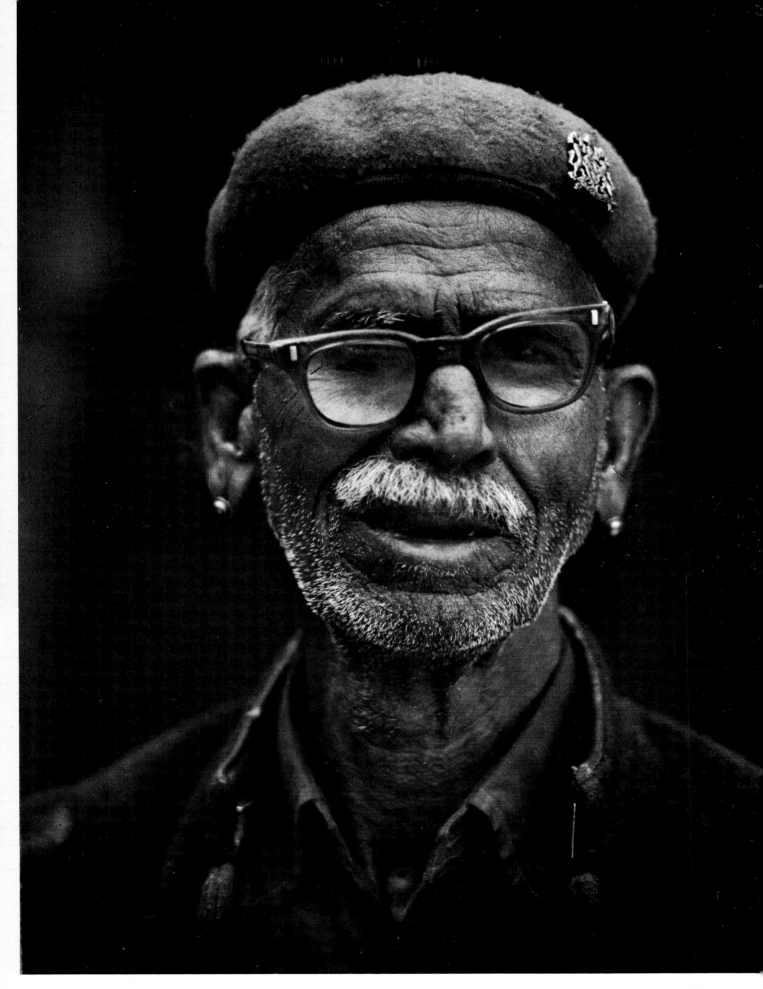

Jagdish Agarwal

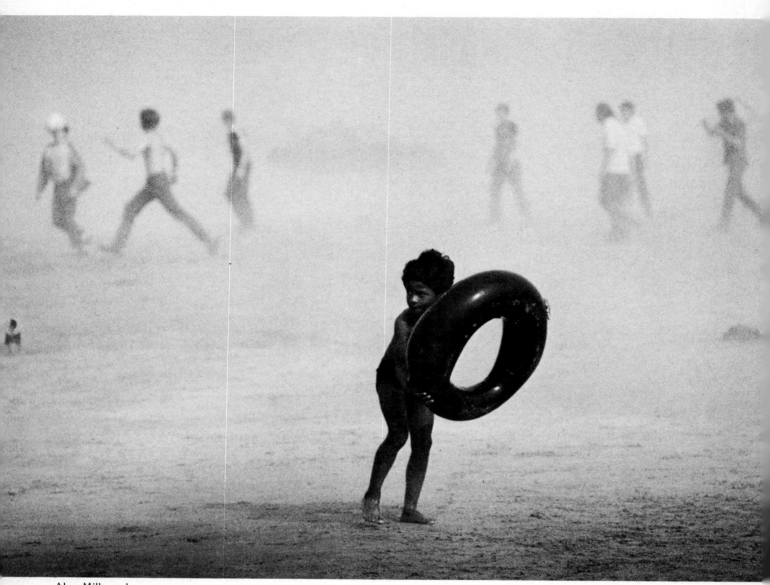

Alan Millward

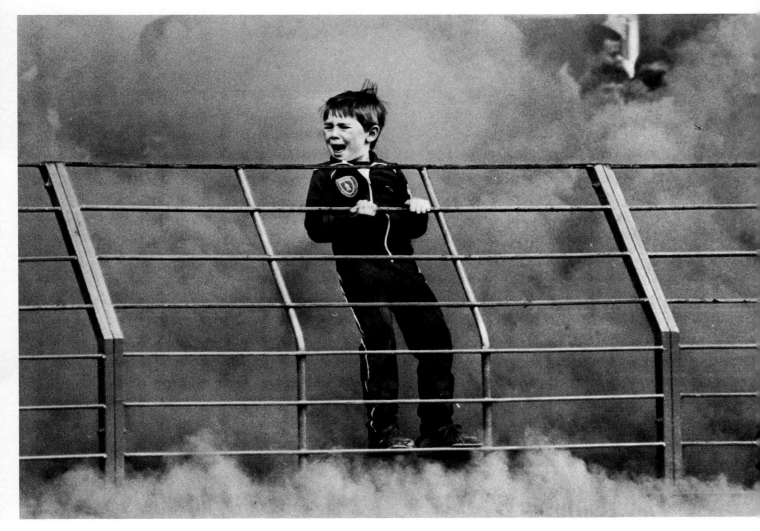

Neil Jones

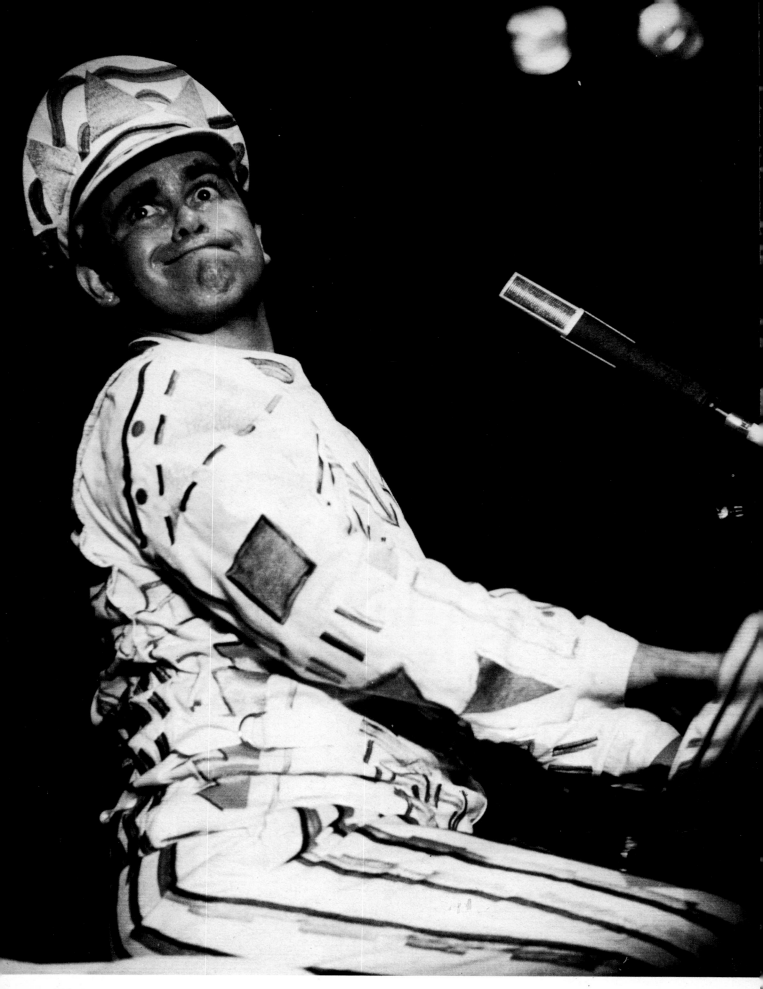

Bob King

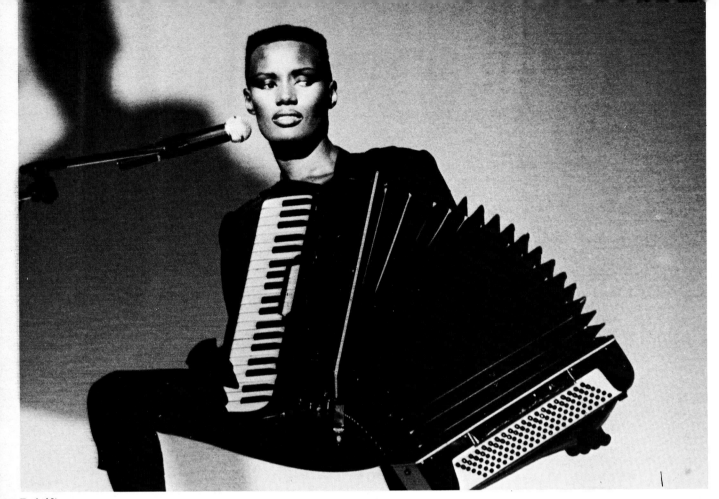

Bob King

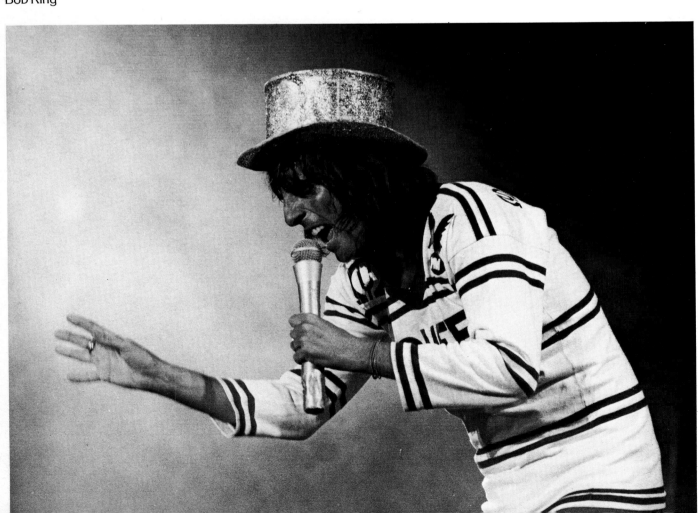

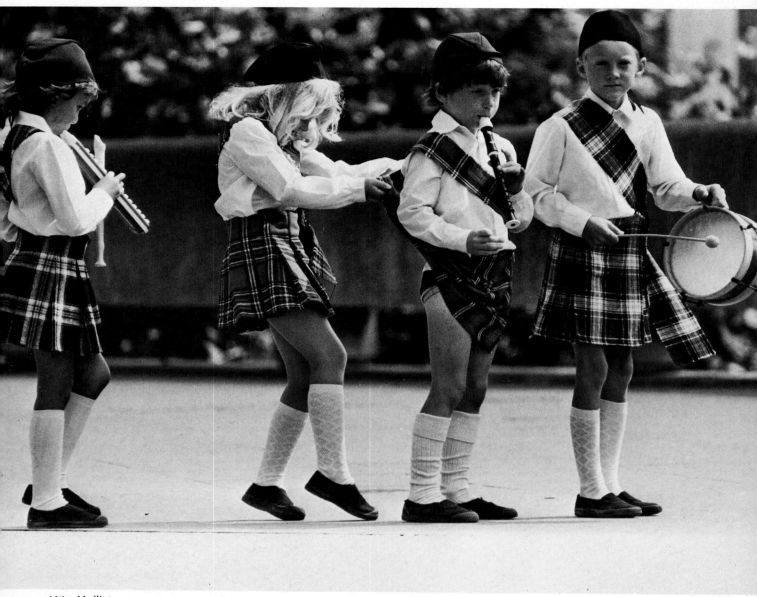

Mike Hollist

134

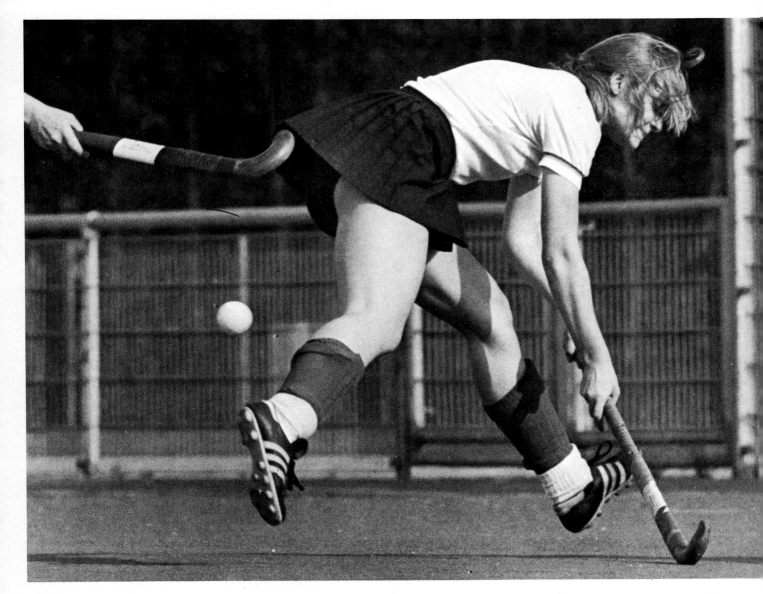

Bodo Goeke

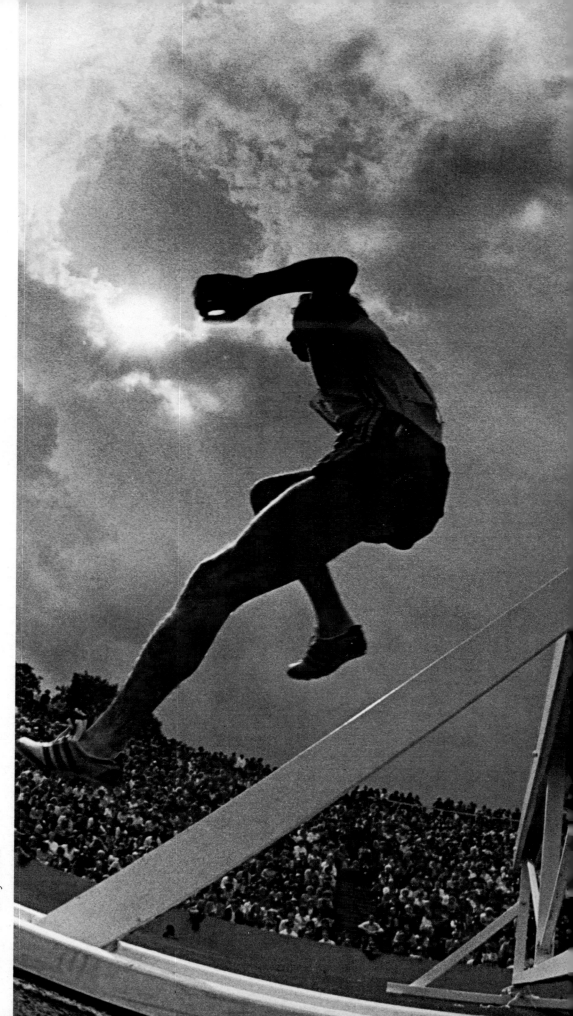

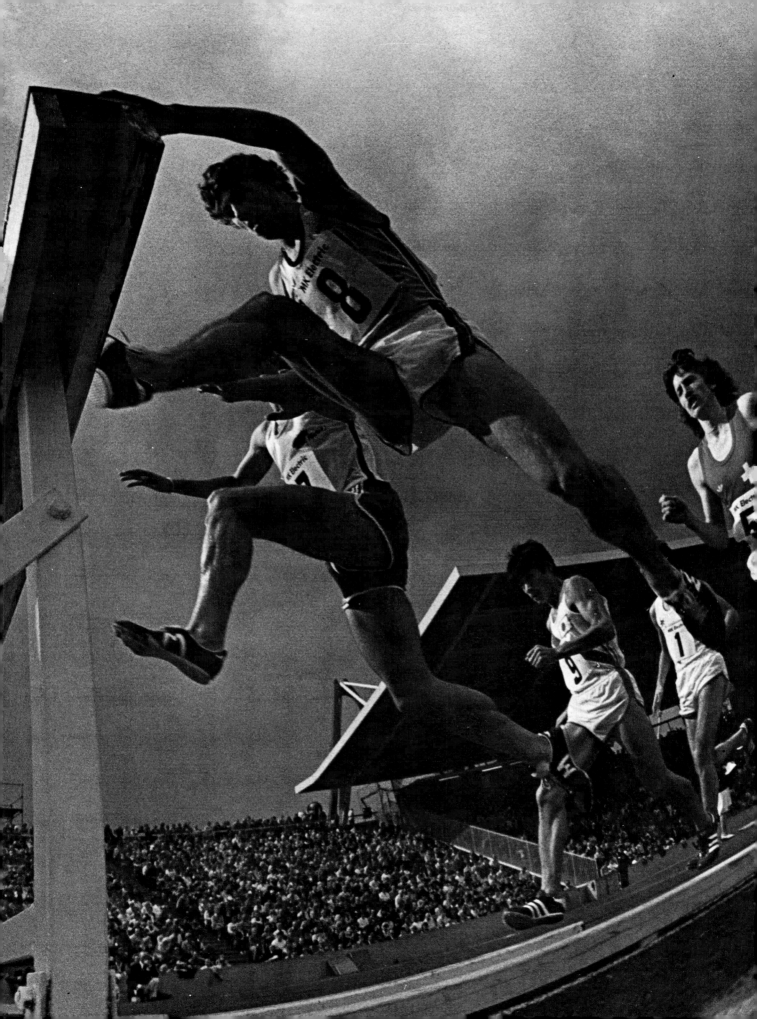

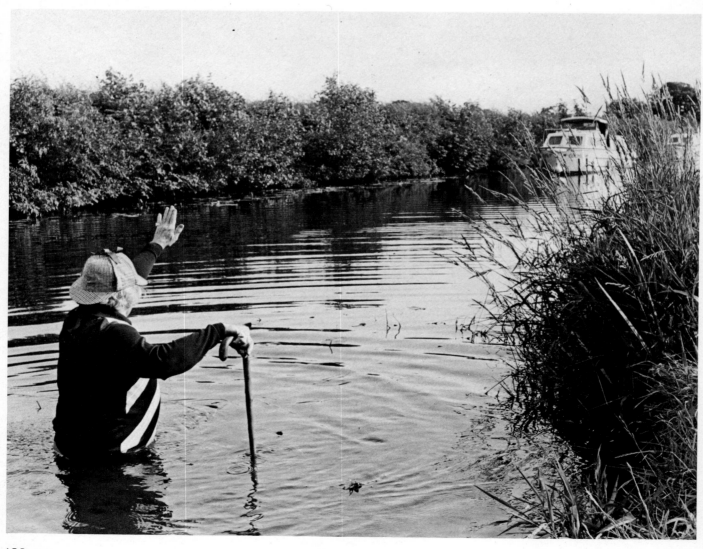

Noel Houghton

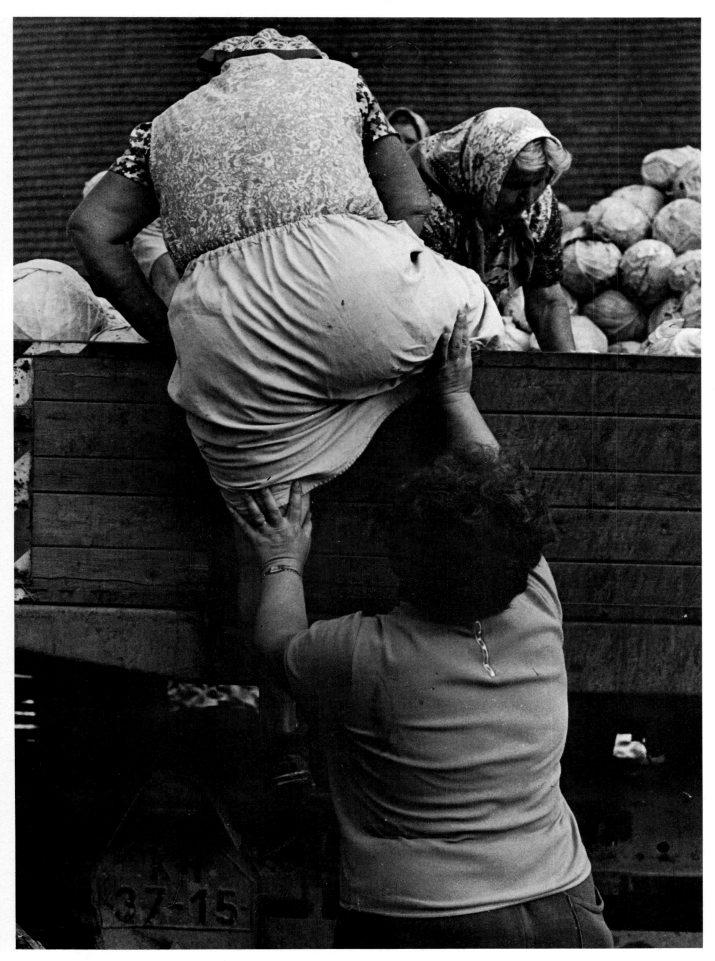

Alena Vykulilová

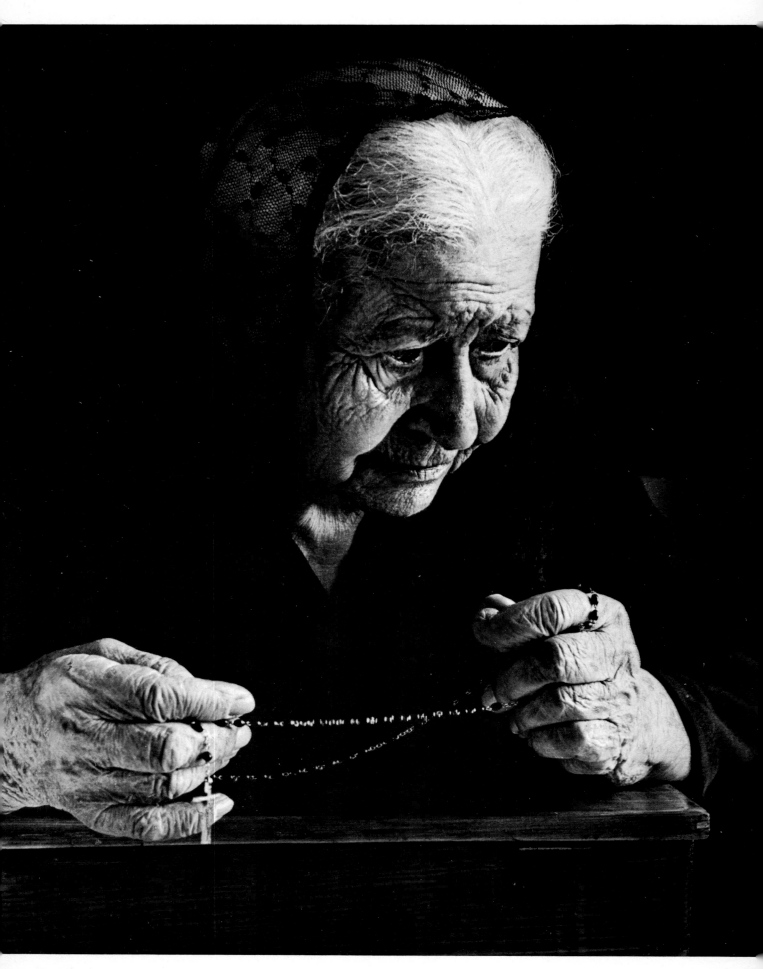

Jos. A. Vella

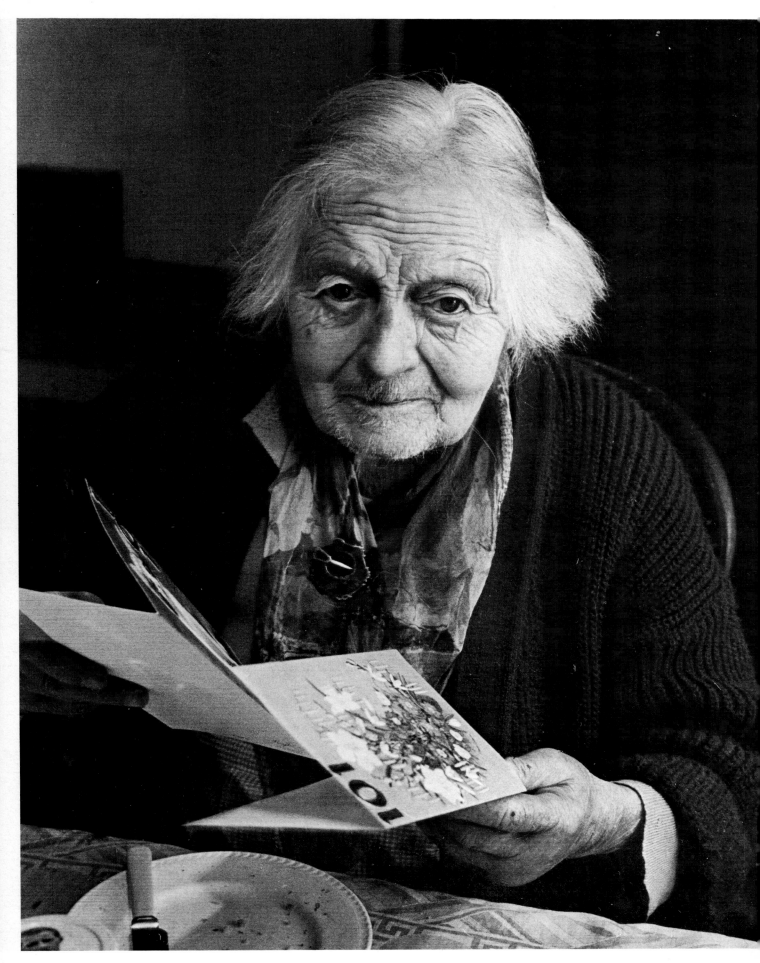

Peter Elgar

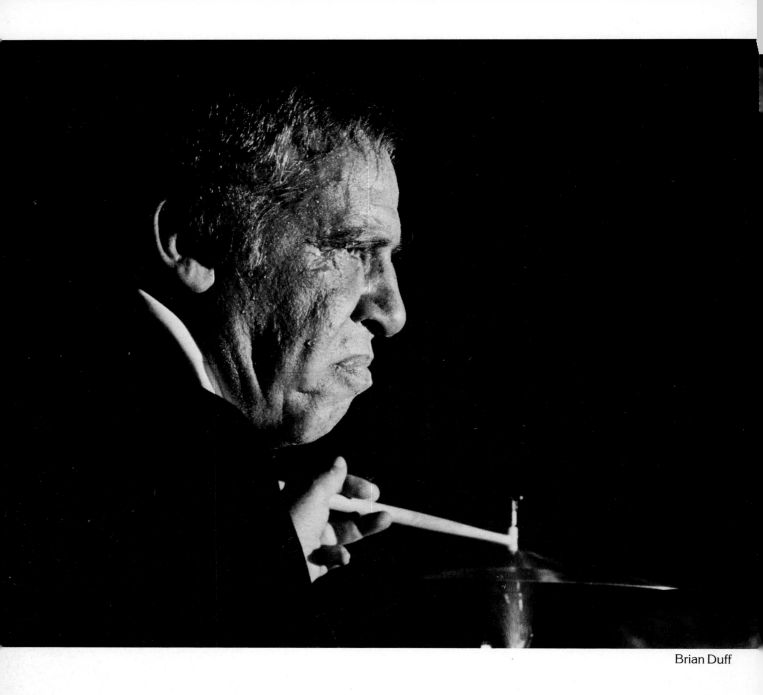

Brian Duff

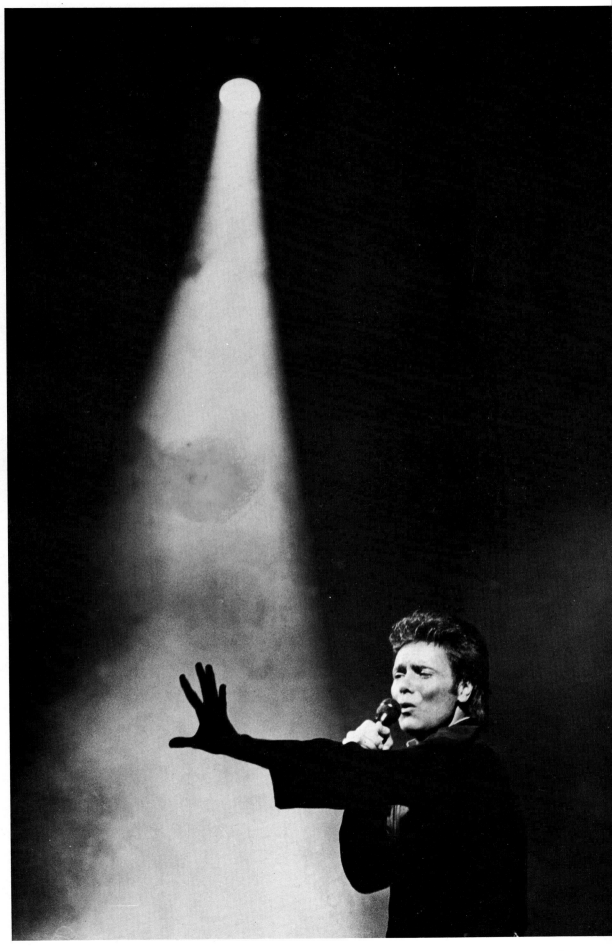

Kevin Fitzpatrick

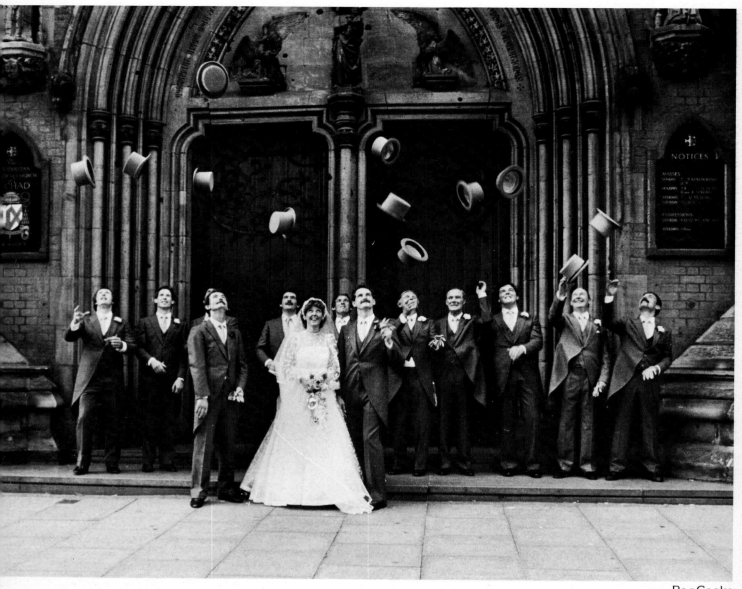

Reg Cooke

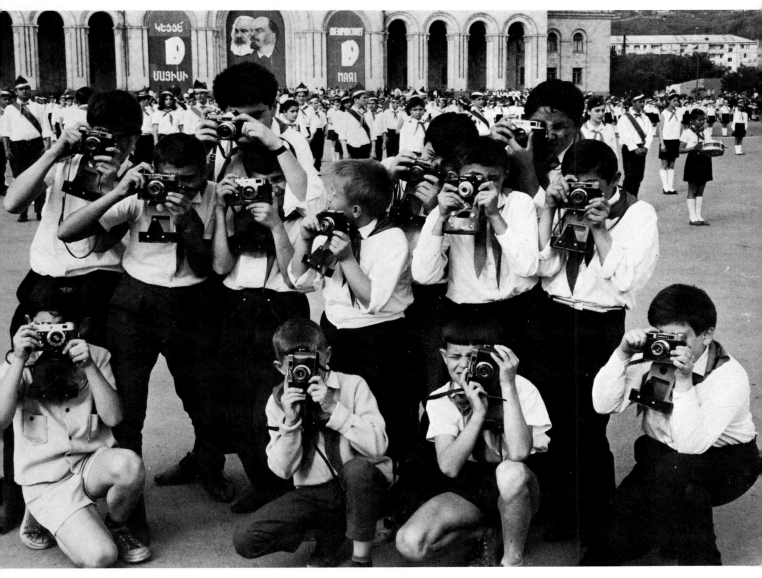

Douglas Jardine

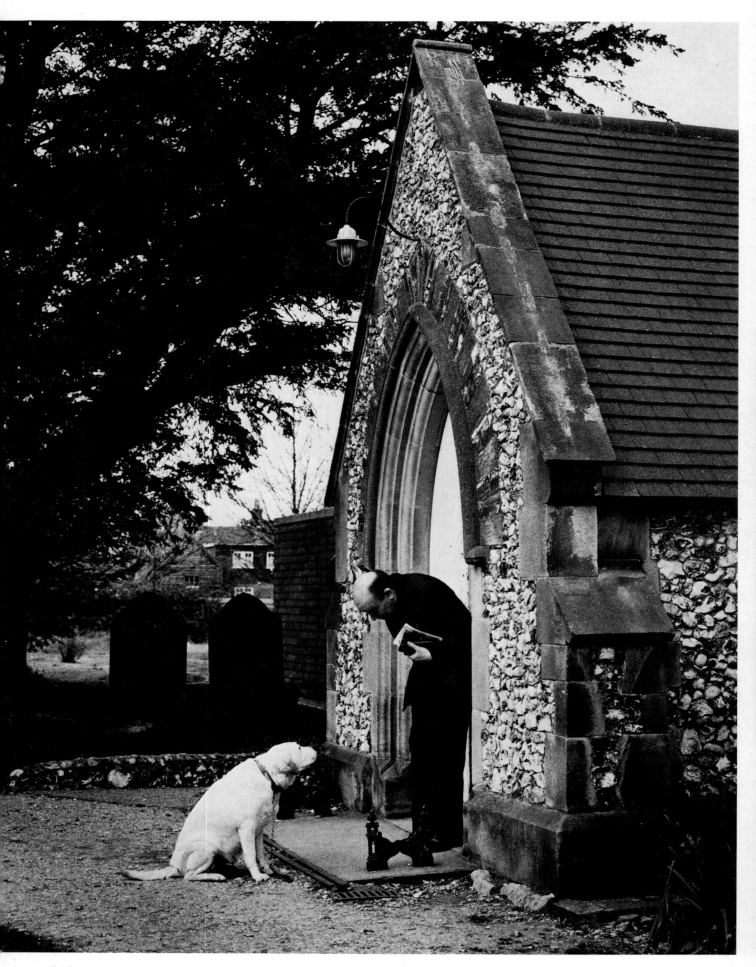

William Blackham

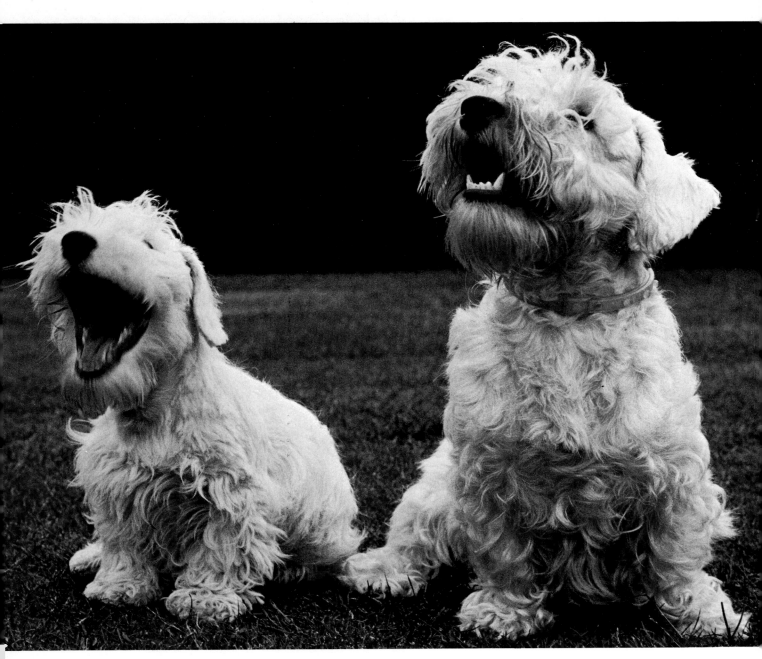

Tony Boxall

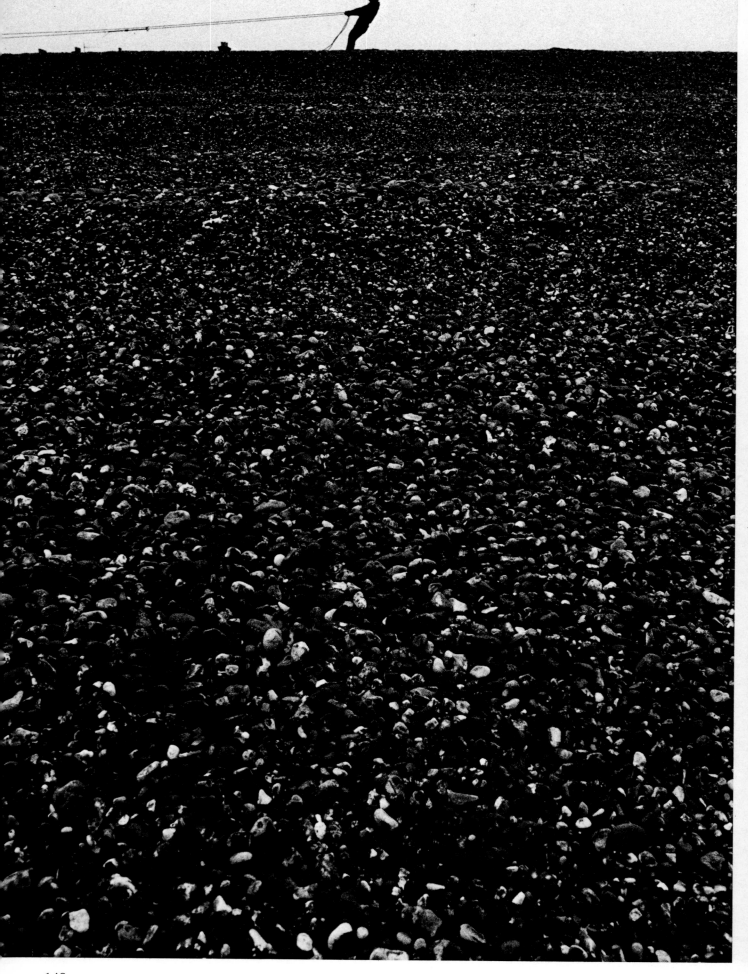

William Cheung

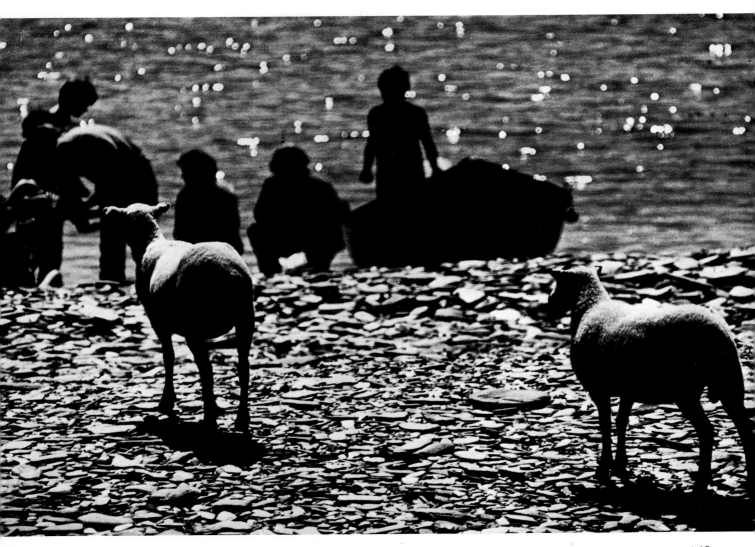

Margaret Salisbury

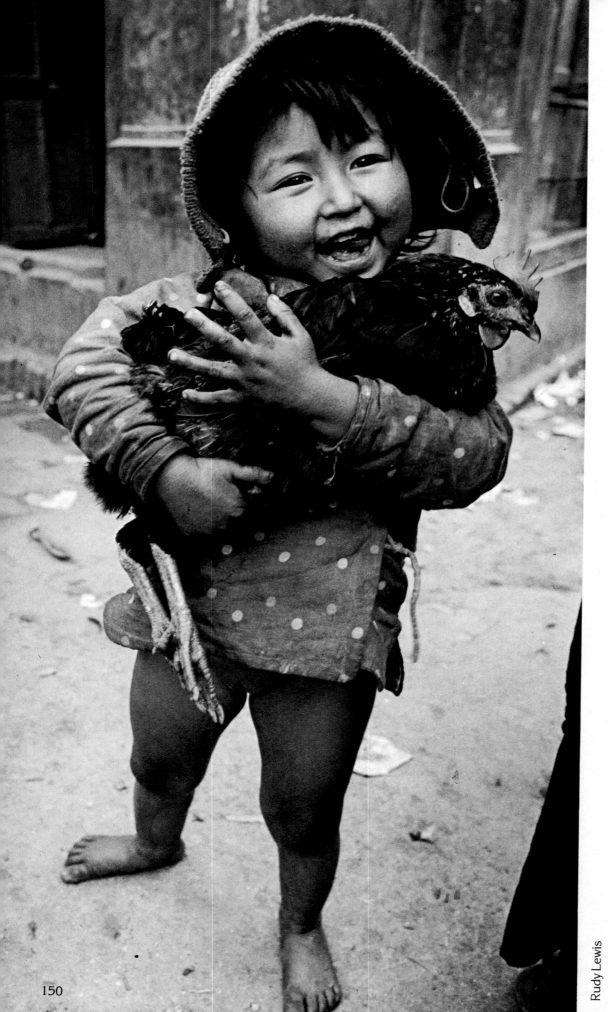

150

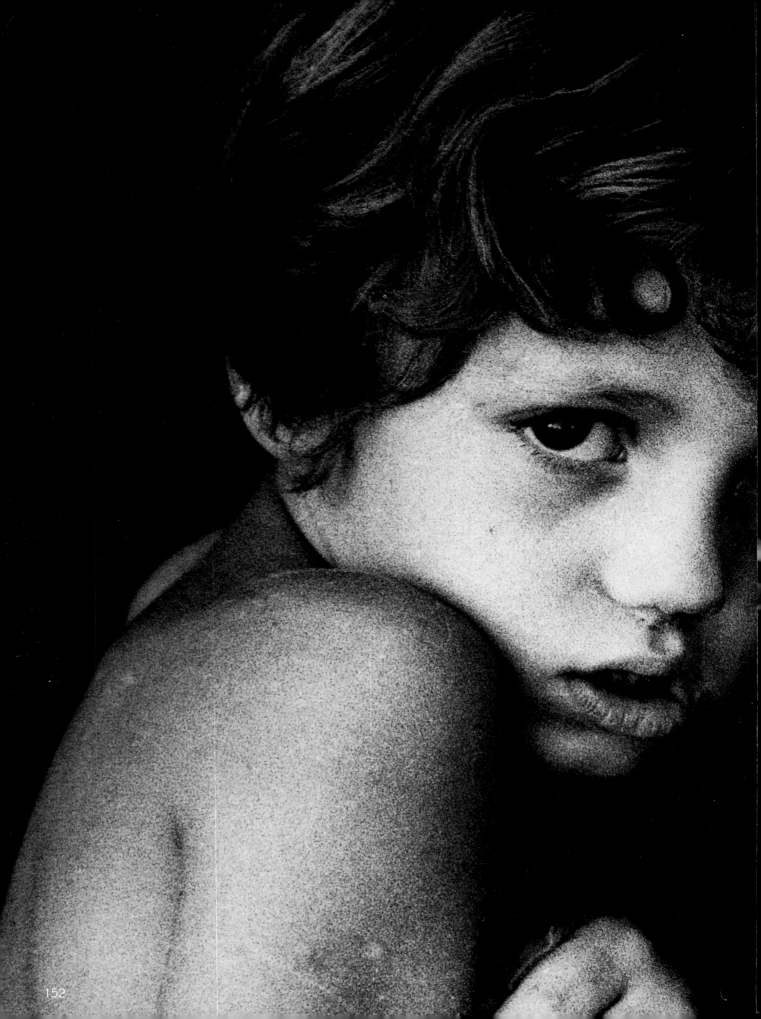

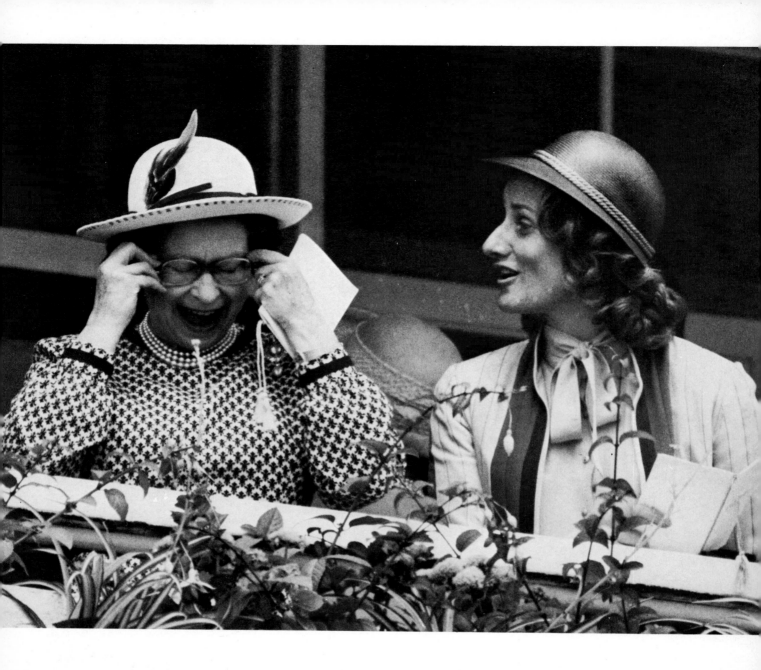

Mike Hollist

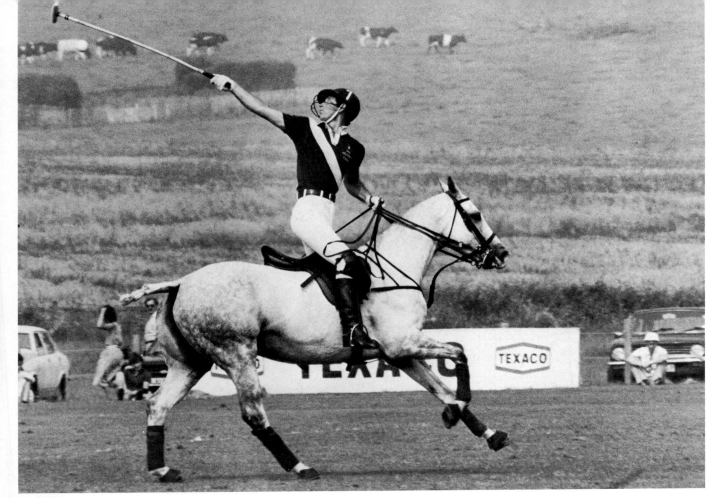

Harry Prosser

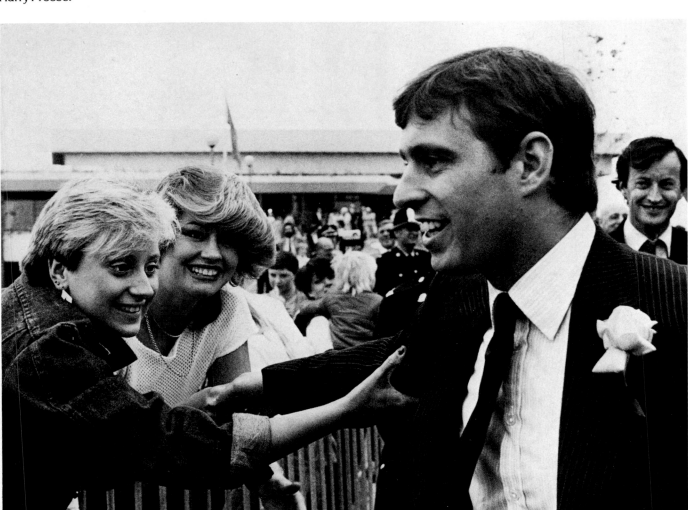

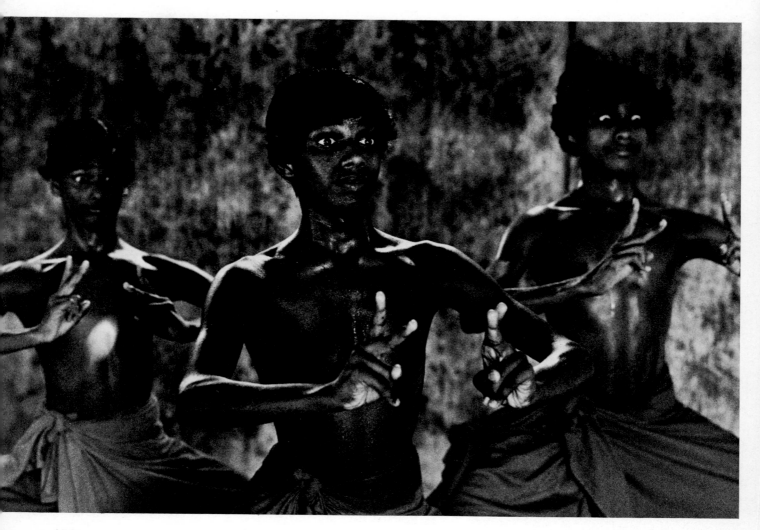

Gebhard Krewitt

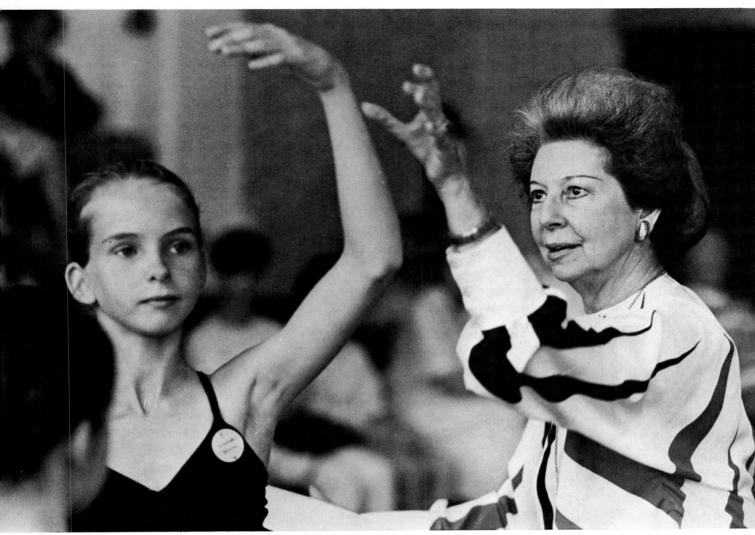

Asadour Guzelian

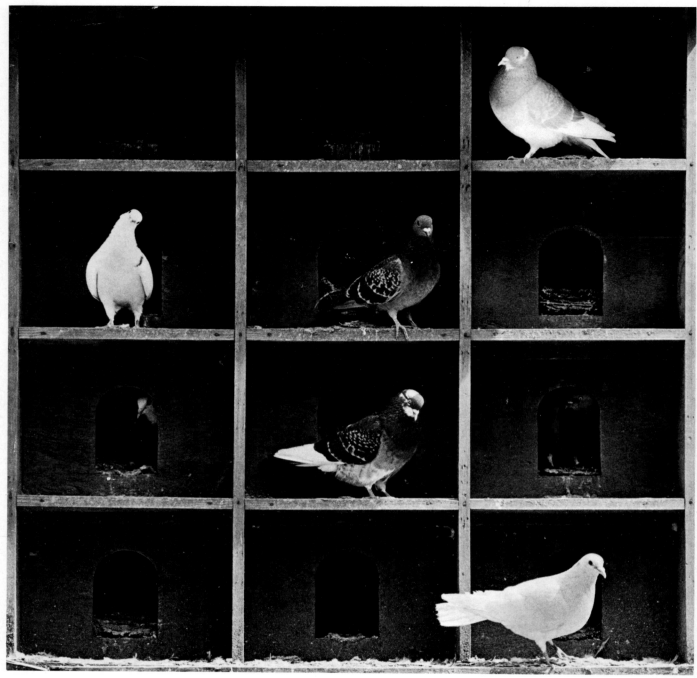

J. Durham

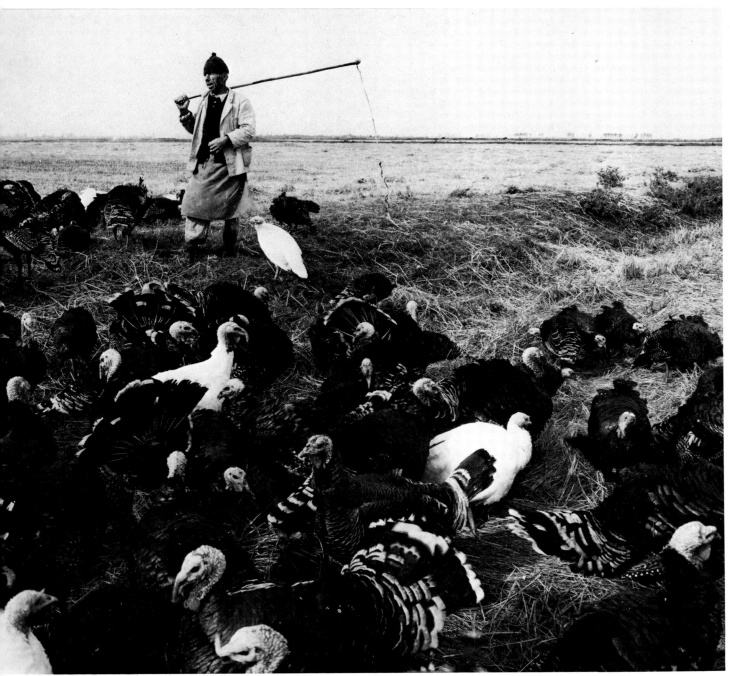

A. Sutkus

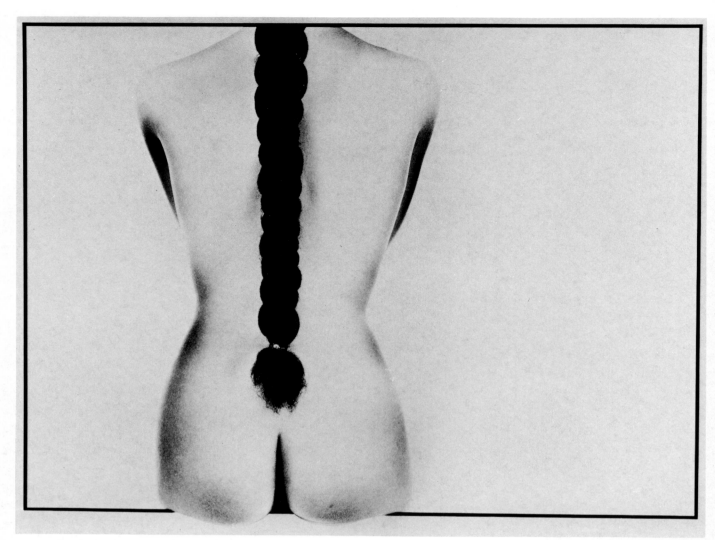

David Chamberlain

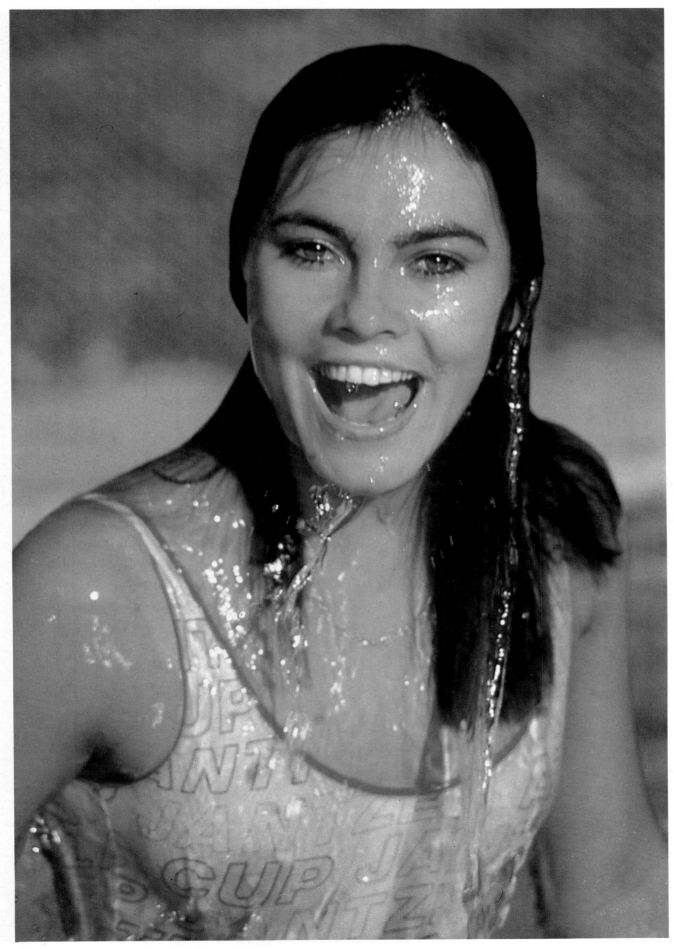

Andrzej Sawa

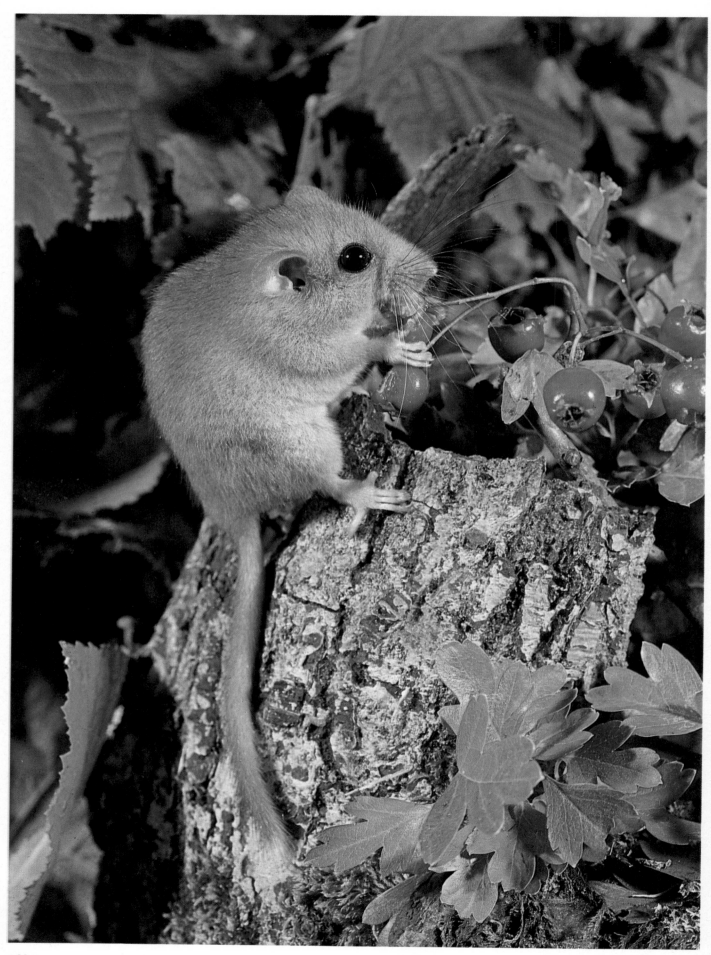

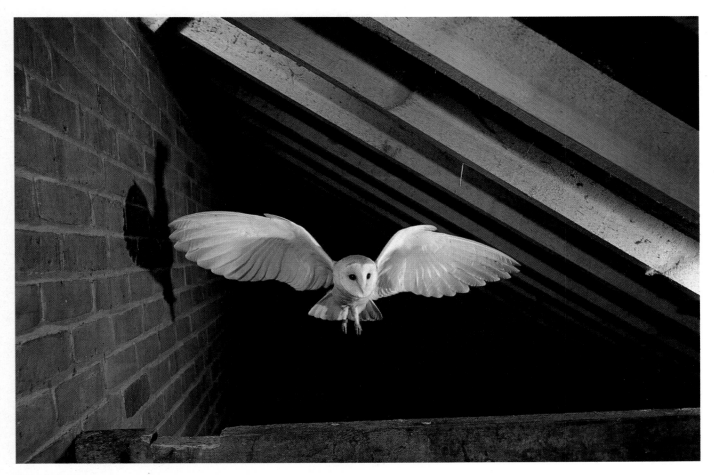

E.A. Janes

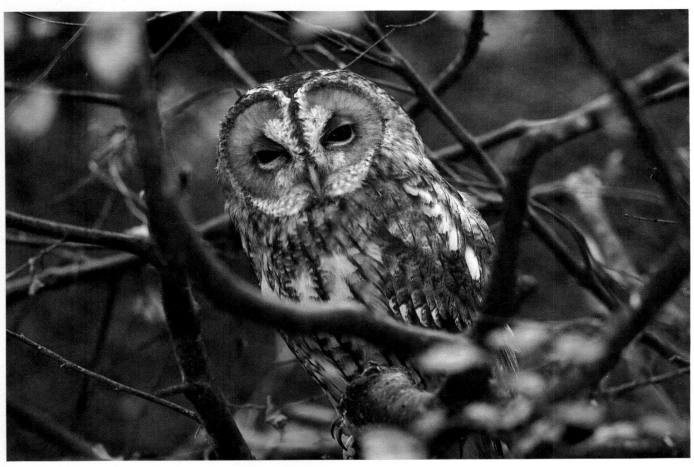

Heather Angel

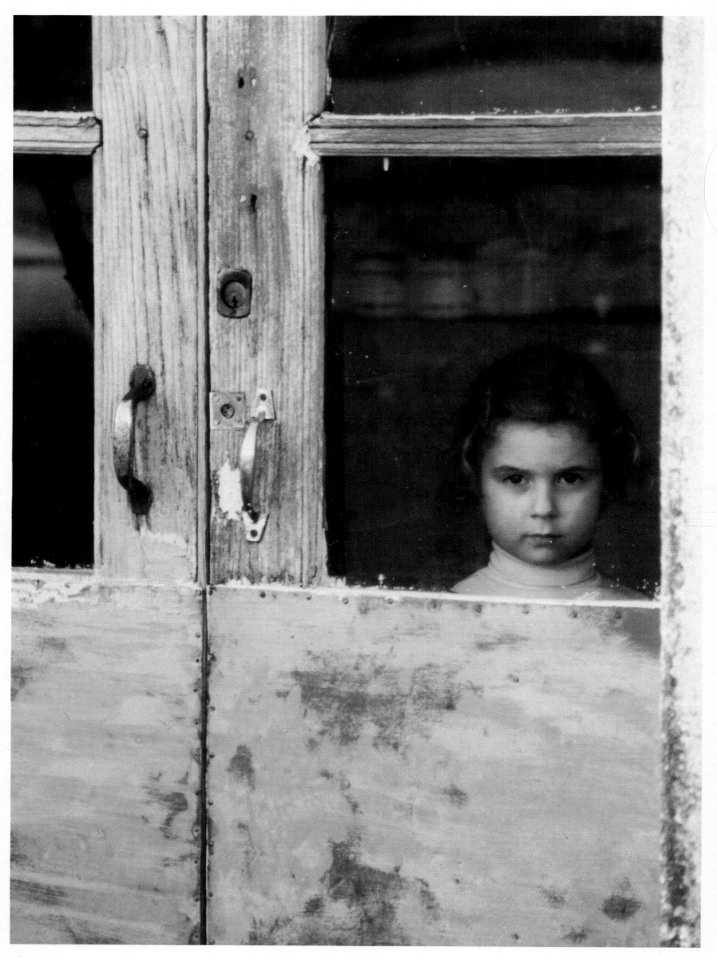

Beatriz Astoreka

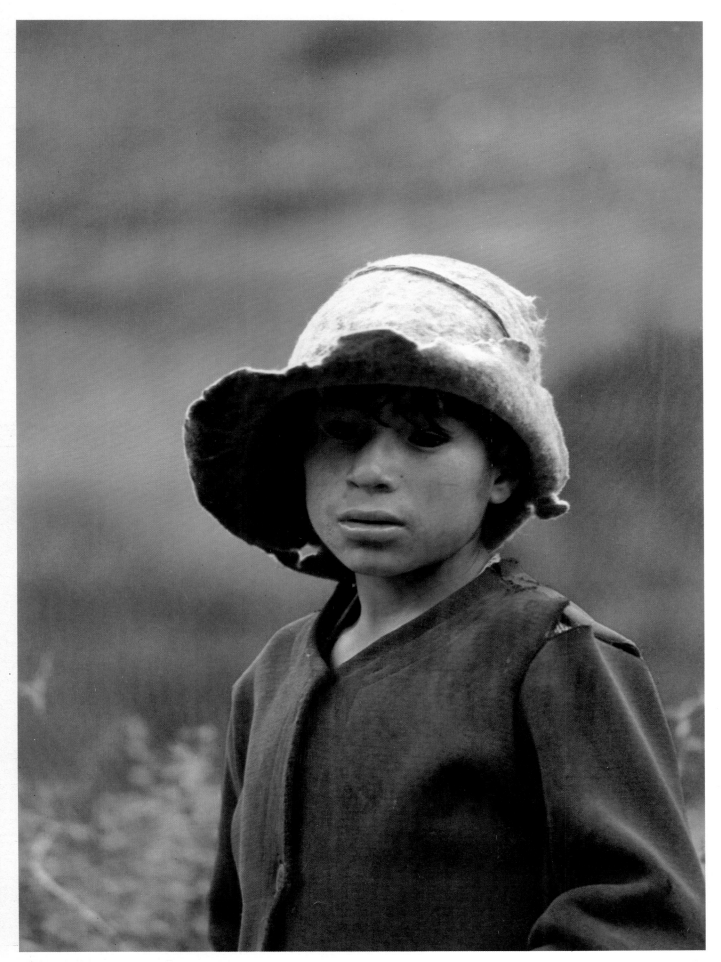

Beatriz Astoreka

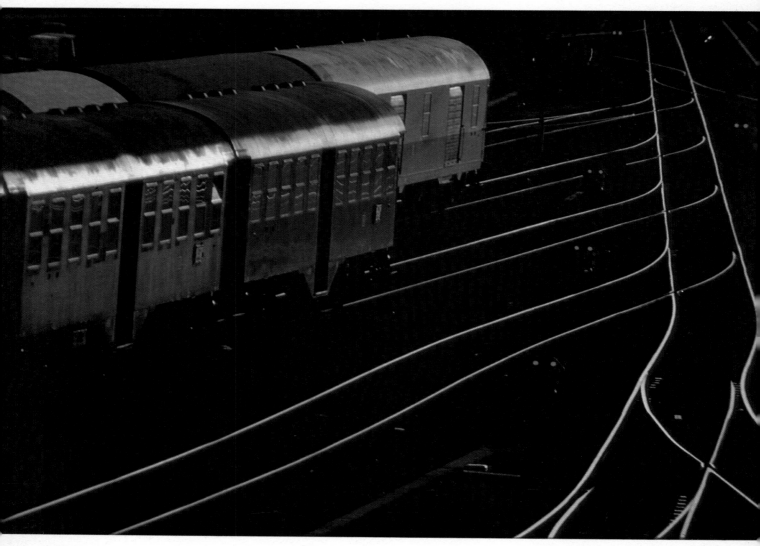

Gerd Steiber

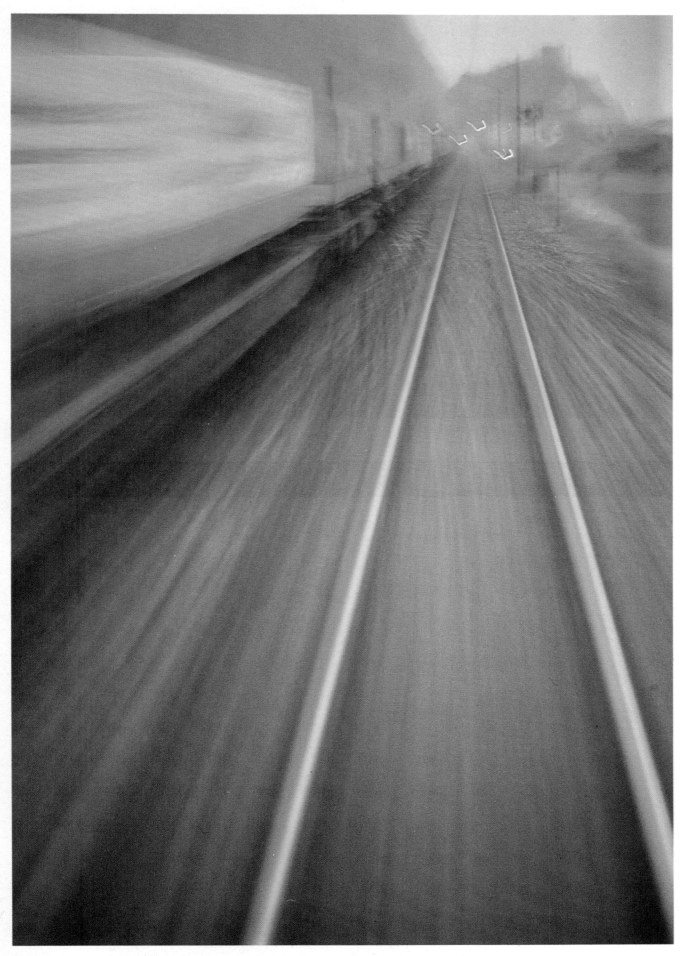

Peter Kniep

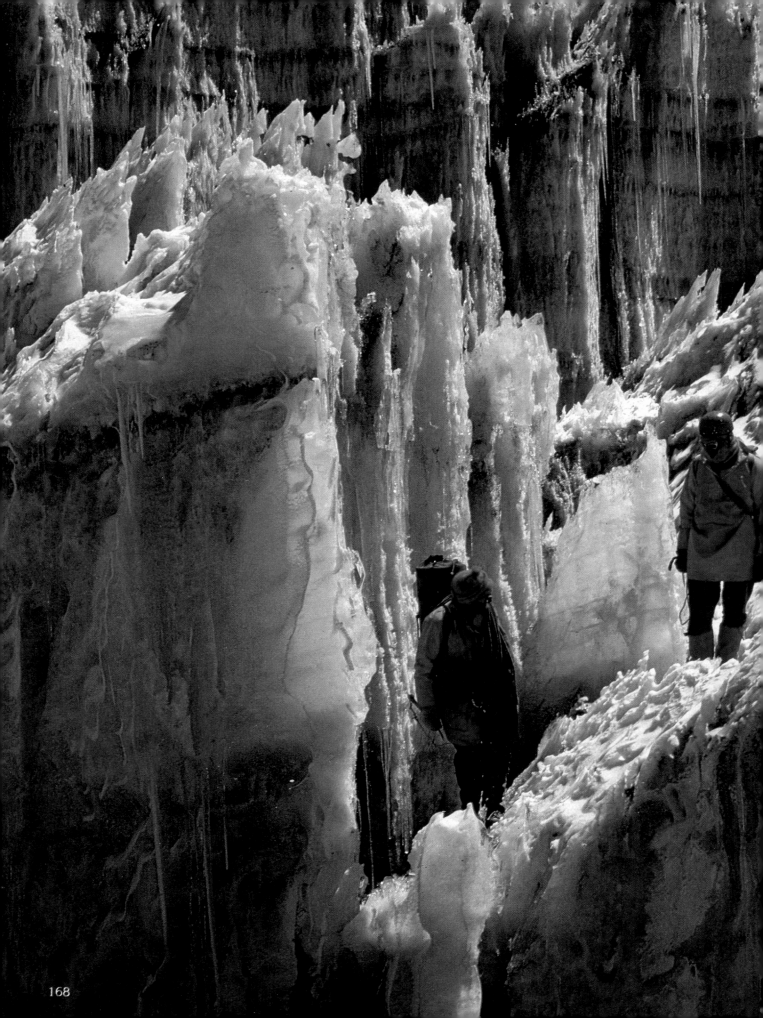

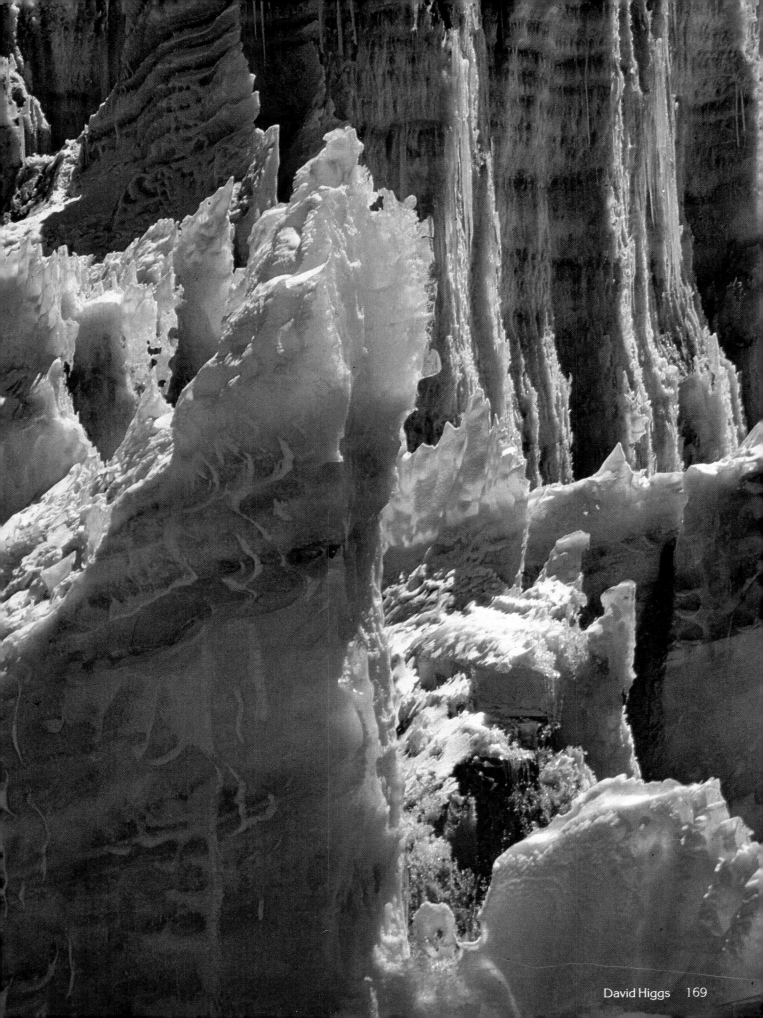

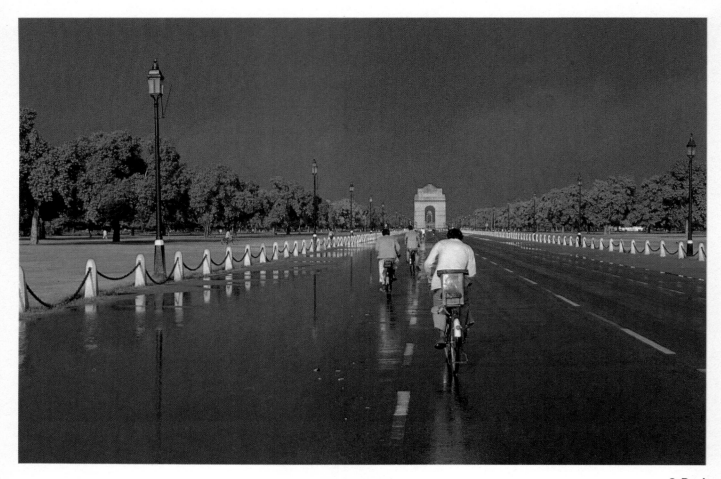

S. Paul

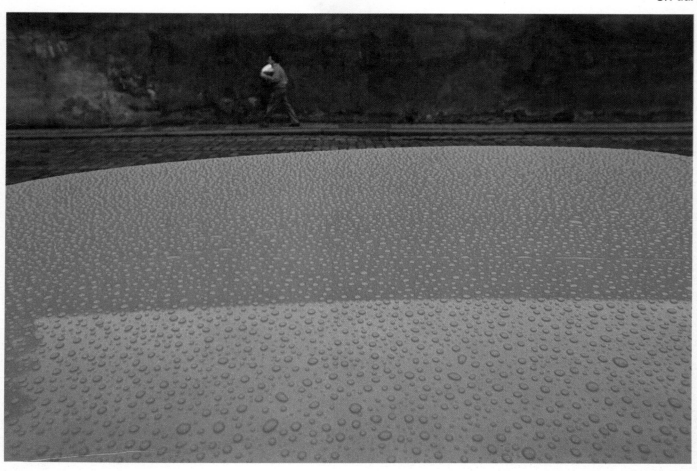

František Dostál

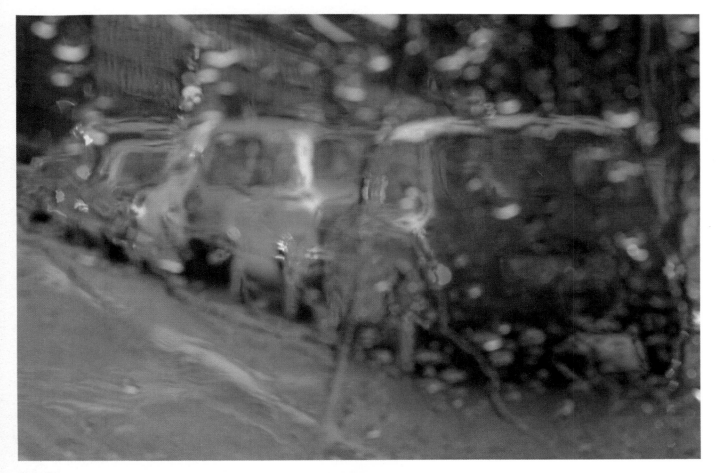

P. Jeffery

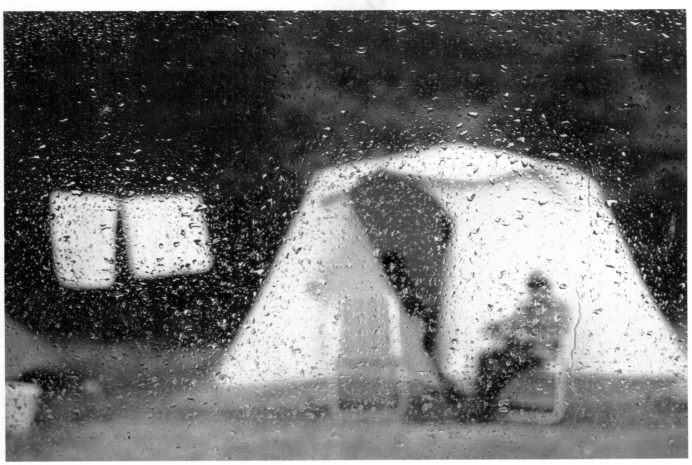

Bob Moore

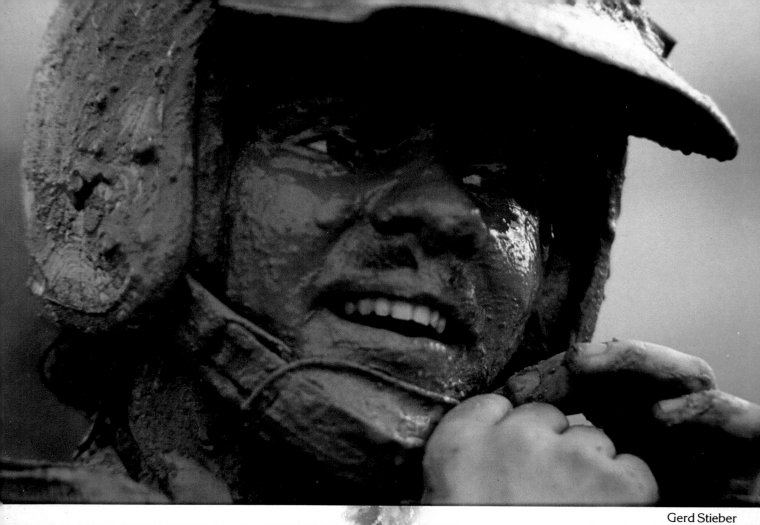

Gerd Stieber

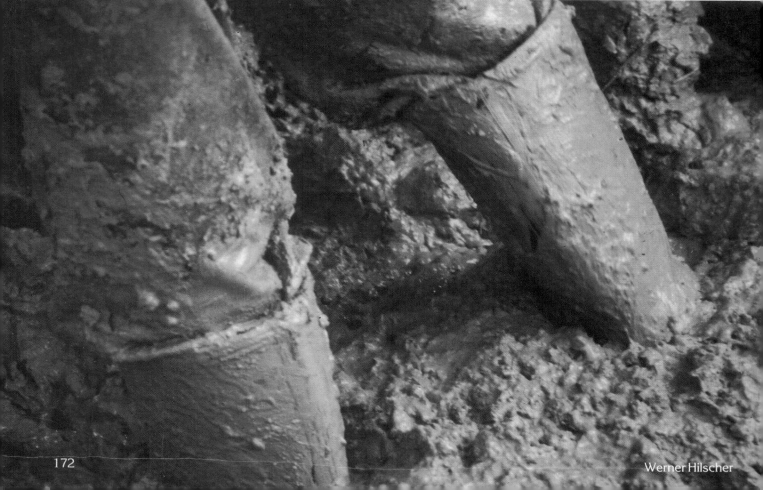

Werner Hilscher

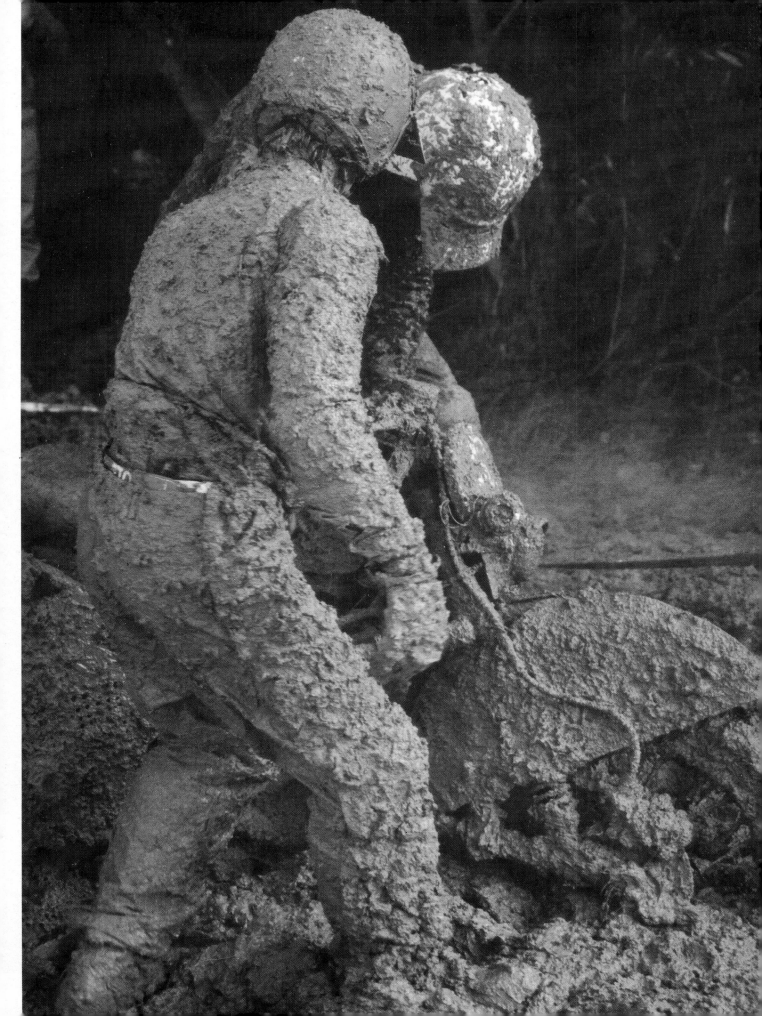

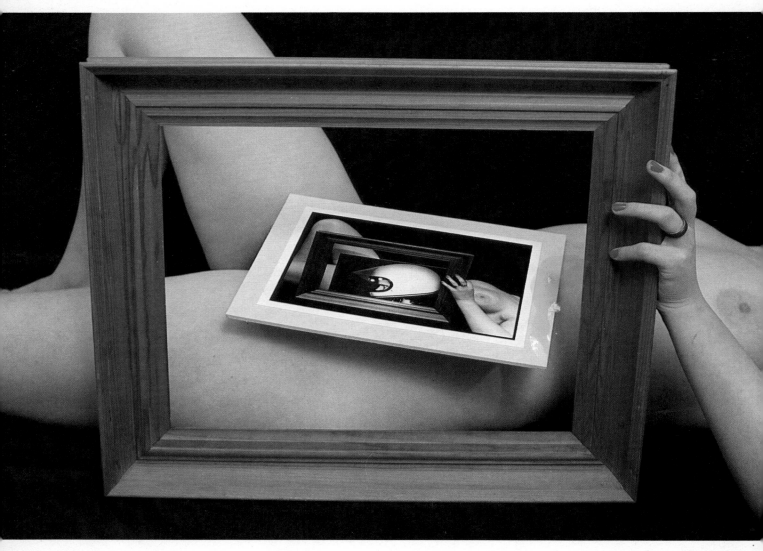

Ernand Pillegaard

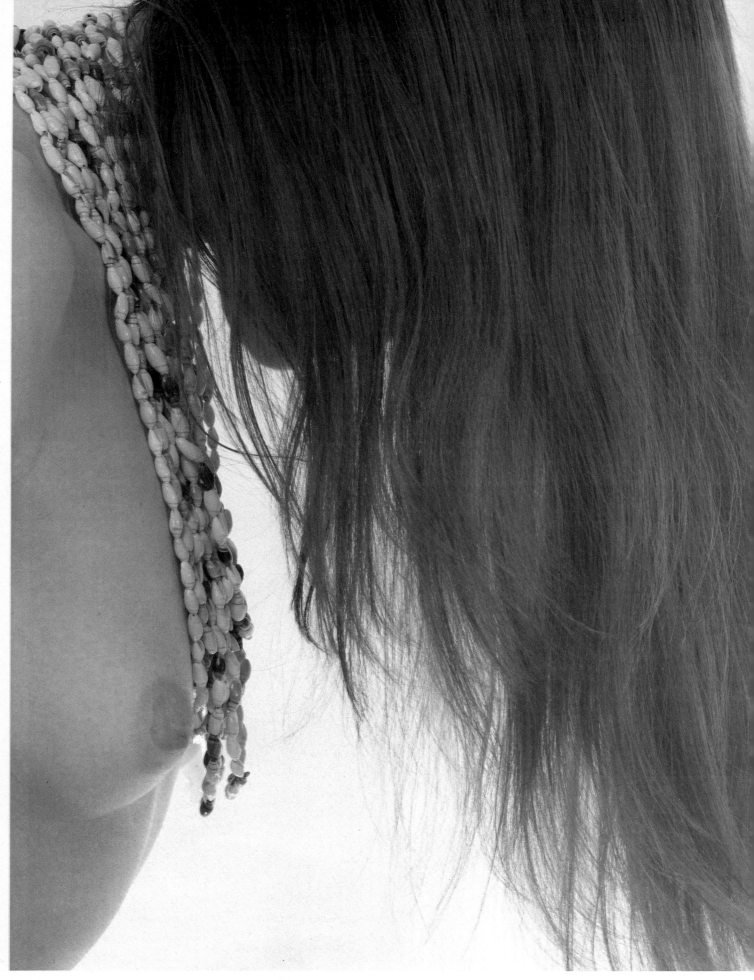

Bob Tanner

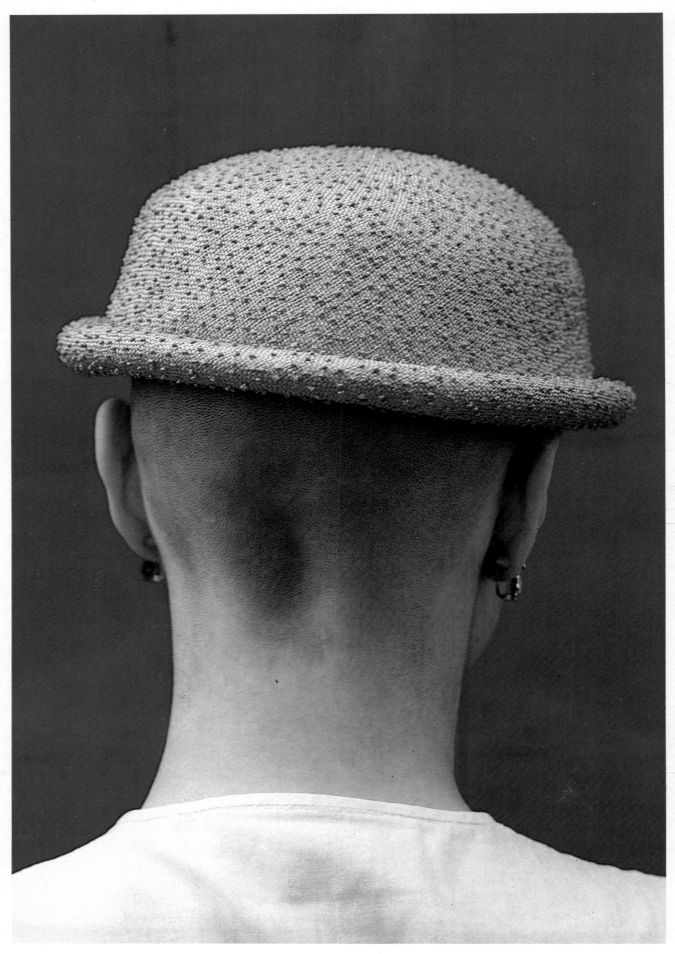

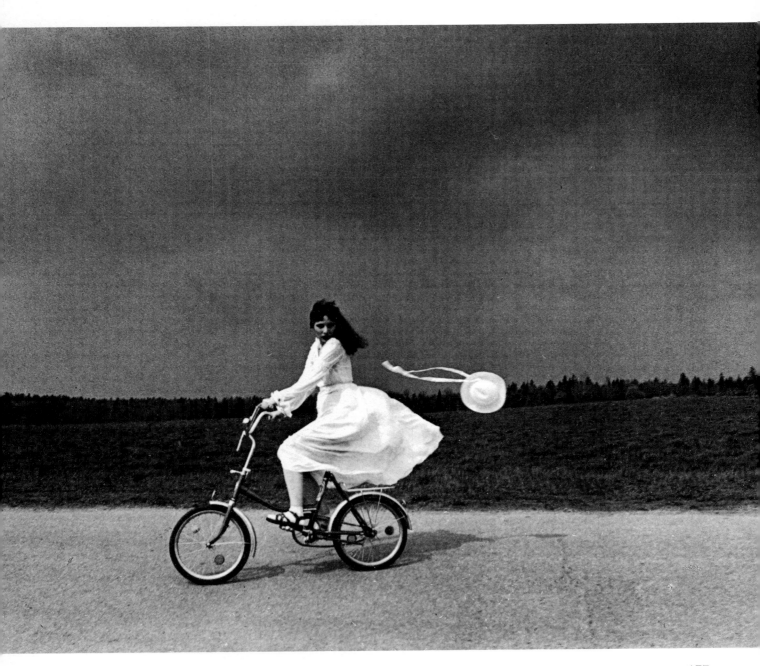

Romualdos Rakauskas

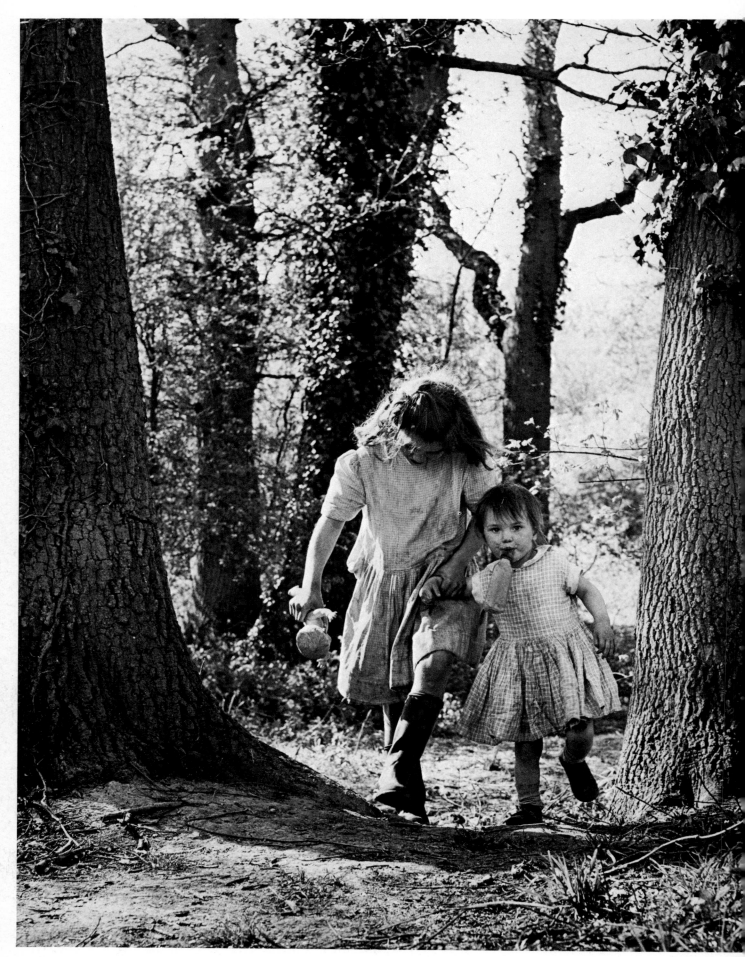

Tony Boxall

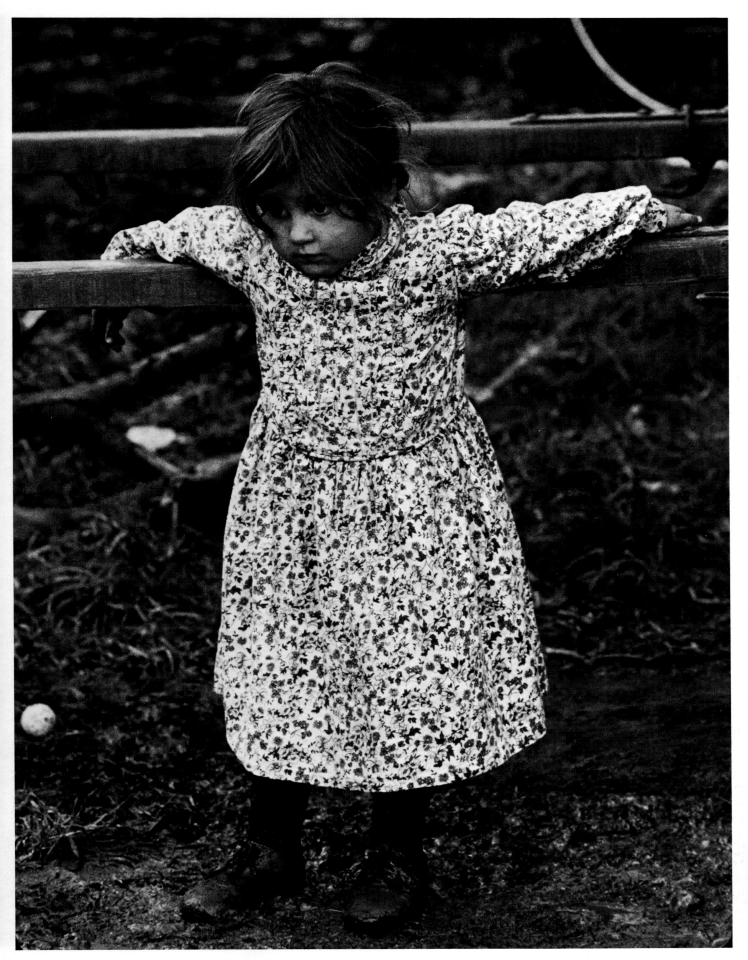

Neil Proctor

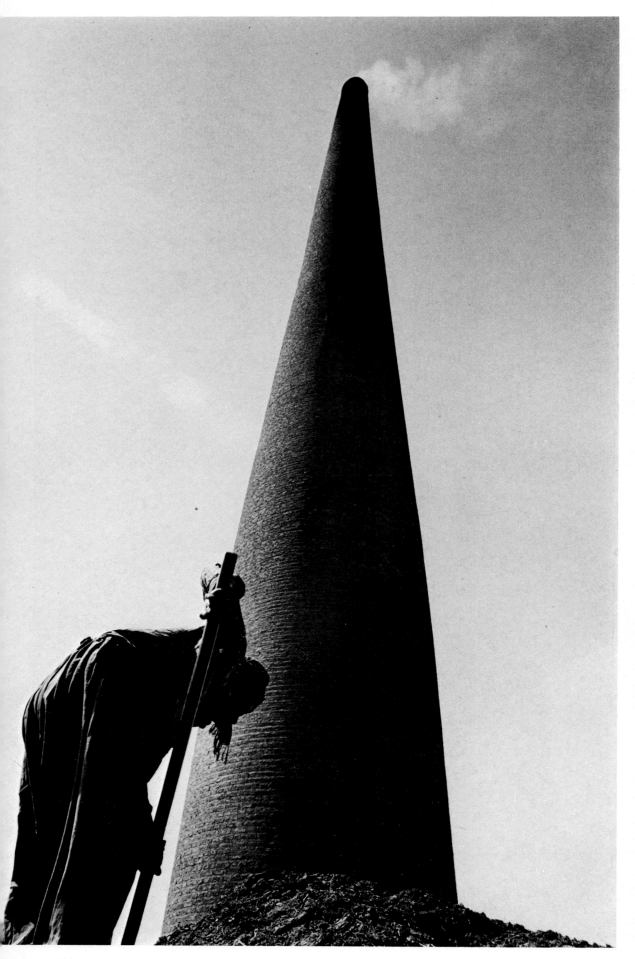

180 Afshin Shahroodi

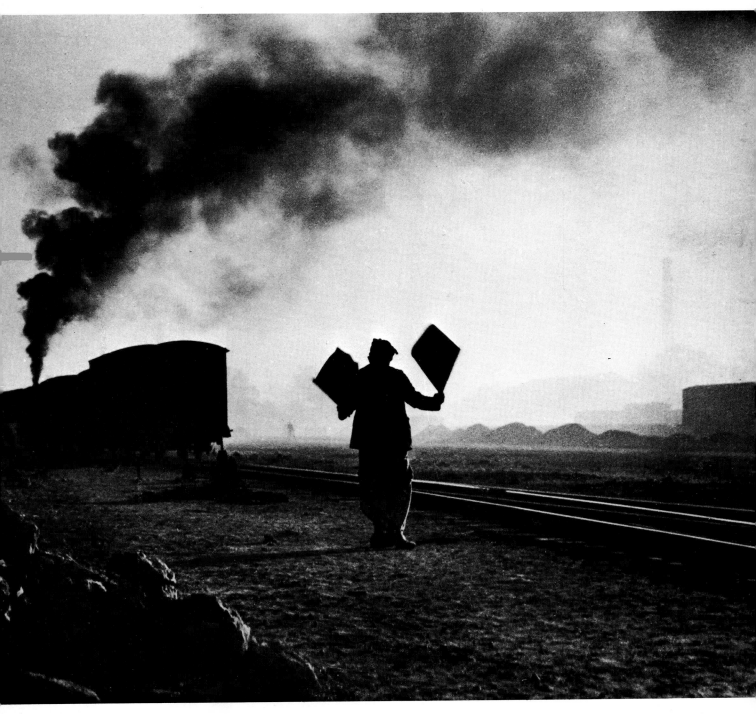

Datta Khopker

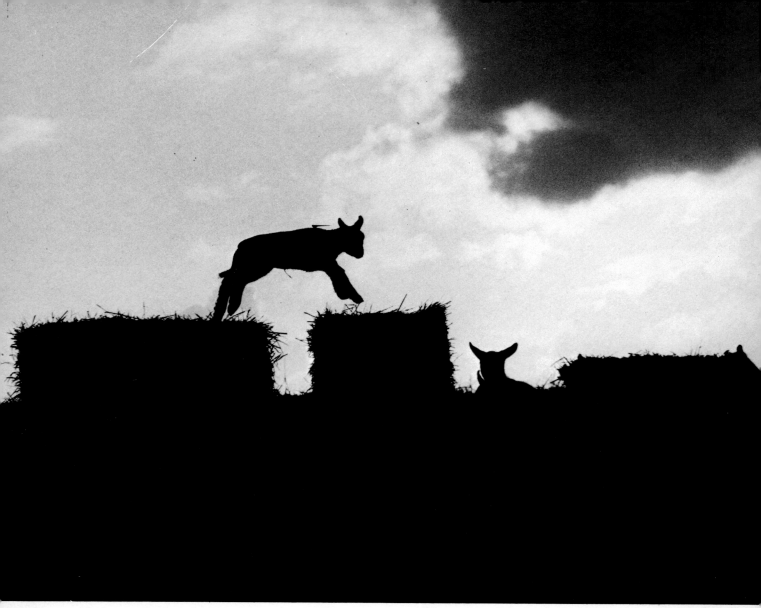

Jane Miller

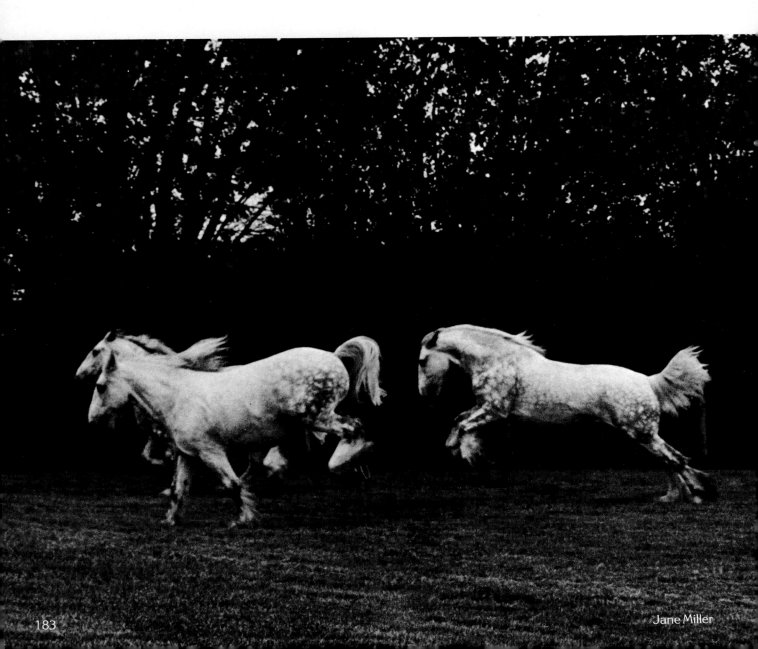

183 Jane Miller

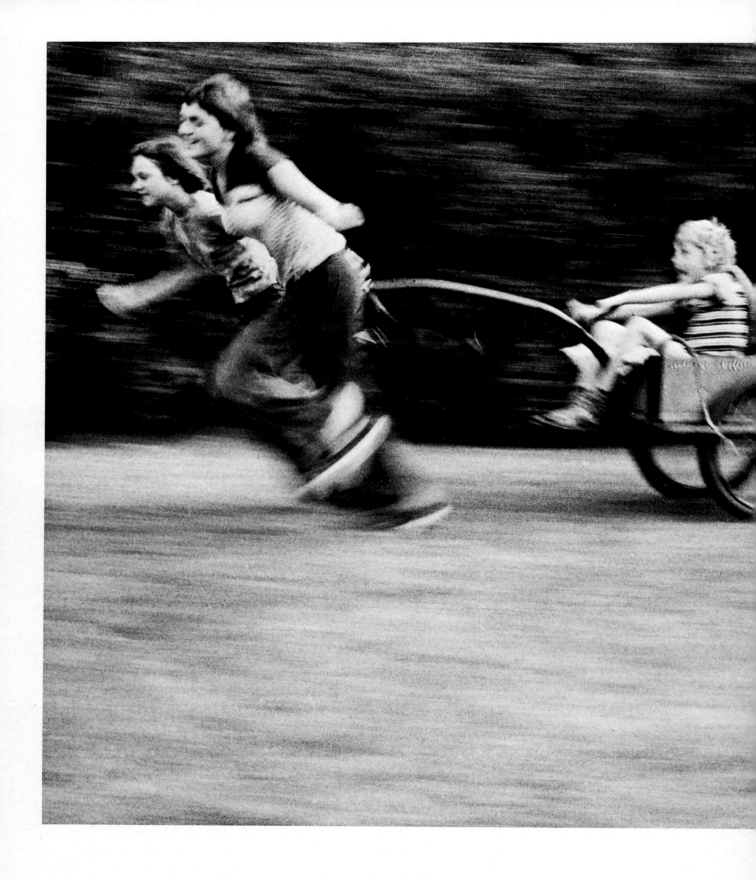

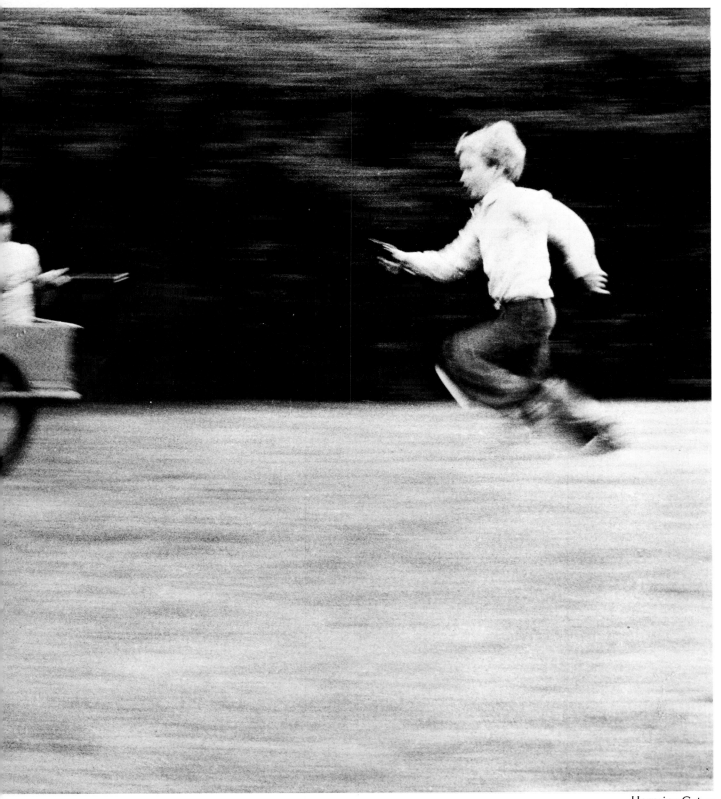

Hermine Gsteu

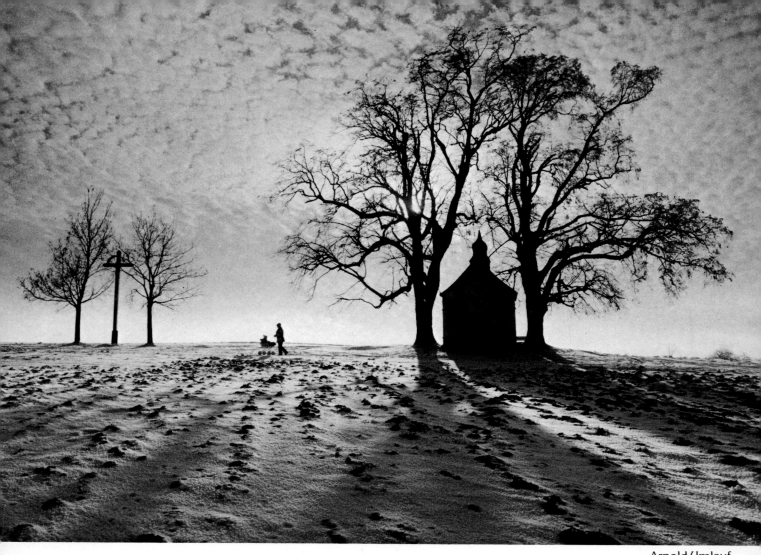

Arnold Umlauf

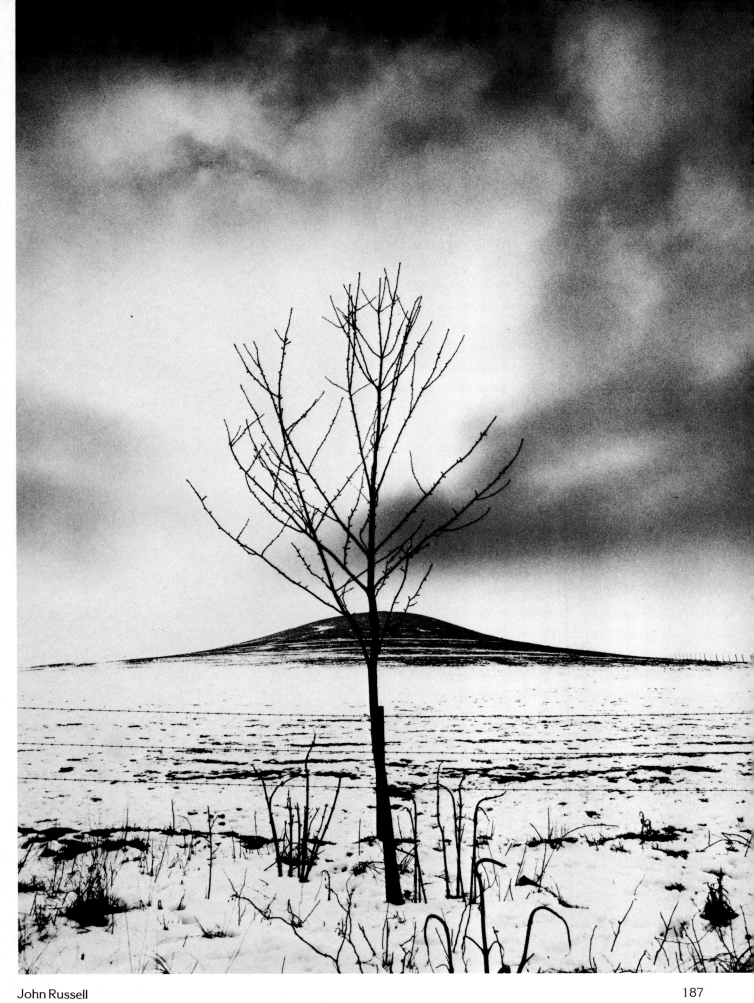

John Russell

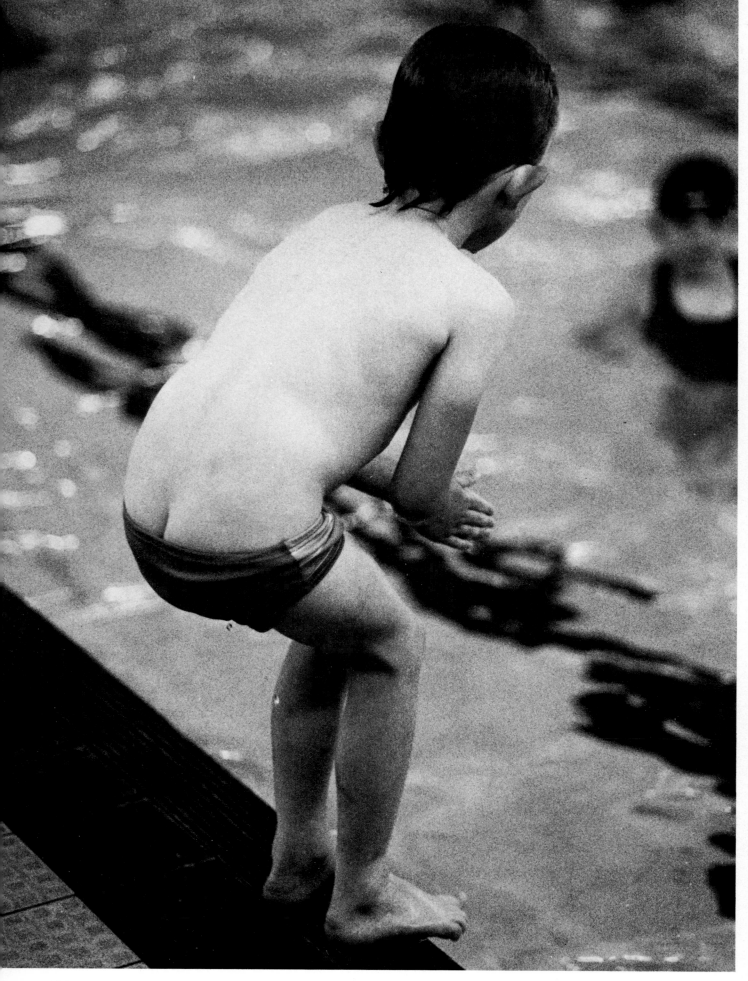

Ian Rodger

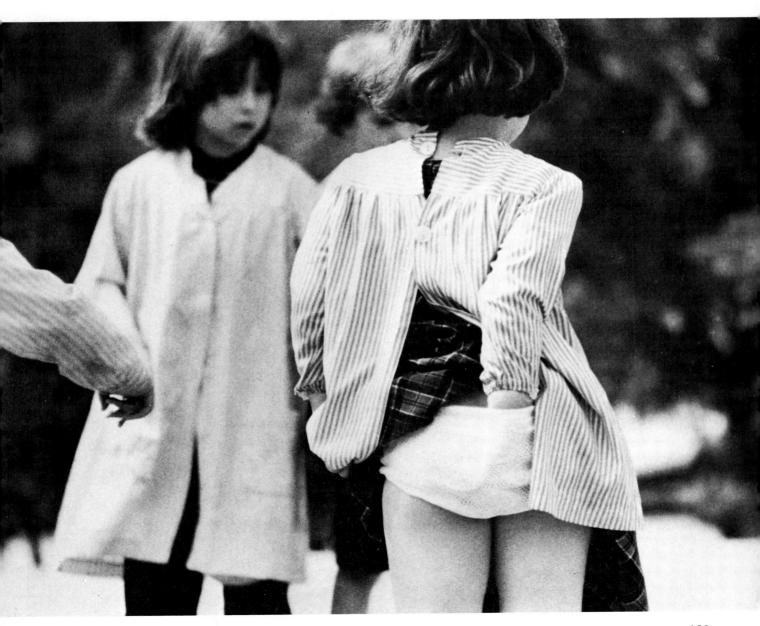

Alexandra Bors-Costide

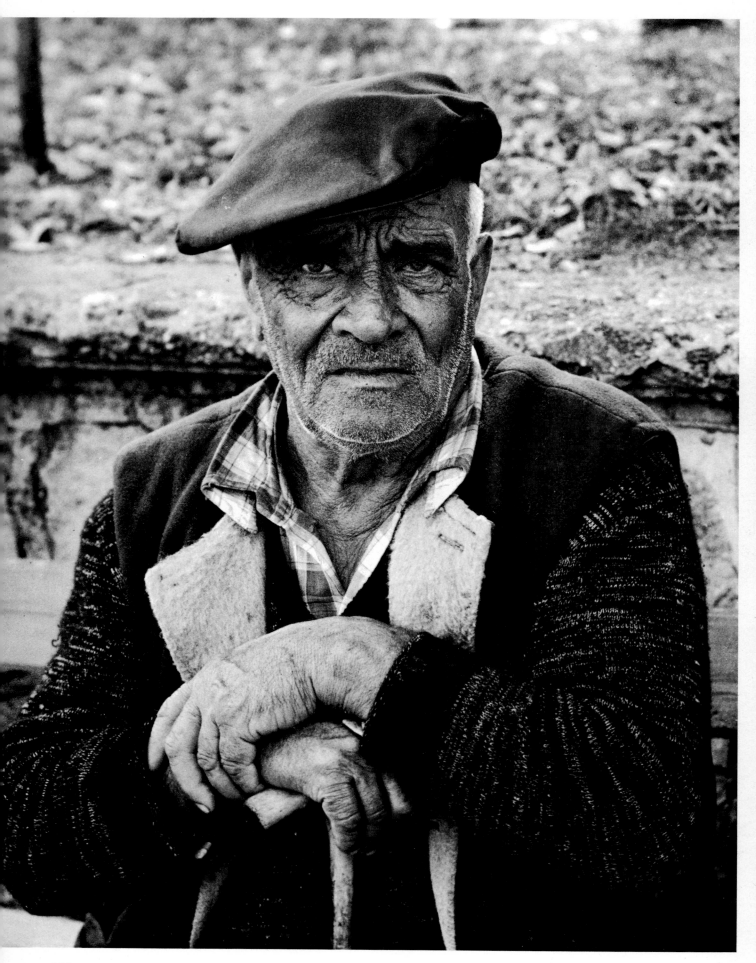

A. Sutkus

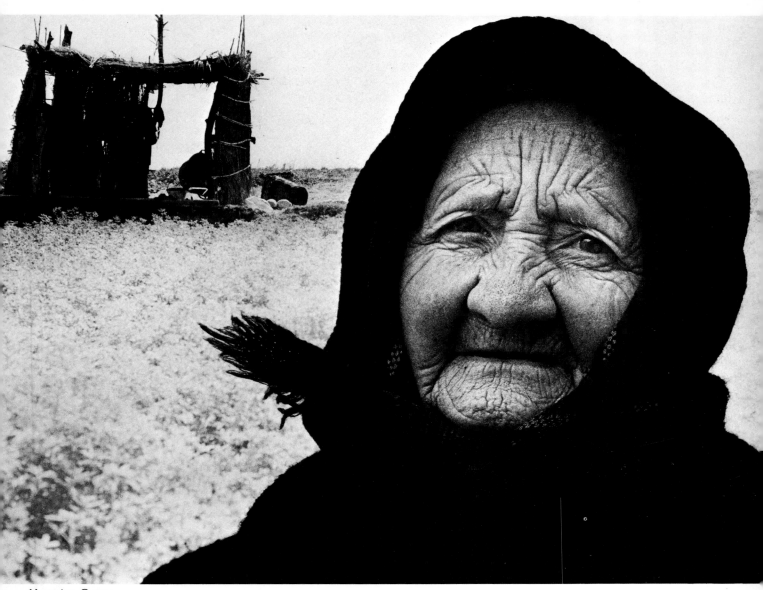

Hermine Gsteu

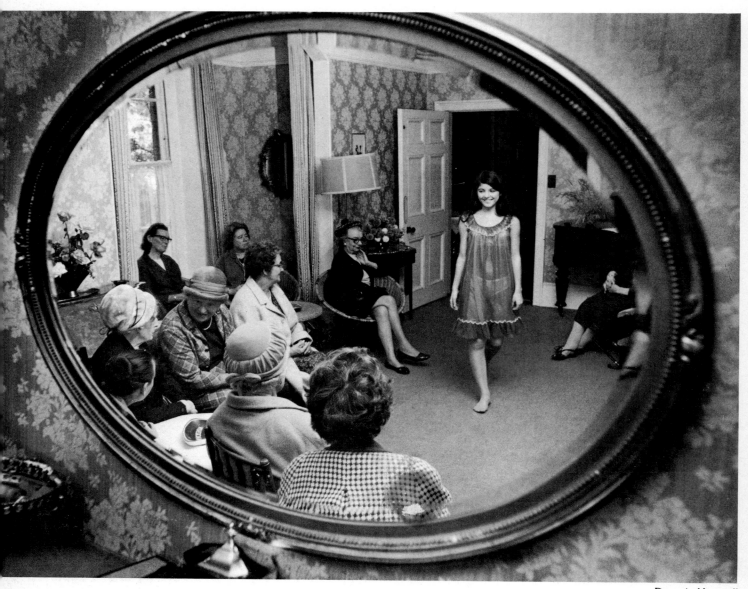

Dennis Mansell

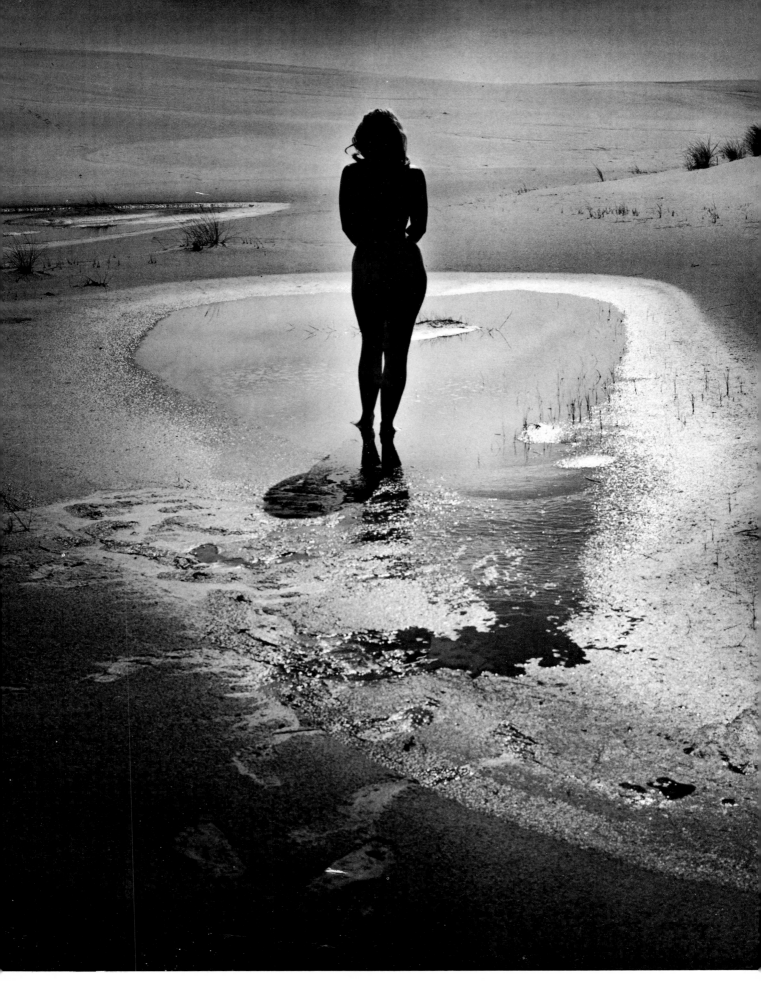

Andrzes Krynicki

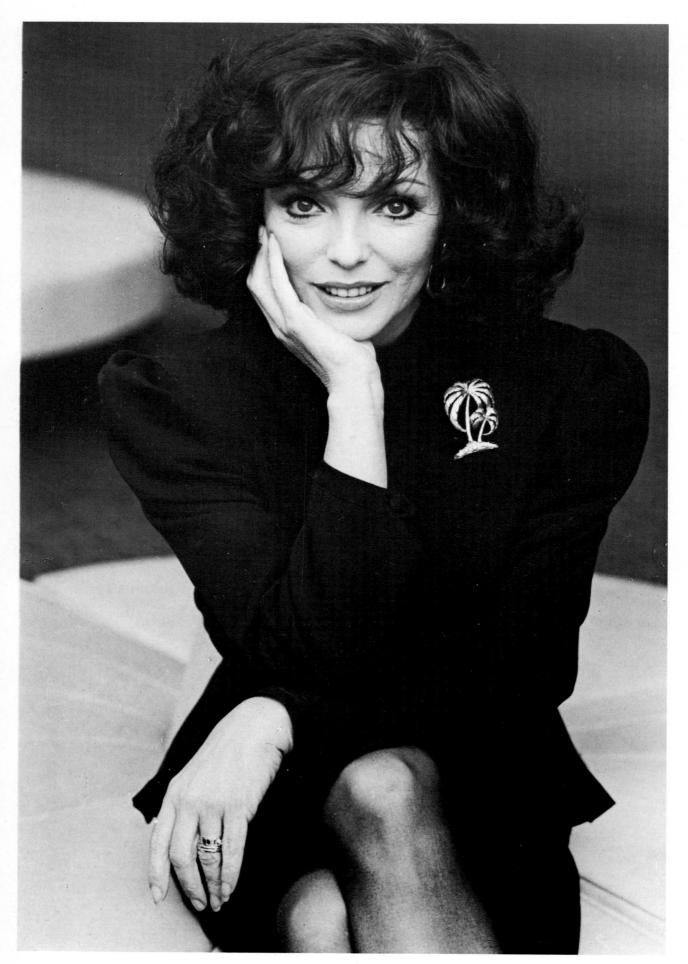

194 Eddie Brown

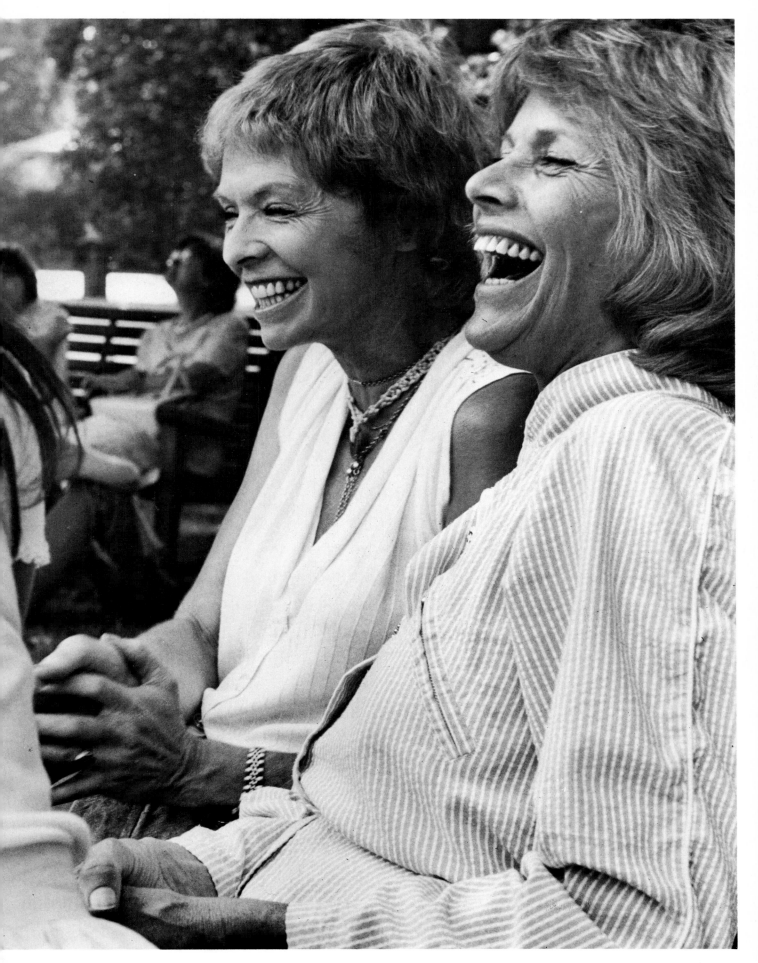

Bill Cross

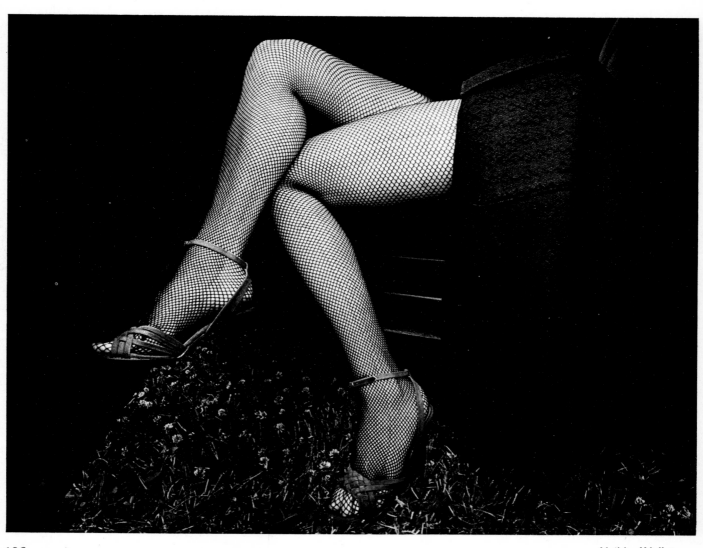

Veikko Wallstrom

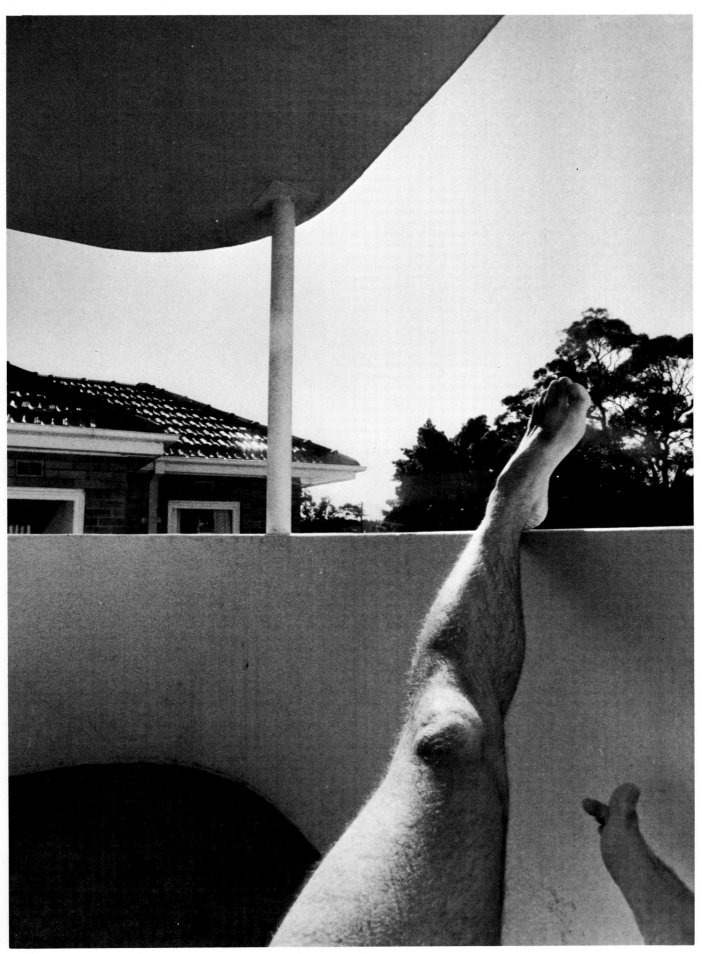

Graham Monro

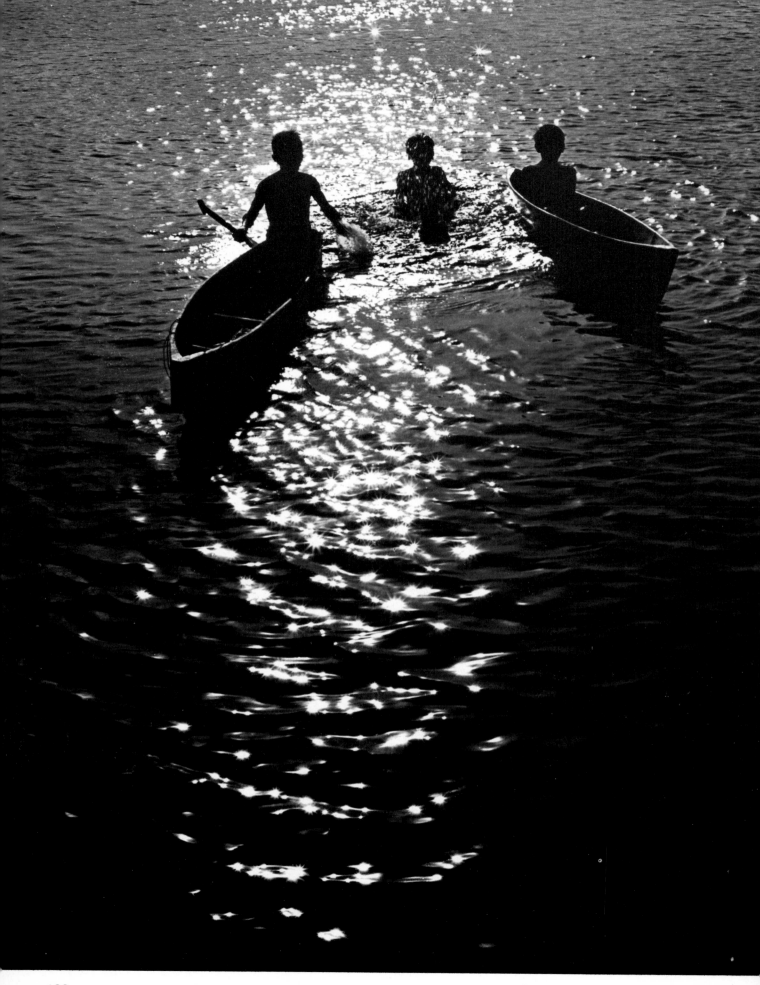

Kok-Pheng Liew

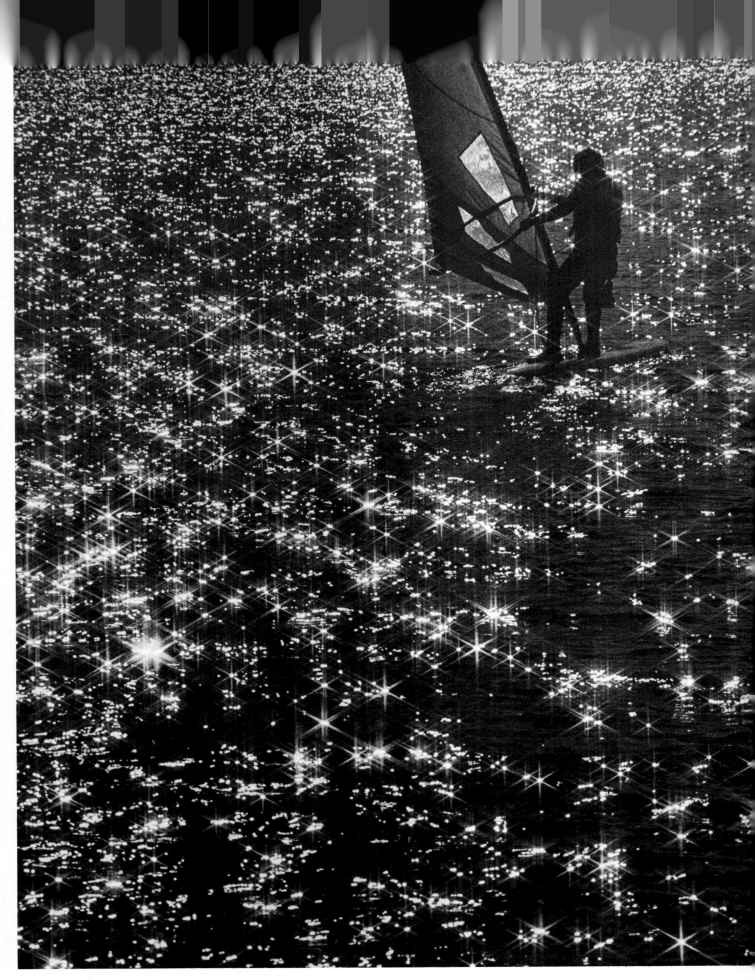

Eddie Brown

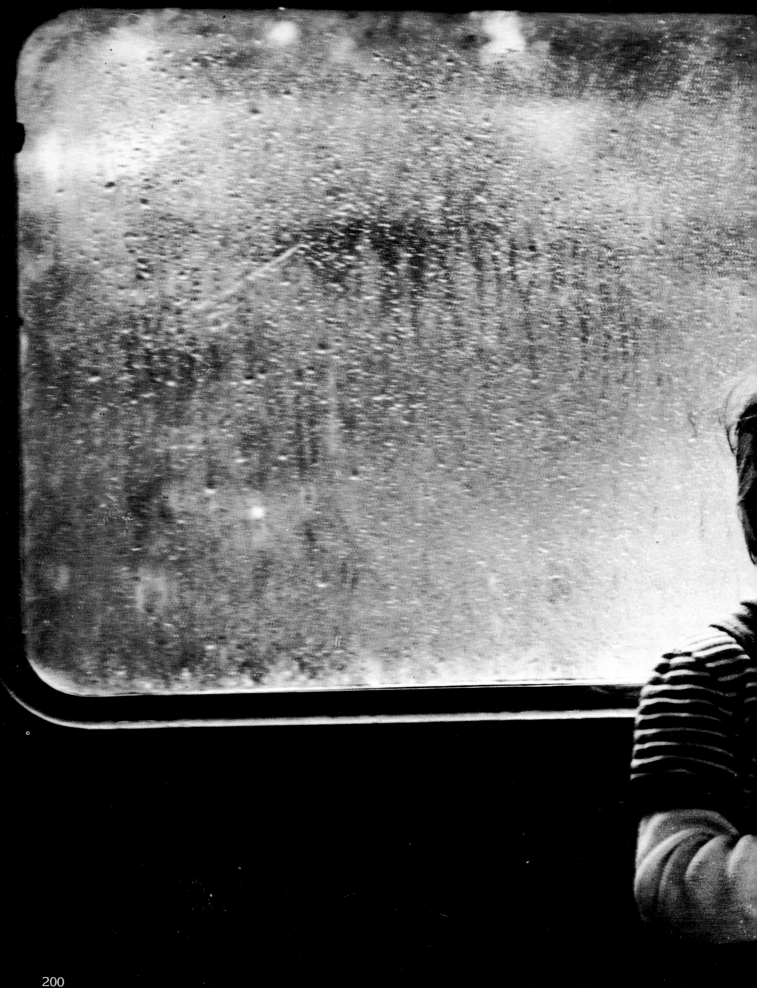

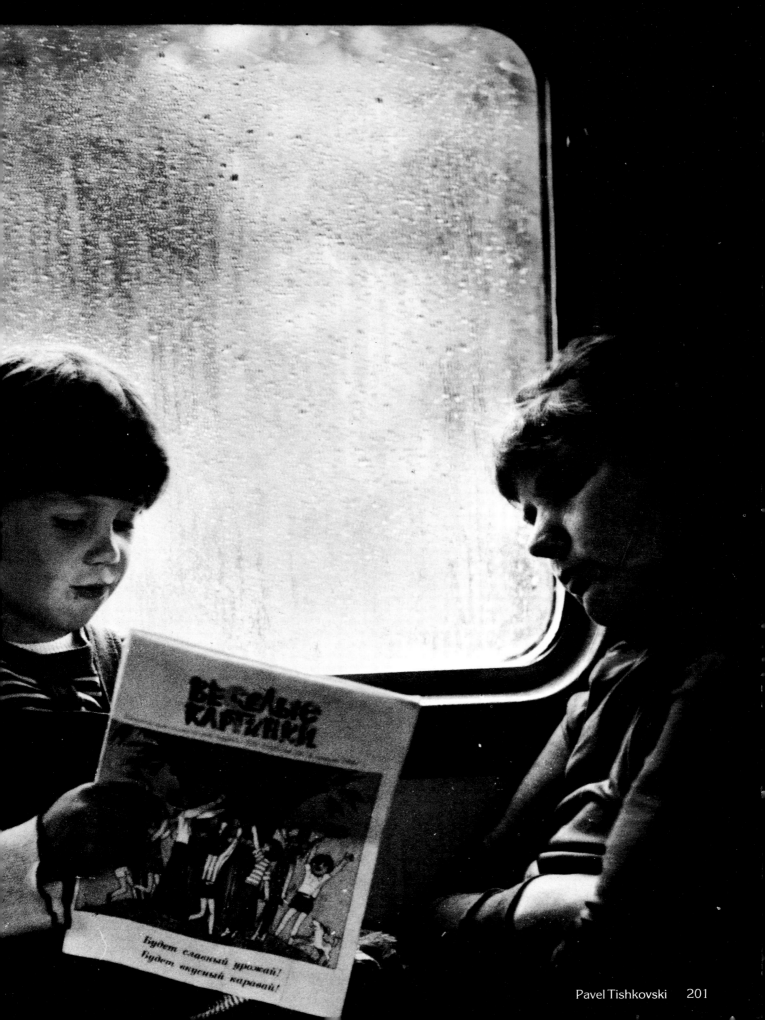

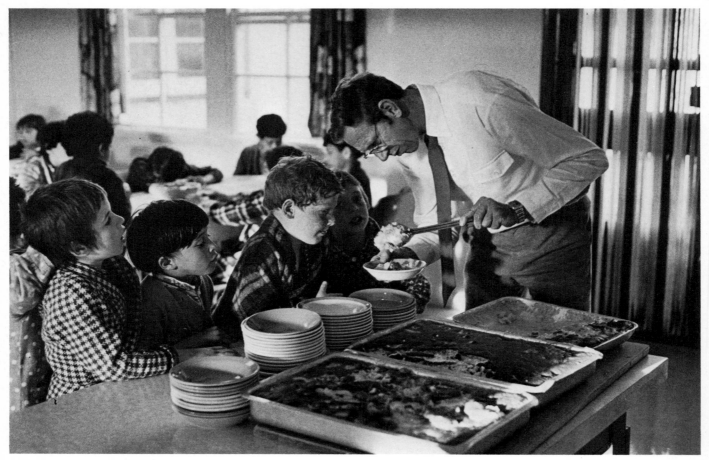

Terry O'Connor

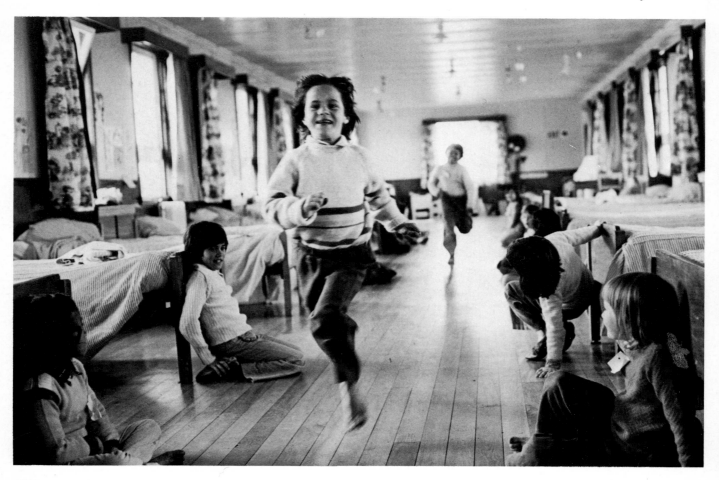

Terry O'Connor

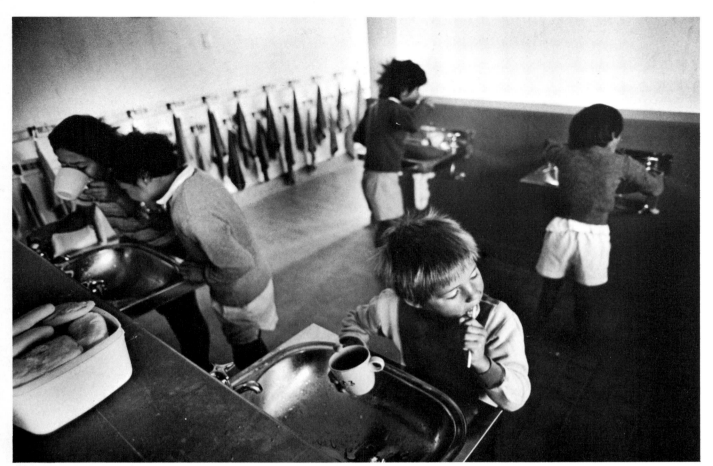

Terry O'Connor

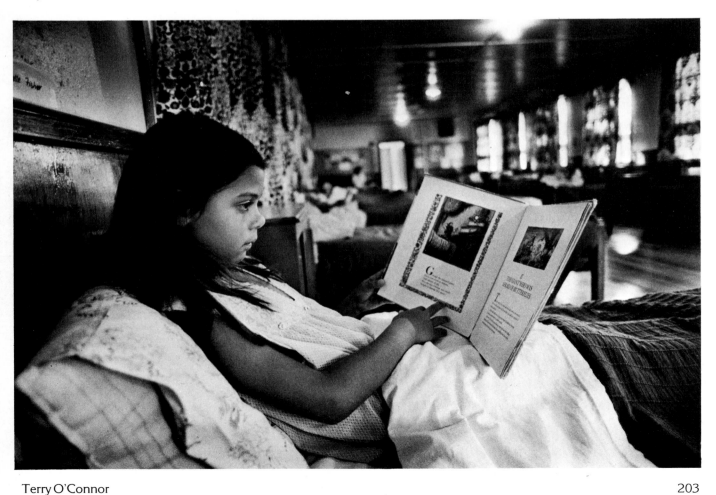

Terry O'Connor

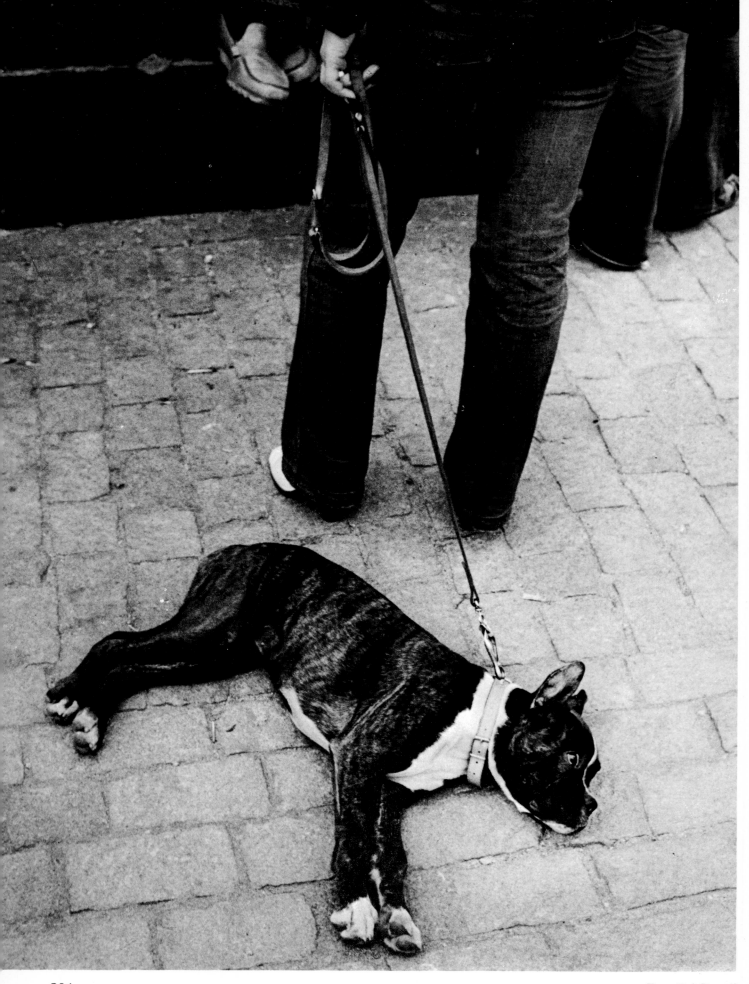

František Dostál

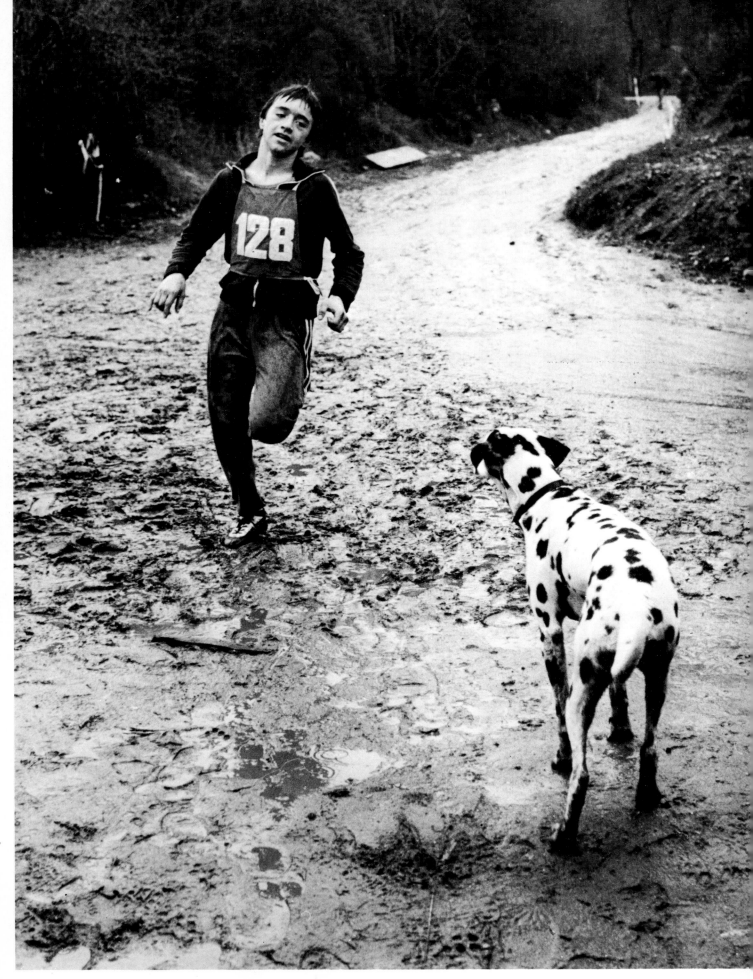

František Dostál

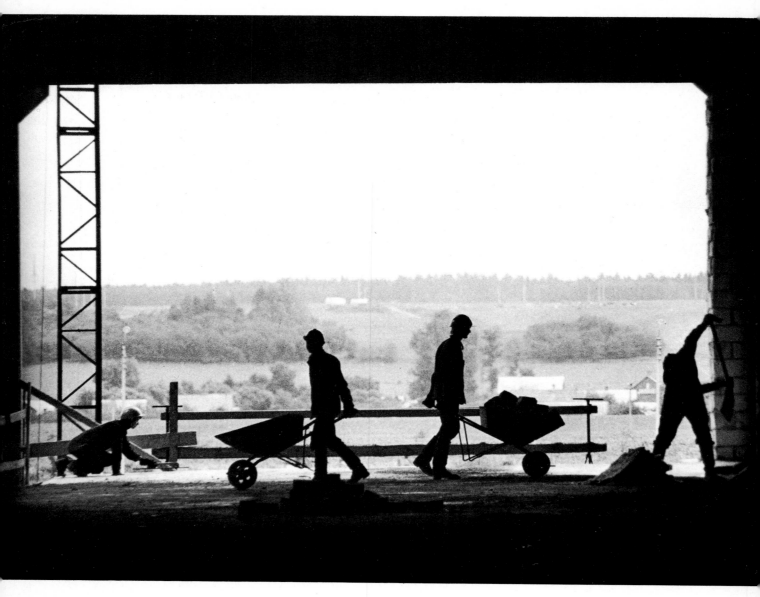

A. Žižiunas

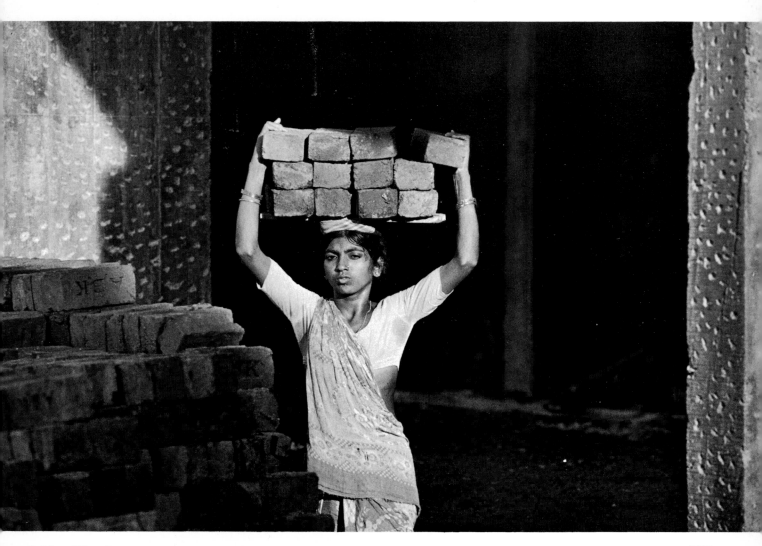

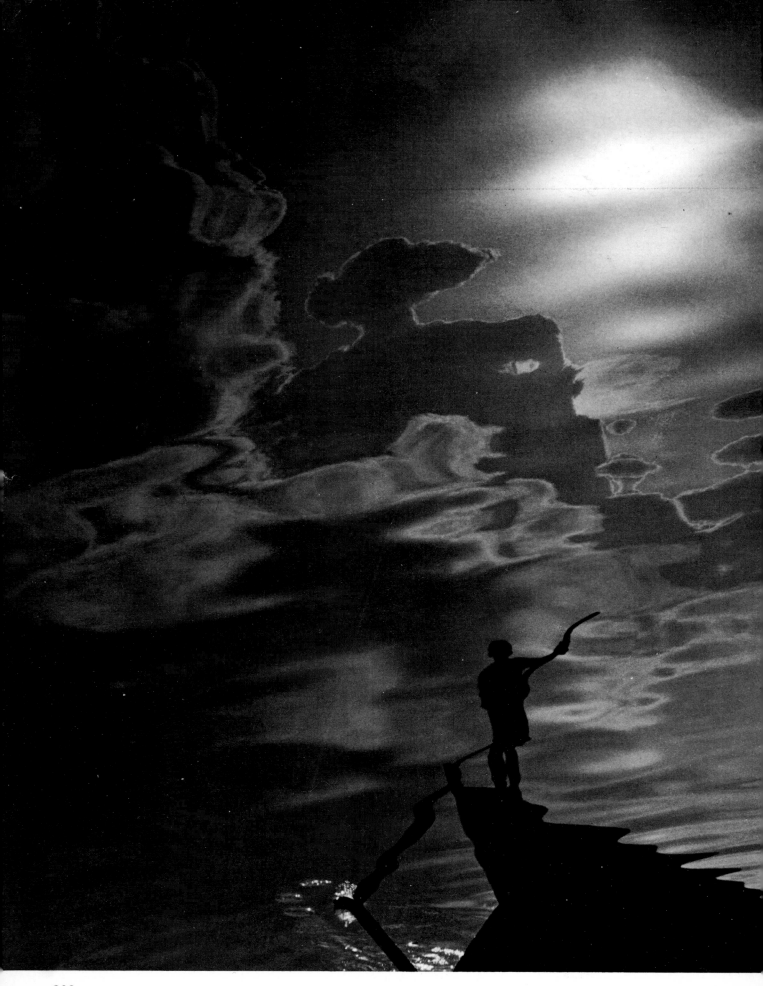

H.K. Heng

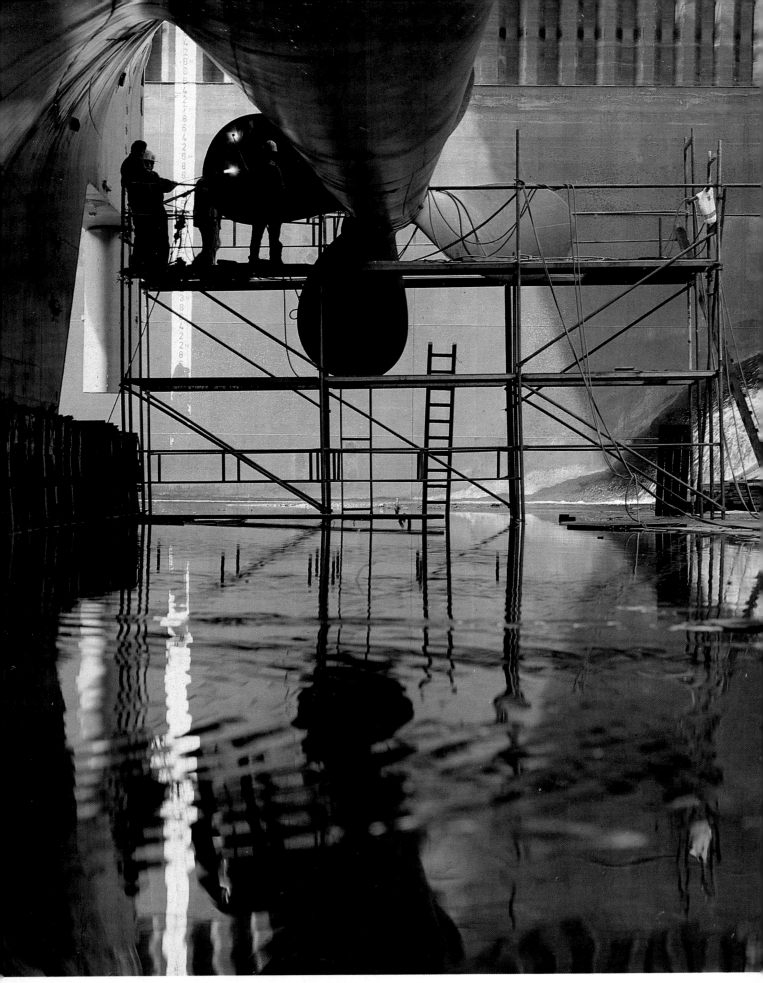

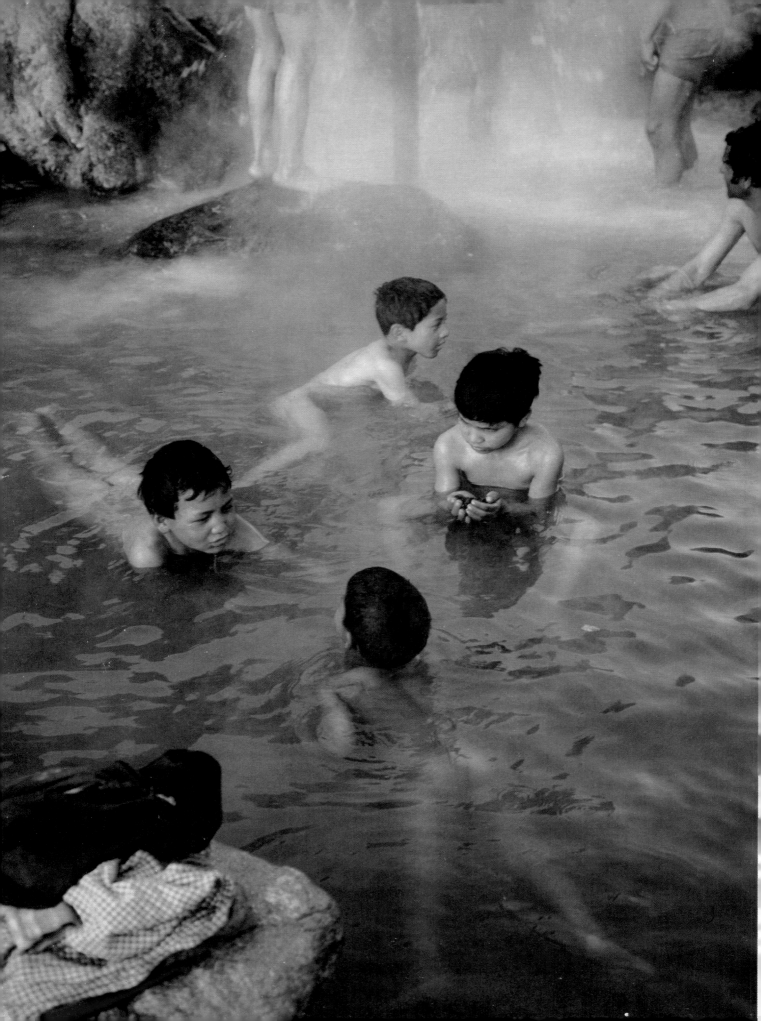

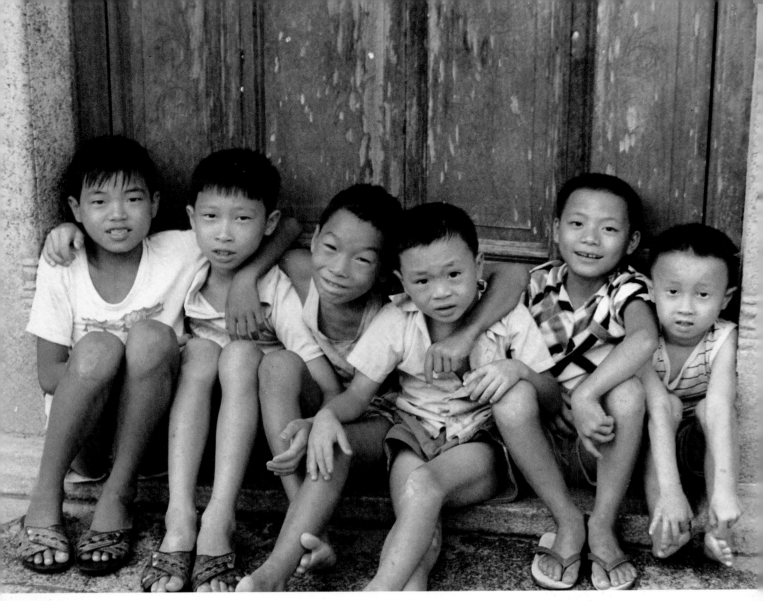

Steve Moger

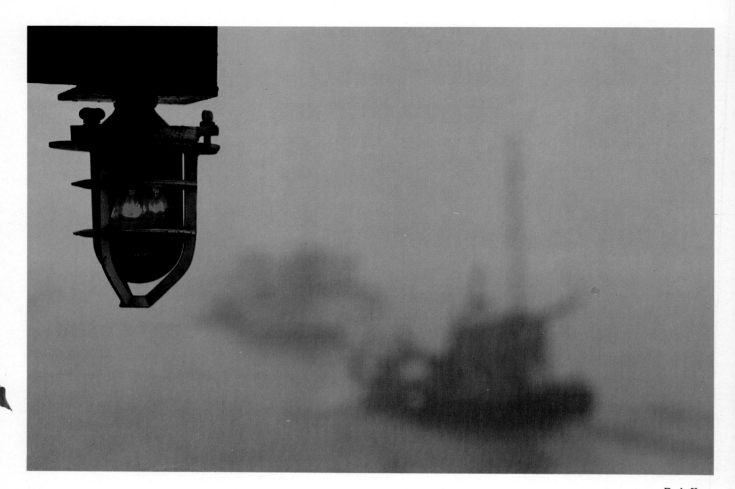

P. Jeffery

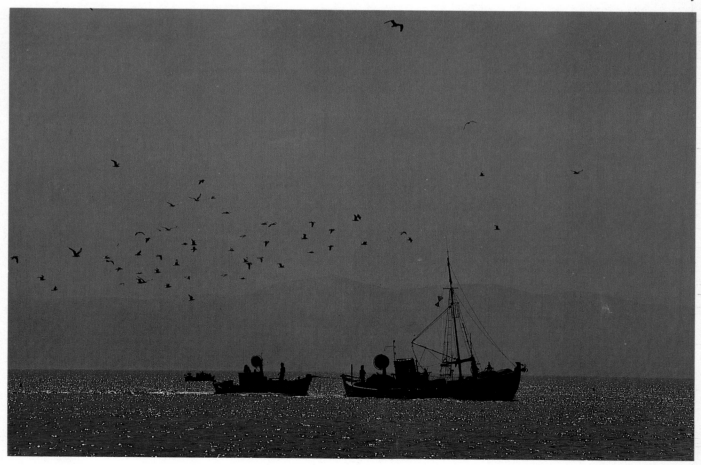

Dorina Stathopoulou

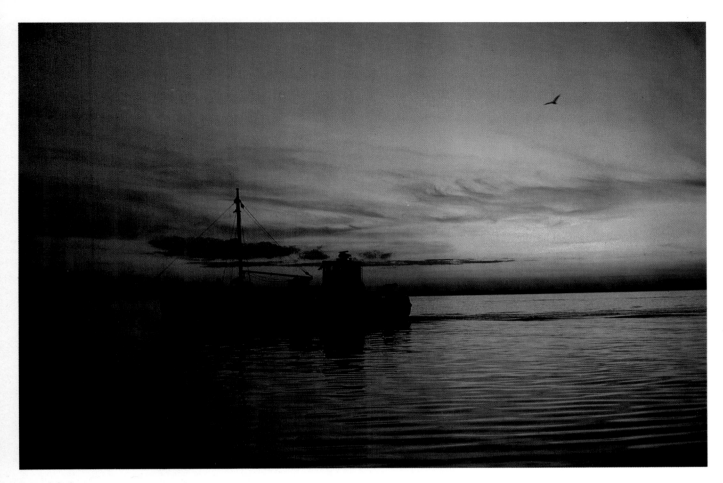

David Galavan

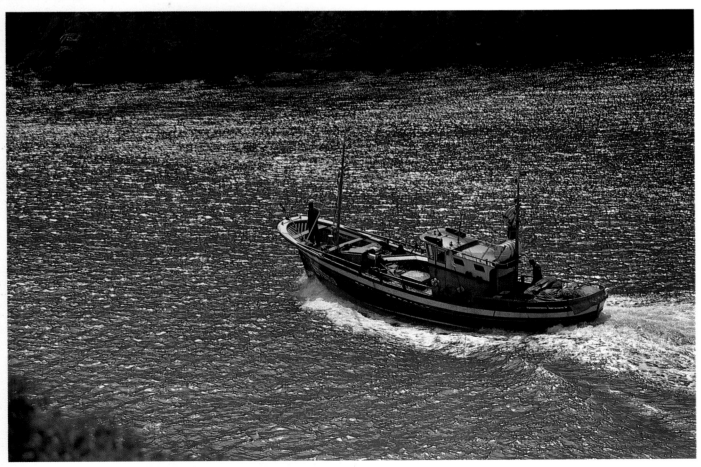

Ray Hoey

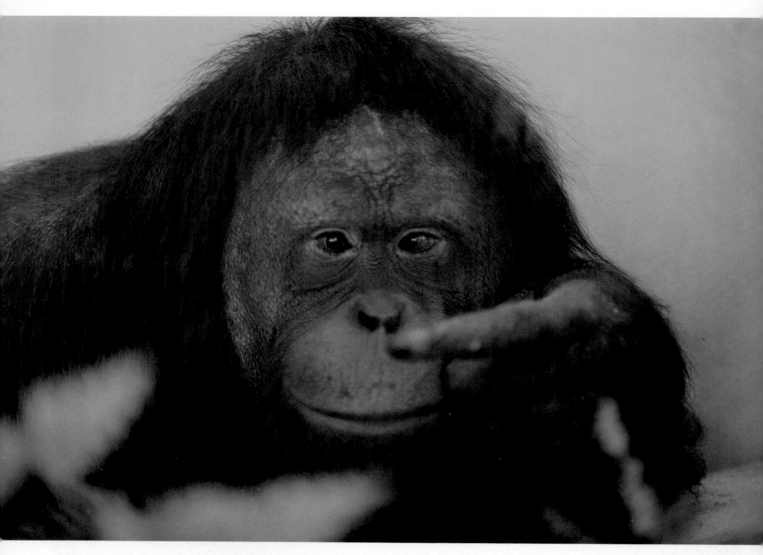

Ron Davies

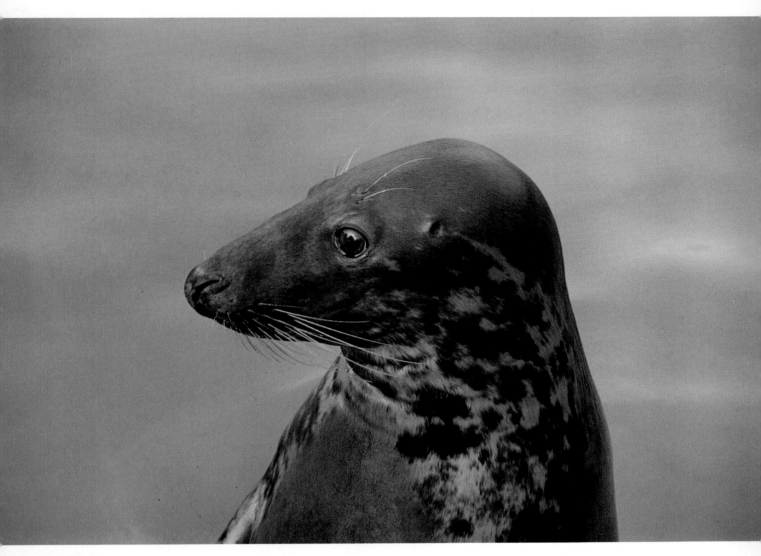

Philip Tampin

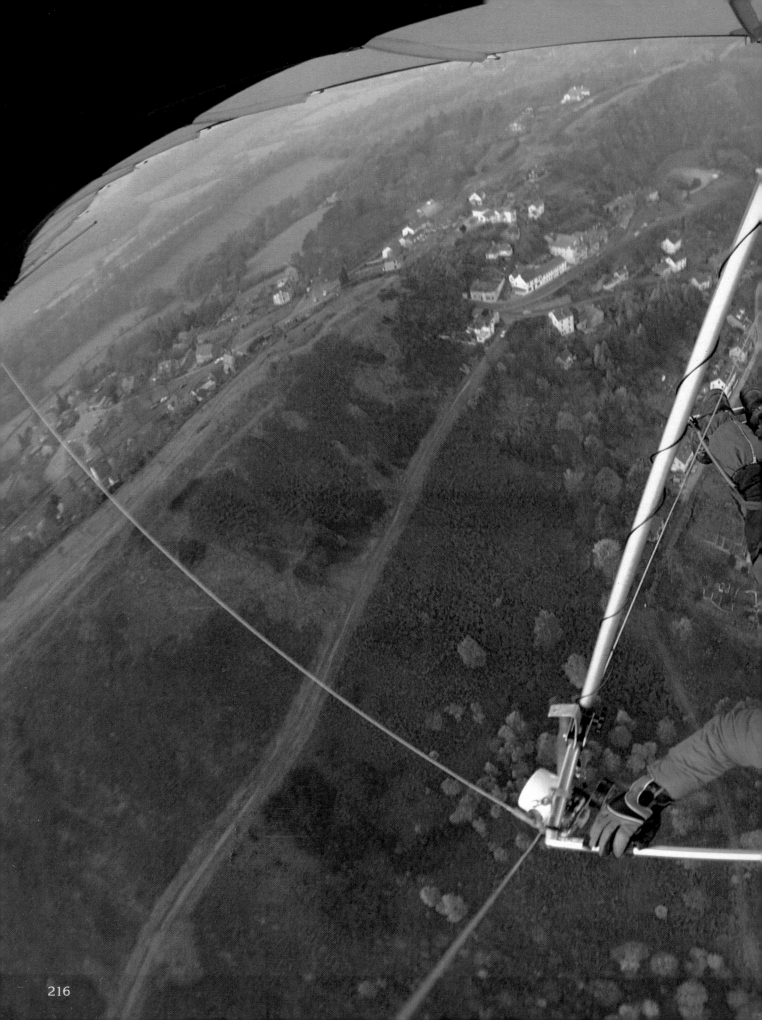

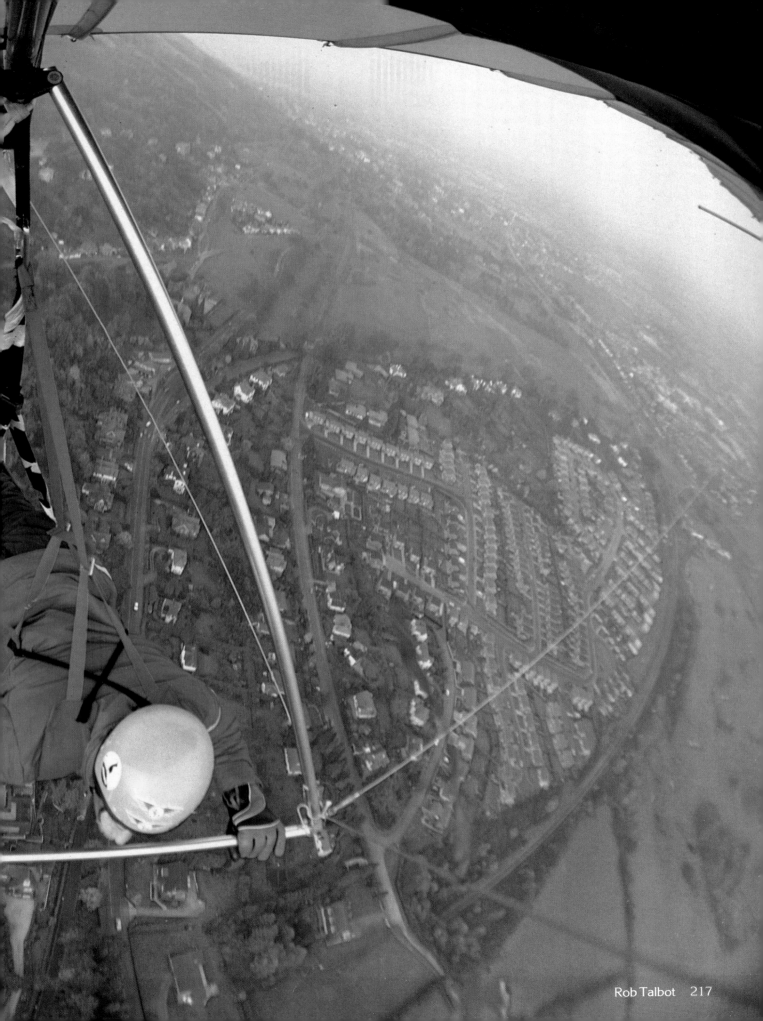

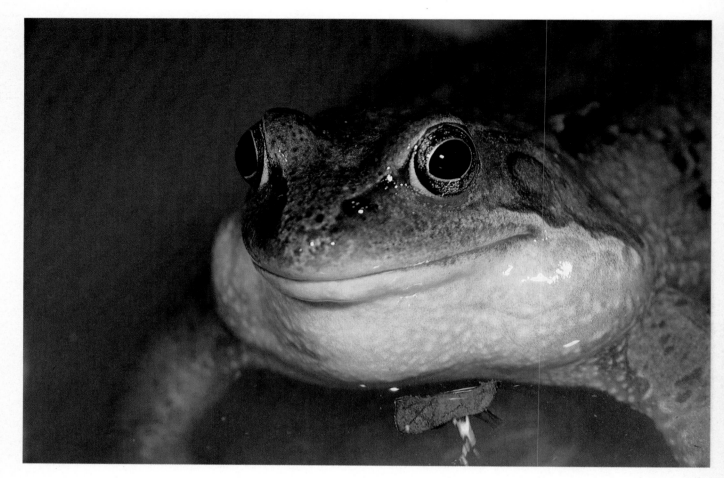

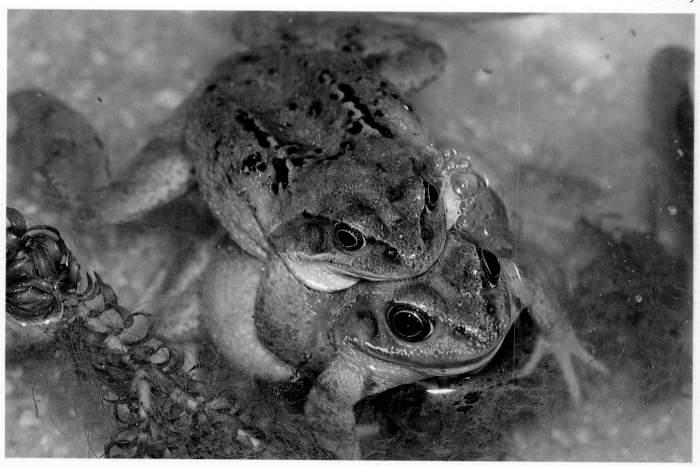

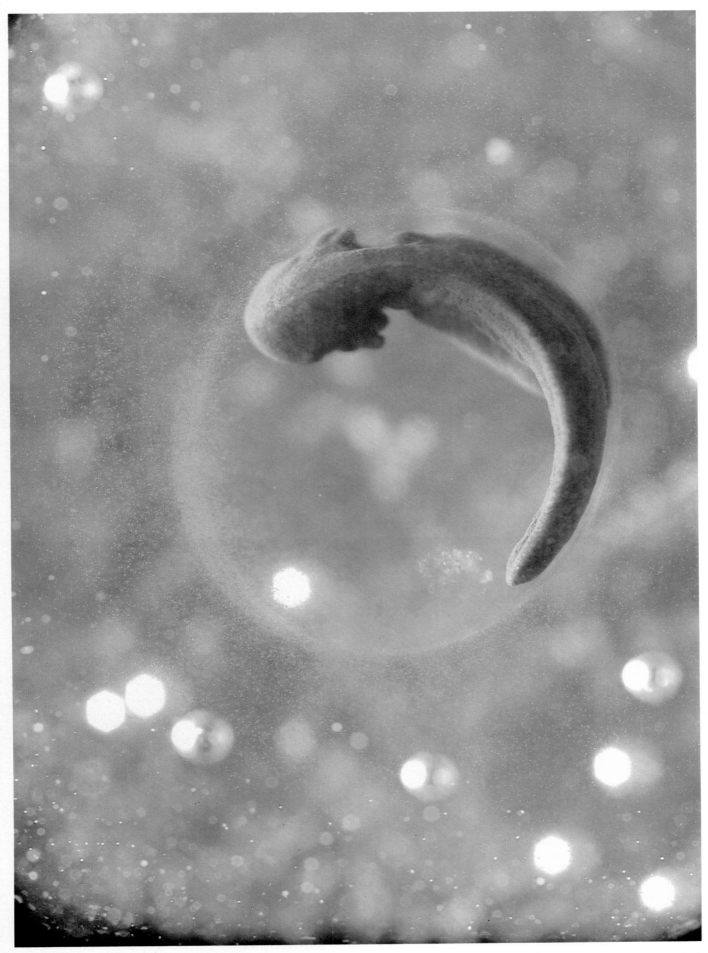

Pat Clay

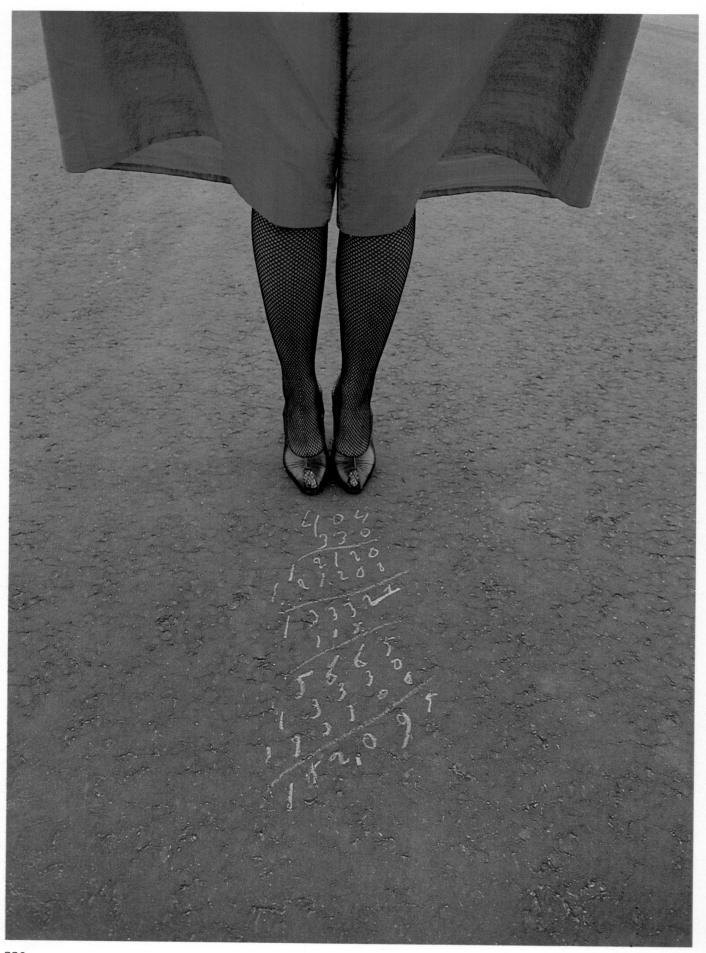

Frank Peeters

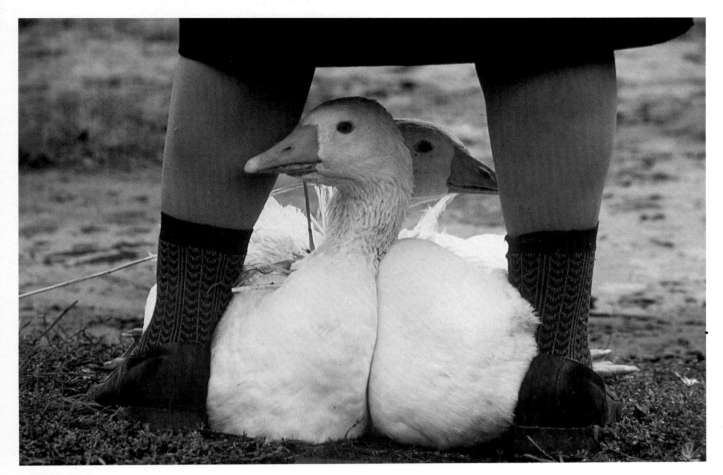

Andrzej Sawa

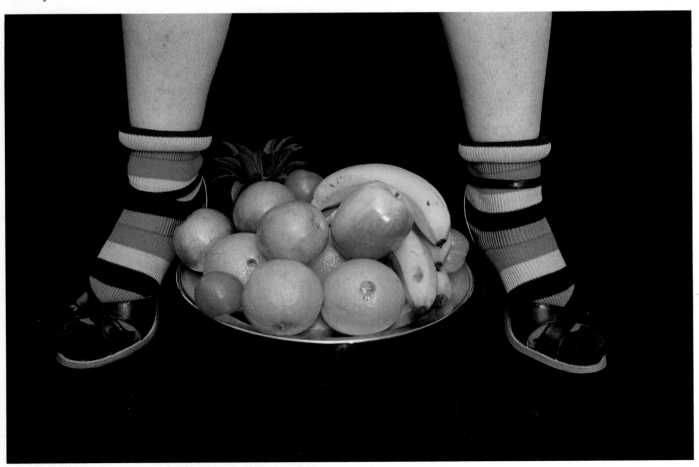

Erland Pillegaard

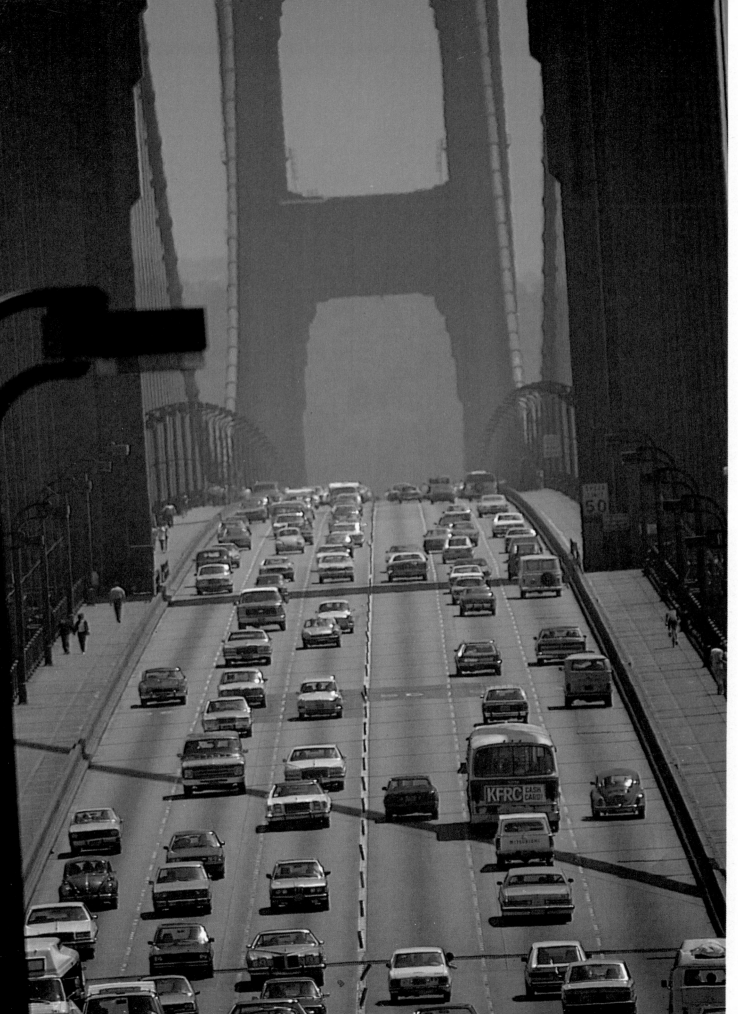

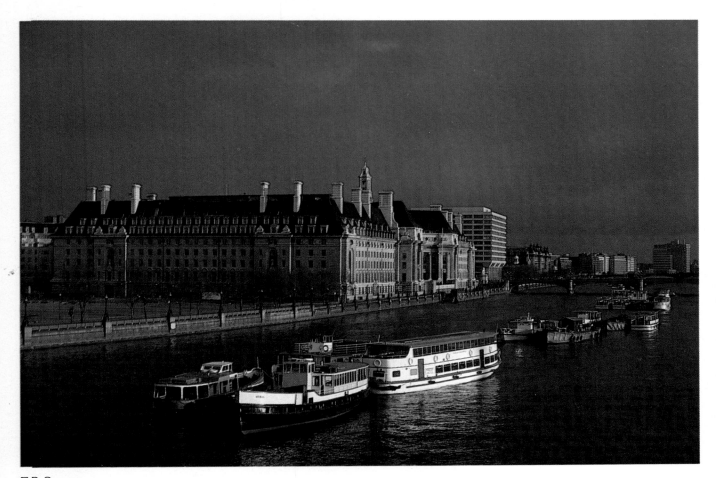

F.P. Symes

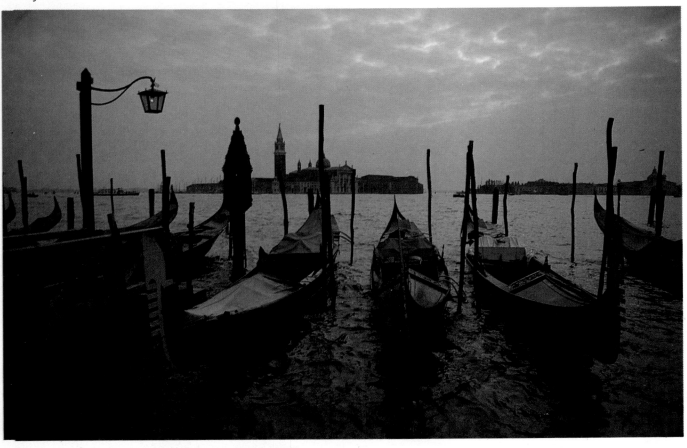

Richard Tucker

Graham Monro

Technical Data

Jacket
Photographer	H. F. Keeling (UK)
Camera	Canon A1
Lens	100 mm
Film	Kodak Ektachrome 64

Front End Paper
Photographer	Stephen Shakeshaft (UK)
Camera	Nikon
Lens	200mm
Film	Kodak Tri-X

18/19
Photographer	Dan Reader (UK)
Camera	Olympus OM1
Lens	21 mm
Film	Kodachrome

20
Photographer	Philip Long (UK)
Camera	Canon AE1 Program
Lens	Canon 50 mm
Film	Fujichrome 400

21
Photographer	Ursula Jochum (UK)
Camera	Nikon EM
Lens	Tech data not supplied
Film	Kodachrome

22
Photographer	John Jerstice (UK)
Camera	Canon F1
Lens	50 mm
Film	Kodachrome

Photographer	Manjulk Agarwal (France)
Camera	Nikon F3
Lens	80-200 mm Zoom
Film	Ektachrome

23 Upper
Photographer	Dr D.C. Wheeler FRPS (UK)
Camera	Pentax
Lens	135 mm
Film	Kodachrome

23 Lower
Photographer	Richard Tucker FRPS (UK)
Camera	Nikon F3
Lens	24 mm
Film	Kodachrome 64

24/25
Photographer	Peter Wilkinson FRPS (UK)
Camera	Penta
Lens	Tech data not supplied
Film	

26
Photographer	Patric Duzer (France)
Camera	Nikon F1
Lens	300 mm
Film	Kodak Tri-X

27
Photographer	Peter Underhay (UK)
Camera	Canon A1
Lens	70-350 mm Tamron zoom
Film	Ektachrome

28
Photographer	Denny Rowland (UK)
Camera	Canon F1
Lens	Fish Eye
Film	Kodachrome

29
Photographer	Norman Pealing FRPS (UK)
Camera	Hasselblad
Lens	80 mm
Film	Ilford VPS

30
Photographer	Pablo Esgueva (Spain)
Camera	Olympus OM2
Lens	38 mm
Film	Ektachrome

31
Photographer	Ed Over (UK)
Camera	Nikon F2
Lens	500 mm
Film	Kodachrome

32
Photographer	Denis Kennedy (UK)
Camera	Nikon F3
Lens	85 mm
Film	Kodachrome

33
Photographer	Wilhelm Kleinöder (West Germany)
Camera	Olympus OM2
Lens	300 mm
Film	Agfapan Vario XL

34/35
Photographer	L McLean ARPS (UK)
Camera	Minolta
Lens	400mm Rokkor
Film	Kodak Tri-X

36
Photographer	S. M. Ho (Malaysia)
Camera	Olympus OM2
Lens	80-200 mm zoom
Film	XP1

37
Photographer	John Timbrell (UK)
Camera	Fujica ST
Lens	50 mm
Film	Ilford FP4

38

Photographer	Douglas Jardine (UK)
Camera	Leica M2
Lens	50 mm
Film	Kodak Tri-X

39

Photographer	Juergen Hasenkopf (UK)
Camera	Canon A1
Lens	200 mm
Film	Ilford HP5

40

Photographer	J. E. Durham ARPS (UK)
Camera	Canon F1
Lens	50 mm
Film	Ilford FP4

41

Photographer	H.C. Hernandez Irquierdo (Spain)
Camera	Canon FTB
Lens	50 mm
Film	Ilford HP5

42

Photographer	Bill Wisden FRPS (UK)
Camera	Canon
Lens	16 mm
Film	Ilford FP4

43

Photographer	Gerd Romahn (West Germany)
Camera	Canon A1
Lens	17 mm
Film	Ektachrome

44

Photographer	Ian Rodger (UK)
Camera	Olympus OM1
Lens	28 mm
Film	Ilford HP5

45

Photographer	David Townend (UK)
Camera	Canon AE1
Lens	28 mm Canon
Film	Ilford FP4

46

Photographer	Malcolm Andrew (UK)
Camera	Hasselblad
Lens	80 mm-plus 2x Convertor
Film	Kodak Tri-X

47

Photographer	J.A. Batten (UK)
Camera	Leicaflex SL
Lens	50 mm Summicron
Film	Ilford FP4

48

Photographer	Alan Benson (UK)
Camera	Olympus OM1
Lens	75-205 mm zoom
Film	Ilford FP4

49

Photographer	Vlado Bǎca (Czechoslavakia)
Camera	Mamiya RB67
Lens	250 mm Sekor
Film	Agfa 400

50

Photographer	Patric Duzer (France)
Camera	Nikon F1
Lens	300 mm
Film	Kodak Tri-X

51

Photographer	Stanley Matchett (UK)
Camera	Nikon FE
Lens	50 mm
Film	Ilford HP5

52

Photographer	Ray Spence (UK)
Camera	Canon A1
Lens	50 mm
Film	Ilford FP4

53

Photographer	Gunther Prätor (DDR)
Camera	Praktica VLC3
Lens	Sonar 135 mm
Film	Tech data not supplied

54

Photographer	Vlado Bača (Czechoslavakia)
Camera	Mamiya RB67
Lens	250 mm Sekor
Film	Agfa 400

55

Photographer	John Renwick (UK)
Camera	Minolta SRT 101B
Lens	35 mm
Film	Ilford HP5

56

Photographer	A Sutkus (Lithuania/USSR)
Camera	
Lens	Tech data not supplied
Film	

57

Photographer	David Thorsteinsson (Iceland)
Camera	Leica M4
Lens	28 mm
Film	Kodak Tri-X

58

Photographer	E. Freeman ARPS (USA)
Camera	Leica 3A
Lens	50 mm Summicron
Film	Tech data not supplied

59

Photographer	David Townend (UK)
Camera	Canon AE1
Lens	28 mm Canon
Film	Ilford FP4

60

Photographer	Stuart Johnstone (UK)
Camera	Nikon FM
Lens	50 mm
Film	Plus-X

61

Photographer	Dennis Mansell ARPS (UK)
Camera	Pentax
Lens	28 mm
Film	Kodak Tri-X

62

Photographer	Frederick Kennedy (UK)
Camera	Olympus OM2
Lens	135 mm Zuiko
Film	Ilford FP4

63

Photographer	Peeter Tooming (Estonia/USSR)
Camera	
Lens	Tech data not supplied
Film	

64

Photographer	Mike Jesson (UK)
Camera	Praktica LTL3
Lens	70-150 Tamron zoom
Film	Ilford FP4

65

Photographer	Bob Tanner (UK)
Camera	Hasselblad
Lens	150 mm
Film	Ektachrome

66

Photographer	J.A. Dick (UK)
Camera	Olympus OM2
Lens	50 mm Zuiko
Film	Kodachrome

67

Photographer	J.A. Dick (UK)
Camera	Olympus OM2
Lens	300 mm Zuiko
Film	Kodachrome

68

Photographer	Derek Ground (UK)
Camera	Pentax SV
Lens	70-200 mm zoom
Film	Kodachrome

69

Photographer	Lisa B Kolber (USA)
Camera	Minolta X6-A
Lens	50 mm
Film	Kodachrome

70/71

Photographer	Nurset Eren (Turkey)
Camera	Canon FTB
Lens	Tech data not supplied
Film	Kodachrome II

72/73

Photographer	Derek Grant (UK)
Camera	Canon A1
Lens	80-200 mm zoom
Film	Kodachrome

74

Photographer	F.P. Symes (UK)
Camera	Nikon FE
Lens	135 mm Nikkor
Film	Ektachrome

75

Photographer	Christian Him (France)
Camera	Olympus OM2
Lens	75-150 mm zoom
Film	Ektachrome

76

Photographer	Peter Karry (UK)
Camera	Nikormat
Lens	70-100 mm zoom
Film	Kodachrome

77

Photographer	Rob Talbot (UK)
Camera	Nikon F3
Lens	180 mm Nikor
Film	Ektachrome

78 Upper

Photographer	Irene Booth ARPS (UK)
Camera	Praktica MTL3
Lens	70-150 mm zoom
Film	Agfa CT18

78 Lower

Photographer	C.E. Barwell (New Zealand)
Camera	
Lens	Tech data not supplied
Film	

79 Upper

Photographer	John Jerstice LRPS (UK)
Camera	Canon F1
Lens	50 mm
Film	Kokachrome

79 Lower

Photographer	Fayek Salama (UK)
Camera	Canon A1
Lens	70-210 mm Canon zoom
Film	Kodachrome

80
Photographer Gul Anand (India)
Camera Olympus XA
Lens Tech data not supplied
Film Kodachrome

81
Photographer William Cheung FRPS (UK)
Camera Olympus OM2
Lens 17 mm
Film Kodak Tri-X

82
Photographer Tim Bishop ARPS (UK)
Camera Nikon F2
Lens 300 mm
Film Ilford HP5

83
Photographer Alex Cleland (UK)
Camera Olympus OM2
Lens 200 mm
Film Ilford HP5

84
Photographer Martin Langer
 (West Germany)
Camera Nikon F2
Lens 35 mm
Film Kodak Tri-X

85
Photographer Gebhard Krewitt
 (West Germany)
Camera Nikon F2
Lens 85 mm
Film Tech data not supplied

86/87
Photographer Peter Upton LRPS (UK)
Camera Nikon F3
Lens 80-200 mm Nikkor zoom
Film Ilford HP5

88/89
Photographer Albert Clotet Amich
 (Spain)
Camera Nikon F
Lens Tech data not supplied
Film Kodak Tri-X

90/91
Photographer Mike Hollist (UK)
Camera Nikon F2
Lens 85 mm
Film Kodak Tri-X

92
Photographer Erland Pillegaard
 (Denmark)
Camera Olympus OM2
Lens 75-150 mm zoom
Film Ilford FP4

93 Upper
Photographer S Trzaska (Poland)
Camera Nikon F2
Lens 20 mm
Film Kodak Tri-X

93 Lower
Photographer Juan B Pásez (Colombia)
Camera Nikon F
Lens 24 mm
Film Ilford FP4

94 Upper
Photographer Frank Loughlin (UK)
Camera Nikon F2
Lens 28 mm
Film Kodak Tri-X

94 Lower
Photographer Tim Bishop ARPS (UK)
Camera Nikon F2
Lens 300 mm
Film Ilford HP5

95
Photographer Tim Bishop ARPS (UK)
Camera Nikon F2
Lens 300 mm
Film Ilford HP5

96
Photographer John Davidson (UK)
Camera Nikon
Lens 105 mm
Film Kodak Tri-X

97
Photographer Nicholas Scott ARPS (UK)
Camera Mamiya 645
Lens 80 mm
Film Ilford FP4

98
Photographer Antoni López (Spain)
Camera Pentax
Lens 135 mm
Film Agfa Pan 100

99
Photographer Neale Davison ARPS (UK)
Camera Pentax SP2
Lens 135 mm Soligor
Film Ilford HP5

100
Photographer Reg Cooke (UK)
Camera Pentax
Lens 28 mm
Film Ilford HP5

101
Photographer John Walker (UK)
Camera Rolleiflex
Lens Tech data not supplied
Film

102

Photographer	Manolo Torre (Spain)
Camera	
Lens	Tech data not supplied
Film	

103

Photographer	Hector Zampaglione (Spain)
Camera	Leicaflex SL
Lens	90 mm Elmarit
Film	Kodak Tri-X

104/105

Photographer	Bill Cross (UK)
Camera	Leica M4
Lens	35 mm
Film	Tech data not supplied

106

Photographer	John Renwick (UK)
Camera	Minolta SRT 101 B
Lens	35 mm
Film	Ilford HP5

107

Photographer	Gunther Prätor (DDR)
Camera	Praktica VLC3
Lens	135 mm Sonar
Film	Tech data not supplied

108

Photographer	Kenneth Deitcher (USA)
Camera	Canon A1
Lens	28 mm Tamron
Film	Kodak Tri-X

109

Photographer	D.H. Armstrong (UK)
Camera	Mamiya
Lens	135 mm Sekor
Film	Ilford FP4

110

Photographer	Margaret Salisbury FRPS (UK)
Camera	Canon AE1
Lens	80-150 mm zoom
Film	Ilford FP4

111

Photographer	Asko Salmi (Finland)
Camera	Canon F1
Lens	20 mm
Film	Kodak Tri-X with red filter

112

Photographer	Michael Armstrong (Australia)
Camera	Bronica S2A
Lens	Tech data not supplied
Film	Kodak Tri-X

113

Photographer	A.J. Stimpson (UK)
Camera	Pentax ME
Lens	100-200 mm Vivitar zoom
Film	Ektachrome

114 Upper

Photographer	Peter Upton LRPS (UK)
Camera	Nikon F3
Lens	80-220 mm Nikkor zoom
Film	Ilford HP5

114 Lower

Photographer	G.I. Ratcliffe (UK)
Camera	Pentax SP500
Lens	Standard
Film	Kodachrome

115 Upper

Photographer	H.S. Fry FRPS (UK)
Camera	Nikon S3
Lens	80-200 mm Nikkor zoom
Film	Kodachrome

115 Lower

Photographer	Sir George Pollock Hon FRPS (UK)
Camera	Canon OM-2
Lens	24 mm Zuiko
Film	Agfachrome 50S

116

Photographer	Kurt Lang ARPS (UK)
Camera	Hasselblad
Lens	150 Sonnar
Film	Kodak VPS2

117

Photographer	Sung Ming ARPS (Taiwan)
Camera	Hasselblad
Lens	150 mm
Film	Kodak C120

118

Photographer	Erkki Niemela (Finland)
Camera	Leicaflex SL2
Lens	180 mm
Film	Kodachrome

119

Photographer	Rob Talbot (UK)
Camera	Nikon F3
Lens	180 mm Nikkor
Film	Ektachrome

120/121

Photographer	Peter Waller (UK)
Camera	Olympus OM1
Lens	35-110 mm zoom
Film	Agfa CT18

122

Photographer	Roger Lane (UK)
Camera	Olympus OM1
Lens	50 mm
Film	Ektachrome

123
Photographer Heather Angel FRPS (UK)
Camera Nikon
Lens 200 mm
Film Ektachrome

124
Photographer David Horwell (UK)
Camera Olympus OM1
Lens 50 mm
Film Agfa CT21

125
Photographer Valerie Hames (UK)
Camera Tech data not supplied
Lens
Film Agfa CT18

126
Photographer Bob Moore FRPS (UK)
Camera Nikon FE
Lens 16 mm Nikon
Film Tech data not supplied

127 Upper
Photographer Edwin Appleton FRPS (UK)
Camera Leica R4
Lens 500 mm
Film Kodachrome 64

127 Lower
Photographer Ulrich Kloes
 (West Germany)
Camera Canon F1
Lens 200 mm Soligor
Film Ektachrome 160

128
Photographer Thomas Beyer
 (West Germany)
Camera Canon AE
Lens 28-85 mm Tokina zoom
Film Fujichrome 100

129
Photographer Jagdish Agarwal (India)
Camera Nikon FE
Lens Tech data not supplied
Film Kodak Plus-X

130
Photographer Alan Millward FRPS (UK)
Camera Pentax ME
Lens 80-200 mm zoom
Film Ilford FP4

131
Photographer Neil Jones (UK)
Camera Nikon FM
Lens 300 mm
Film Kodak Tri-X

132/133
Photographer Bob King (Australia)
Camera Nikon
Lens Tech data not supplied
Film Kodak Tri-X

134
Photographer Mike Hollist (UK)
Camera Nikon F2
Lens 85 mm
Film Kodak Tri-X

135
Photographer Bodo Goeke
 (West Germany)
Camera Canon F1
Lens 300 mm
Film Kodak Tri-X

136/137
Photographer Mervyn Rees (UK)
Camera Nikon F2
Lens 16 mm
Film Kodak Tri-X

138
Photographer Noel Houghton (UK)
Camera Pentax KX
Lens 50 mm
Film Kodak Tri-X

139
Photographer Alen Vykulilová
 (Czechoslavakia)
Camera Minolta SRT 303
Lens 50 mm
Film Orwo

140
Photographer Jos A Vella FRPS (Malta)
Camera Mamiyaflex C330
Lens 180 mm
Film Ilford FP4

141
Photographer Peter Elgar ARPS (UK)
Camera Pentax ES
Lens 55 mm
Film Ilford HP5

142
Photographer Brian Duff FRPS (UK)
Camera Nikon
Lens Tech data not supplied
Film

143
Photographer Kevin Fitzpatrick (UK)
Camera Canon A1
Lens 135 mm
Film Kodak Tri-X

144
Photographer Reg Cooke (UK)
Camera Pentax
Lens 28 mm
Film Ilford HP5

145
Photographer Douglas Jardine (UK)
Camera Leica M2
Lens 50 mm
Film Kodak Tri-X

146
Photographer William Blackham (UK)
Camera Hasselblad
Lens 80 mm Planar
Film Ilford HP5

147
Photographer Tony Boxall FRPS (UK)
Camera Mamiya C33
Lens 80 mm
Film Kodak Tri-X

148
Photographer William Cheung FRPS (UK)
Camera Olympus OM2
Lens 17 mm
Film Kodak Tri-X

149
Photographer Margaret Salisbury FRPS (UK)
Camera Canon AE1
Lens 80-200 mm zoom
Film Ilford FP4

150
Photographer Rudy Lewis (UK)
Camera Nikon F2
Lens 28 mm Nikkor
Film Kodak Tri-X

151
Photographer Clive B Harrison FRPS (UK)
Camera Olympus OM1
Lens 100 mm Zuiko
Film Ilford XP1-400

152/153
Photographer Hector Zampaglione (Spain)
Camera Leicaflex SL
Lens 90 mm Elmarit
Film Kodak Tri-X

154
Photographer Mike Hollist (UK)
Camera Nikon F2
Lens 85 mm
Film Kodak Tri-X

155 Upper
Photographer Harry Prosser (UK)
Camera Canon A1
Lens 400 mm
Film Kodak Tri-X

155 Lower
Photographer Mike Hollist (UK)
Camera Nikon F2
Lens 85 mm
Film Kodak Tri-X

156
Photographer Gebhard Krewitt (West Germany)
Camera Nikon F2
Lens 85 mm
Film Tech data not supplied

157
Photographer Asadour Guzelian (UK)
Camera Nikon FM
Lens 105 mm
Film Ilford HP5

158
Photographer J.E. Durham ARPS (UK)
Camera Canon F1
Lens 50 mm
Film Ilford FP4

159
Photographer A Sutkus (Lithuania/USSR)
Camera
Lens Tech data not supplied
Film

160
Photographer David Chamberlain ARPS (UK)
Camera Mamiya RB67
Lens 180 mm Sekor
Film Ilford HP5

161
Photographer Andrzej Sawa (South Africa)
Camera Nikon F3
Lens 80-200 mm Nikkor zoom
Film Ektachrome 200

162
Photographer Heather Angel FRPS (UK)
Camera Nikon
Lens 200 mm
Film Ektachrome

163 Upper
Photographer E.A. Janes FRPS (UK)
Camera Hasselblad
Lens 50 mm Distagon
Film Ektachrome

163 Lower
Photographer Heather Angel FRPS (UK)
Camera Nikon
Lens 200 mm
Film Ektachrome

164/165

Photographer	Beatriz Diez Astoreka (Spain)
Camera	Minolta XGM
Lens	135 mm
Film	Kodachrome

166

Photographer	Gerd Stieber (West Germany)
Camera	Pentax MX
Lens	90 mm
Film	Ektachrome

167

Photographer	Peter Kniep (West Germany)
Camera	Canon AE1
Lens	50 mm
Film	Agfa CT18

168/169

Photographer	David Higgs (UK)
Camera	Olympus OM1
Lens	50 mm Zuiko
Film	Kodachrome

170 Upper

Photographer	S. Paul (India)
Camera	Nikon FM
Lens	55 mm Micro Nikkor
Film	Kodachrome

170 Lower

Photographer	František Dostál (Czechoslavakia)
Camera	Minolta SRT 303
Lens	24 mm Rokker
Film	Orwochrome

171 Upper

Photographer	P Jeffery (UK)
Camera	
Lens	Tech data not supplied
Film	

171 Lower

Photographer	Book Moore FRPS (UK)
Camera	Nikon FE
Lens	16 mm Nikon
Film	Tech data not supplied

172 Upper

Photographer	Gerd Stieber (West Germany)
Camera	Pentax MX
Lens	90 mm
Film	Ektachrome

72 Lower

Photographer	Werner Hilscher (West Germany)
Camera	Canon A1
Lens	200 mm
Film	Ektachrome

173

Photographer	Werner Hilscher (West Germany)
Camera	Canon A1
Lens	200 mm
Film	Ektachrome 400

174

Photographer	Erland Pillegaard (Denmark)
Camera	Olympus OM2
Lens	75-150 mm zoom
Film	Ilford FP4

175

Photographer	Bob Tanner (UK)
Camera	Hasselblad
Lens	150 mm
Film	Ektachrome

176

Photographer	Frank Peeters (Belgium)
Camera	Nikon FM
Lens	105 mm
Film	Kodachrome

177

Photographer	Romualdos Rakauskas (Lithuania/USSR)
Camera	Minolta SRT
Lens	50 mm
Film	TIP 17

178

Photographer	Tony Boxall FRPS (UK)
Camera	Mamiya C33
Lens	80 mm
Film	Kodak Tri-X

179

Photographer	Neil Proctor (UK)
Camera	Pentax LX
Lens	135 mm
Film	Kodak Tri-X

180

Photographer	Afshin Shahroodi (Iran)
Camera	Olympus OM2
Lens	24 mm
Film	Agfa Isopan

181

Photographer	Datta Khopker FRPS (India)
Camera	Rolliecord
Lens	Tech data not supplied
Film	Kodak Tri-X

182/183

Photographer	Jane Miller ARPS (UK)
Camera	Pentax MX
Lens	75-105 zoom
Film	Kodak Tri-X

184/185

Photographer	Hermine Gsteu (Austria)
Camera	Minolta SRT 100
Lens	50 mm
Film	Ilford FP4

186

Photographer Arnold Umlauf
(West Germany)
Camera Canon A1
Lens 24 mm
Film Ilford FP4

187

Photographer John Russell (UK)
Camera Pentax 6X7
Lens 45 mm
Film Ilford FP4

188

Photographer Ian Rodger (UK)
Camera Olympus OM1
Lens 28 mm
Film Ilford HP5

189

Photographer Alexandra Bors-Costide
(Switzerland)
Camera Minolta XG-1
Lens 75-260 mm zoom
Film Ilford HP5

190

Photographer A Sutkus
(Lithuania/USSR)
Camera
Lens Tech data not supplied
Film

191

Photographer Hermine Gsteu (Austria)
Camera Minolta SRT 100
Lens 50 mm
Film Ilford FP4

192

Photographer Dennis Mansell ARPS (UK)
Camera Pentax
Lens 28 mm
Film Kodak Tri-X

193

Photographer Andrzes Krynicki
(Poland)
Camera Rolleiflex)
Lens 80 mm Xentor
Film Orwo NP15

194

Photographer Eddie Brown (UK)
Camera Nikon F2
Lens 300 mm
Film Kodak Tri-X

195

Photographer Bill Cross (UK)
Camera Leica M4
Lens 35 mm
Film Tech data not supplied

196

Photographer Veikko Wallström ARPS
(Finland)
Camera Nikon FE
Lens 43-86 mm zoom
Film Kodak Tri-X

197

Photographer Graham Monro (Australia)
Camera Nikon F3
Lens 20 mm
Film Kodak Tri-X

198

Photographer Kok-Pheng Liew ARPS
(Brunei)
Camera Hasselblad
Lens 150 mm Sonnar
Film Tech data not supplied

199

Photographer Eddie Brown (UK)
Camera Nikon F2
Lens 300 mm
Film Kodak Tri-X

200/201

Photographer Pavel Tishkovski
(Lithuania/USSR)
Camera
Lens Tech data not supplied
Film

202/203

Photographer Terry O'Connor
(New Zealand)
Camera
Lens Tech data not supplied
Film

204/205

Photographer František Dostál
(Czechoslavakia)
Camera Minolta SRT 303
Lens 24 mm Rokkor
Film Orwochrome

206

Photographer A Žižiunas
(Lithuania/USSR)
Camera Minolta SRT
Lens 75-205 mm Vivitar zoom
Film KN-3

207

Photographer Gebhard Krewitt
(West Germany)
Camera Nikon F2
Lens 85 mm
Film Tech data not supplied

208

Photographer H.K Heng ARPS
(Singapore)
Camera Hasselblad
Lens 80 mm Planar
Film Kodak

209
Photographer Bob Tanner (UK)
Camera Hasselblad
Lens 150 mm
Film Ektachrome

210
Photographer Naresh Sohal (UK)
Camera Olympus OM2
Lens 50 mm Zuiko
Film Kodachrome

211
Photographer Steve Moger (UK)
Camera Olympus OM10
Lens 50 mm Zuiko
Film Tech data not supplied

212 Upper
Photographer P. Jeffrey (UK(
Camera
Lens Tech data not supplied
Film

212 Lower
Photographer Dorina Stathopoulou
(Greece)
Camera
Lens Tech data not supplied
Film

213 Upper
Photographer David Galavan (Eire)
Camera Nikon FN
Lens 43-86 mm Nikkor zoom
Film Kodachrome

213 Lower
Photographer Ray Hoey
(West Germany)
Camera Konica FS
Lens 80-210 mm zoom
Film Agfa CT18

214
Photographer Ron Davies (UK)
Camera Olympus OM2
Lens 85 mm Zuiko
Film Kodachrome

215
Photographer Philip Tampin (UK)
Camera Olympus OM-1N
Lens 75-205 mm Vivitar zoom
Film Fujichrome 100

216/217
Photographer Rob Talbot (UK)
Camera Nikon F3
Lens 180 mm Nikkor
Film Ektachrome

218/219
Photographer Pat Clay ARPS (UK)
Camera Nikon FE
Lens 55 mm Nikkor
Film Kodachrome

220
Photographer Frank Peeters (Belgium)
Camera Nikon FM
Lens 105 mm
Film Kodachrome

221 Upper
Photographer Arndrzej Sawa
(South Africa)
Camera Nikon F3
Lens 80-200 mm Nikkor zoom
Film Ektachrome 200

221 Lower
Photographer Erland Pillegaard
(Denmark)
Camera Olympus OM2
Lens 75-150 mm zoom
Film Ilford FP4

222
Photographer Richard Tucker FRPS (UK)
Camera Nikon F3
Lens 24 mm
Film Kodachrome 64

223
Photographer F.P. Symes (UK)
Camera Nikon FE
Lens 135 mm Nikkor
Film Ektachrome

Photographer Richard Tucker FRPS (UK)
Camera Nikon F3
Lens 24 mm
Film Kodachrome 64

224
Photographer Graham Monro
(Australia)
Camera Nikon F3
Lens 20 mm
Film Kodak Tri-X

Rear End Paper
Photographer Romualdas Požerskis
(Lithuanian/USSR)
Camera Minolta SRT
Lens 24 mm Rokker
Film KN3